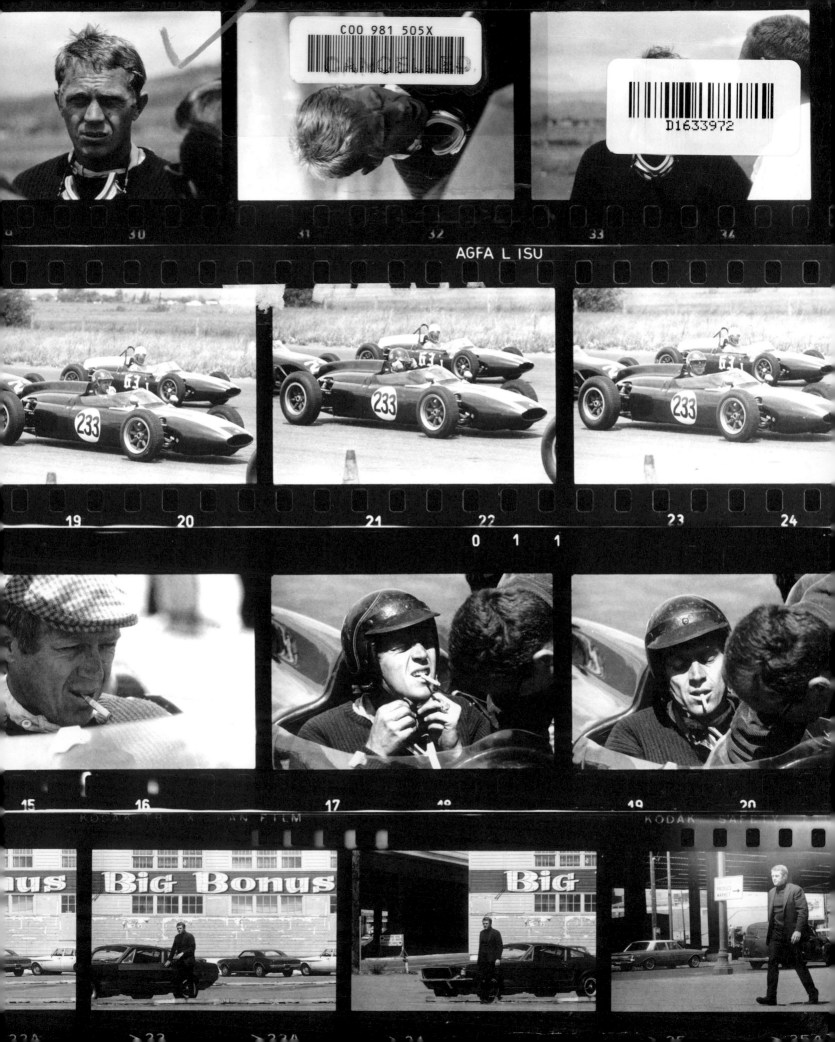

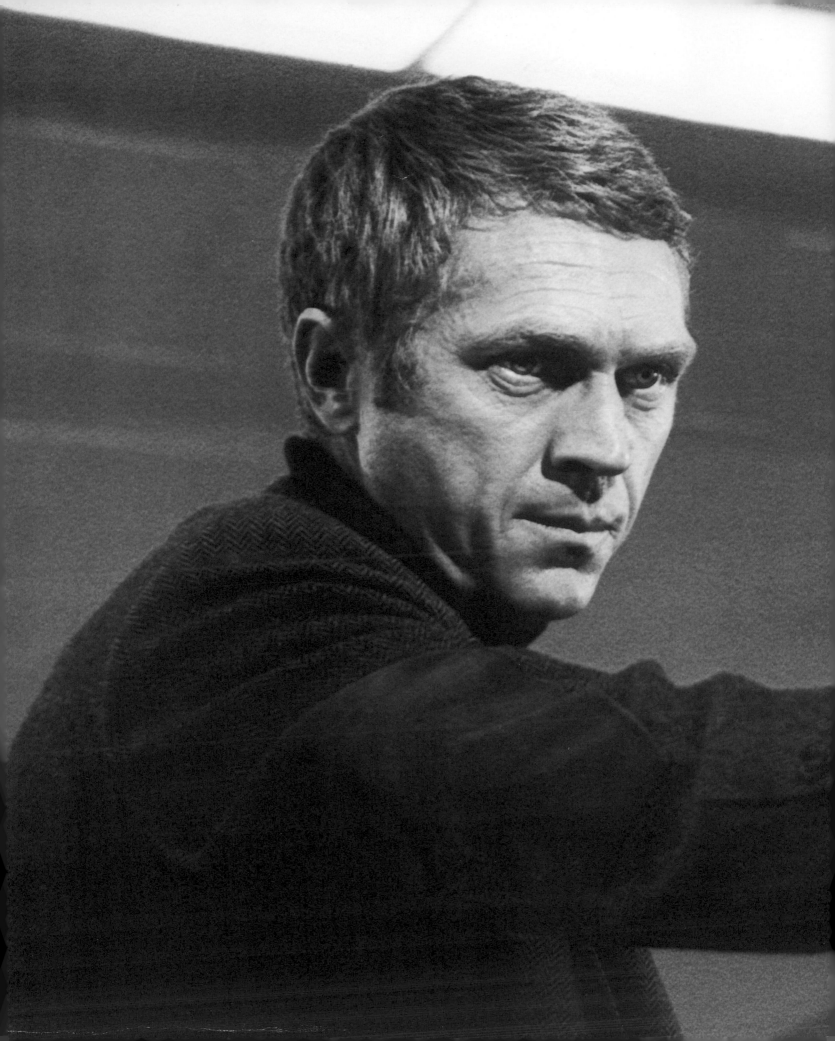

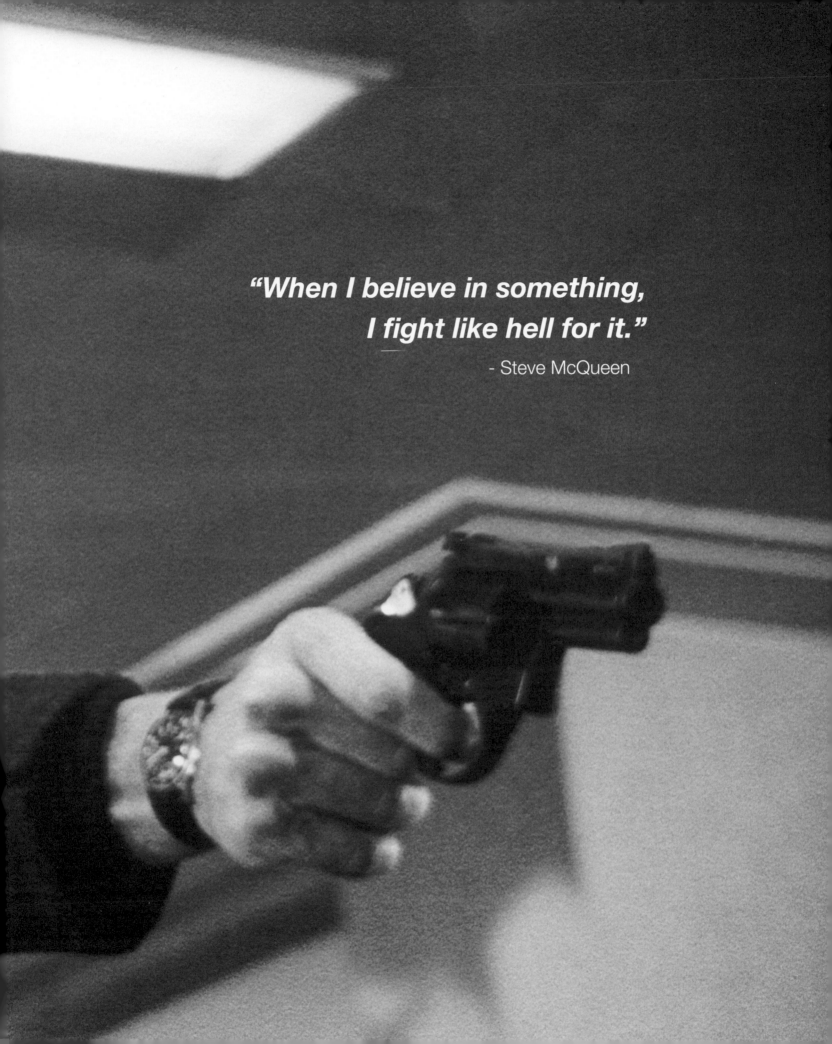

"When I believe in something, I fight like hell for it."

- Steve McQueen

UNSEEN McQUEEN

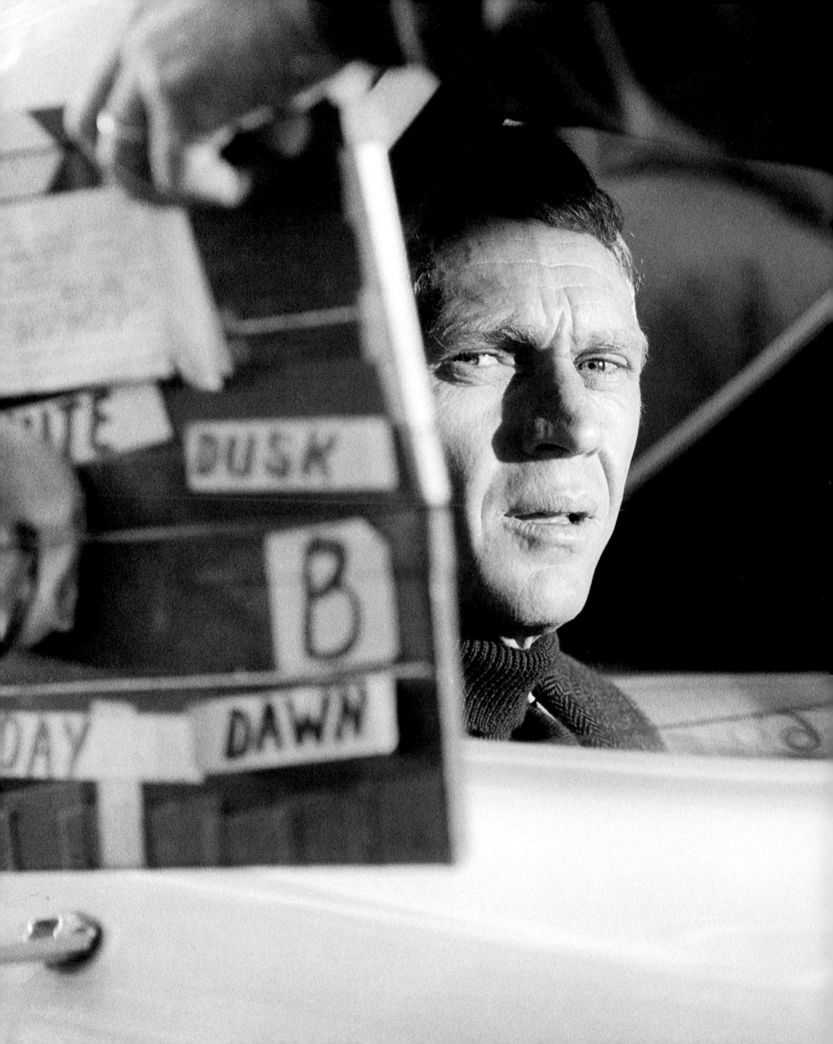

UNSEEN McQUEEN
BARRY FEINSTEIN

Edited by

DAGON JAMES and TONY NOURMAND

Introduction by

DAVE BROLAN

REEL ART PRESS

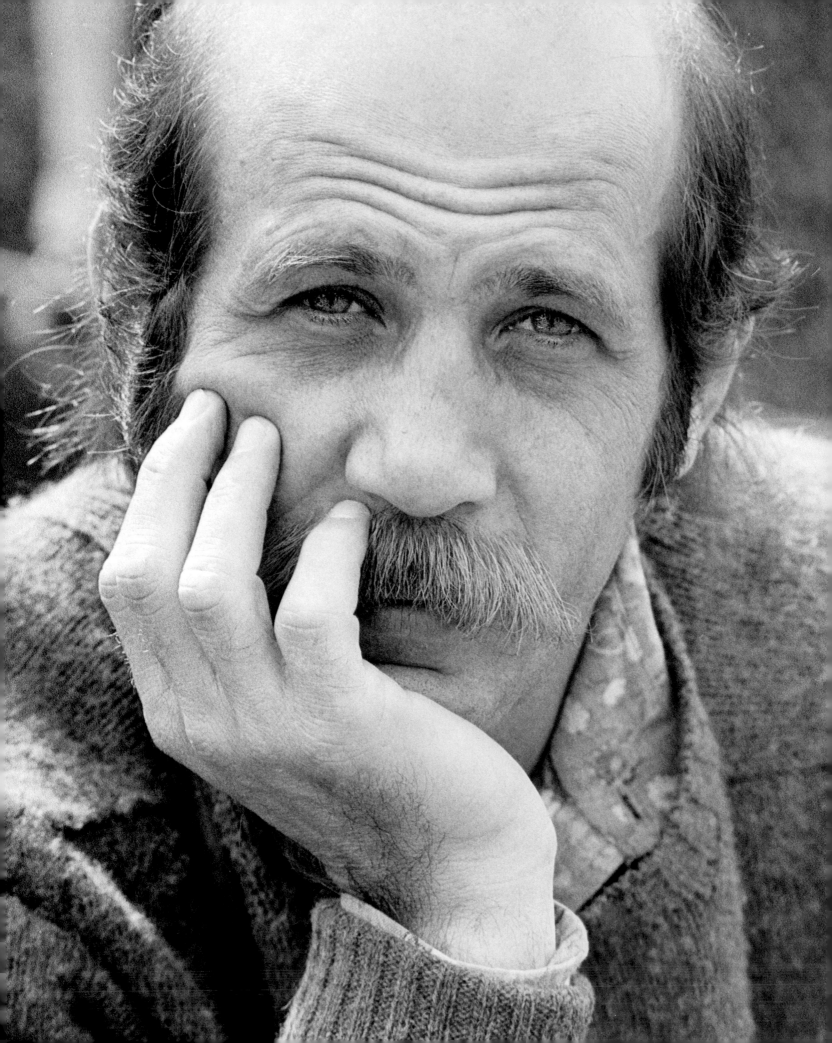

This book is dedicated to Barry and Steve.
Two old friends.

I know Barry would have been so proud of this book. He loved Steve, his friend for many years, and he loved seeing his photographs being printed large and with no fuss. He was protective of his archive and always asked questions before allowing anything to be published, preferring to leave a picture unused than used badly. He was also an award-winning art director, remarking that photo books were often poorly designed, highlighting the design rather than the photographs. A good designer, he would say, should make the pictures look great.

Barry was a huge fan of the art direction of *Lid* magazine so it is perfect that Dagon James has produced the layouts for the book: I know Barry would be most appreciative and want to thank Dagon for being so respectful of his pictures. Dave Brolan worked with Barry for many years, persuading him to open up his archive and share his photographs with the world, which Dave continues to promote and protect in much the same manner as Barry did. I am forever grateful to Dave, not only for his friendship and love of Barry, but for his trustworthy assistance, critical eye, and the unwavering, benevolent attention he continues to focus on the integrity and use of Barry's work.

Barry really did let his pictures do the talking and I am delighted that so many of them are now published for the first time.

Judith Jamison
Woodstock NY, 2013

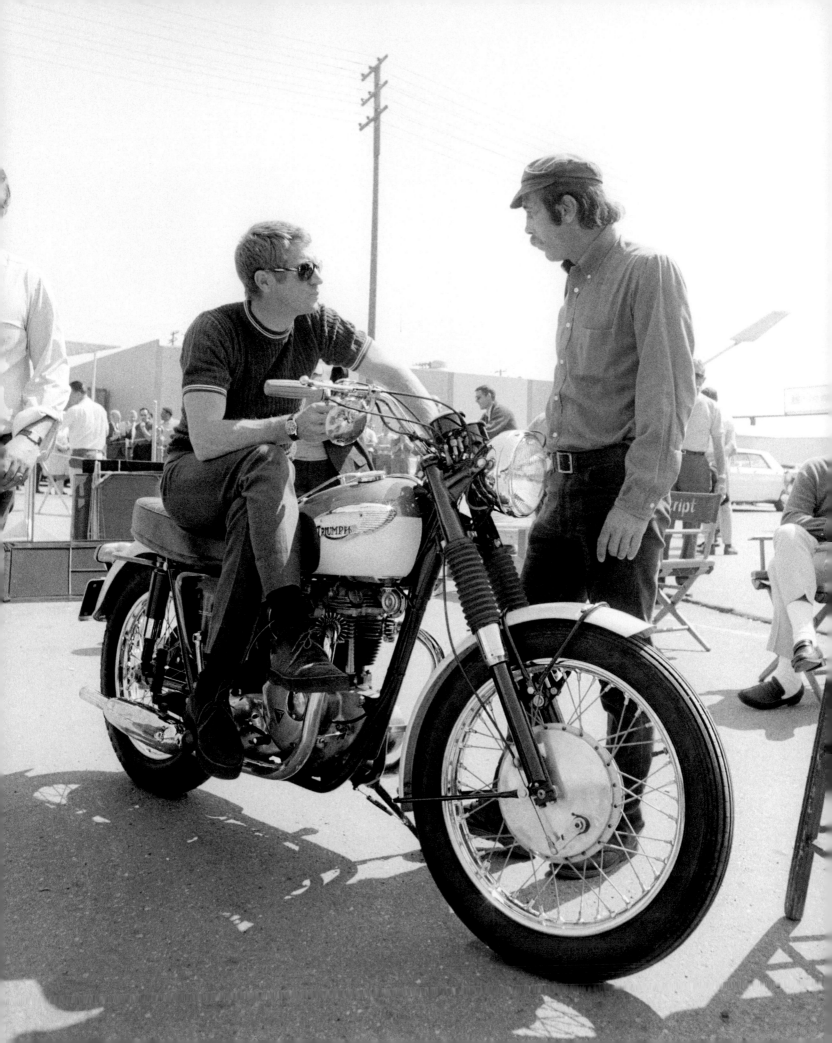

Introduction

Kings of Cool

Barry Feinstein was *the* perfect photographer to shoot stills on the set of Steve McQueen's classic movie *Bullitt*. As an artist, photographer, filmmaker, thrill-seeker and long-time friend of McQueen, he was instinctively in tune with everything that was taking place on and off set.

Starting in the 1950s as a production assistant for Columbia Pictures president Harry Cohn, Barry was perfecting his craft, taking photographs at every opportunity, choosing to shoot things that took his interest or he thought important. On the set with Judy Garland or Clark Gable he was working, but in his own time he documented the curtain falling on old Hollywood, the people, places and events in and around the studios, deliberately avoiding the glamorous side. He produced a remarkable, stark, sometimes ironic and often humorous series of photographs far removed from the usual controlled view endorsed by the all-powerful studios. In the early 1960s, this collection of pictures inspired Bob Dylan to compose a number of essays eventually published in a book *Hollywood Foto-Rhetoric* in which Dylan states, 'First of all I don't think what I had written would have been written without seeing the photographs … and secondly … well I don't know if there is a secondly.'

After Hollywood, through his friendship with Dylan's manager Albert Grossman, Barry began shooting musicians. He told me he had no real interest in straightforward stand up portraits, preferring something different, more unusual and more real with an element of mystery. The cover photo for Dylan's third album, *The Times They Are A Changin'*, happened on the balcony of an apartment in New York; in just a few frames Feinstein knew he had his shot, an unconventional, angled portrait. Despite not seeing himself as a portrait photographer, Barry was commissioned to shoot hundreds of album covers for Dylan, The Byrds, George Harrison, The Rolling Stones, Janis Joplin, Eric Clapton, Dr. John, Ike & Tina Turner, Frank Zappa, Gram Parsons, Barbra Streisand and many, many others covering Jazz, Folk, Blues, Rock, Soul and Gospel.

Also a brilliant documentary photographer with the eye of a fine artist, Barry would work almost unnoticed and be at the centre of the action for the vital moment, knowing exactly when to press the shutter and more importantly, as he said himself, 'knowing when not to'.

I had the good fortune and pleasure of working closely with Barry and his archive, a treasure trove of negatives, slides and prints that is simply staggering in its depth and scope. He was very clear that his pictures could do all the talking, rarely explaining in detail any concept beyond 'I try to do something good then try to do something better', and he was even more guarded about his subjects, a rare and admirable quality. He thought a lot but said little, in fact he rarely said anything that wasn't worth saying. Dylan was described as 'a genius', George Harrison 'a nice kid', Janis Joplin was 'Sweet' and so on. Aside from his incredible archive, he had decades of almost unbelievable stories that involved or concerned just about everyone and everything we would now consider 'cool' or important from the 1960s and 1970s.

To Barry they were friends and associates and everyday encounters, there was no line between work and friendship, it was life, not a job. He occasionally dropped little snippets into conversation, always strictly off the record and only if related to something that was already being talked about. I knew better than to ask but he would never answer a direct question about any of the people with whom he worked, mainly out of loyalty to his friends but also because he was genuinely disdainful of the bullshit that comes with celebrity. Regularly asked, 'What was Bob Dylan like?' Barry would say, 'How would I know? Read his book!' When Marilyn Monroe was found dead, the Magnum photo agency asked Barry to cover the breaking story. A security guard from the studio was keeping the press away from her house but allowed Barry access. He photographed the prescription pill bottle on her bedside table, a powerful, dignified and poignant image, characteristic of all Barry's work.

During his long career, Barry photographed presidents, rock musicians and movie stars. He was always looking for some way to make an interesting picture; for him it was always about the picture, not the subject. When the Beatles played their last ever concert at San Francisco's Candlestick Park in 1966, Barry was there with a movie camera; he needed footage of screaming fans for his movie *You Are What You Eat* which was released in 1968, becoming a cult classic. He did not film the Beatles because he 'didn't need them'!

Bob Neuwirth, Dylan's confidante and tour manager, told me that of all the people on the 1960s' scene, Barry was really the cool one that *everyone* was drawn to and wanted to hang out with, an observation I have heard repeated from people who knew Barry through the years. Writer Tad Wise, in his heartfelt obituary tribute to Barry in *The Woodstock Times*, quoted influential comedian and rant poet extraordinaire Lord Buckley as dubbing Barry, 'His Triple Hip-ness'.

Being as skilled with motorcycles and cars as he was with cameras was another reason why Barry was perfect for *Bullitt*. Barry's bright red 1929, Indian 101 Scout was his pride and joy and his Triumph Bonneville 650 TT was modified by Hollywood stunt ace Bud Ekins, who famously jumped the barbed wire in the classic scene from *The Great Escape* and drove the Mustang in *Bullitt*. His close friendship with the custom car and motorcycle pinstriping legend Von Dutch further allowed Barry to combine his passions, his vivid colour photographs showcasing the skills of both artists.

Skill, knowledge and passion aside, the real reason Barry was on set for *Bullitt* was because of his friendship with McQueen. The pair had been close for many years and shared a love of fast cars and motorcycles; together with Ekins they would tear up the back trails of the Southern Californian desert at every opportunity. Barry had photographed McQueen many times before, mostly at the racetrack. The cars are from another era but McQueen is timelessly magnificent in every photograph, carefully chosen and perfectly framed using available light and uncanny timing. Barry often shot in a sequential, movie-like way, never cropping the frame in print.

When editing his work he would always pick the strongest photo, dismissing a number of equally fine images. The reason for this, he explained, was, 'I'm only interested in printing *great* photographs'. Not good, not interesting, not even unusual ones. If a picture wasn't great then it wasn't printed. Over time he mellowed about releasing outtakes but still maintained his conviction about which of his images were truly great. Reviewing his work now, Barry selected the very best photo every time. Throughout his archive, looking over sheet after sheet of proofs where often none of the frames on the roll of film was ever marked up for printing, it was surprising to see the number of incredible photographs that Barry dismissed; 'interesting maybe, not great', he would say, 'ok but too dark' or 'there's better'. Sometimes he would say 'maybe' but more often just 'no'.

The term 'unseen photographs' is generally misleading and overused, it usually means the next frame on from the one always shown or a poor quality image rejected first time round. As popular culture becomes more studied and valuable with the constant demand for more imagery, many photographers are desperate to find 'new' work. Occasionally, too, a previously overlooked image takes on new meaning over time but never before have I seen such a body of work and a photographer so reluctant to show it. We are looking at photographs that were not only unpublished but mostly never printed before and, if left to Barry's critical eye, would probably have remained unseen.

As filming was due to commence on *Bullitt* in San Francisco, Barry was going through a low point in his personal life. McQueen picked him up, literally, and installed him at the Fairmont hotel and together they went to work. Typical of Barry, he never really revealed just how many pictures he had taken of McQueen, or explained how close they were. A few years back, we sat in his studio and started work on a book of his Bob Dylan photographs, *Real Moments*. Barry insisted he only had twenty great shots of Dylan, we left over one hundred out of the final edit. Similarly, he would offer only a few prints of McQueen that he thought were up to his standard. We got around to discussing his fondness for wearing baseball caps and when asked why he never wore the cool Stetson that was gathering dust in the corner he casually said, 'doesn't fit me, it's McQueen's'.

Although Barry was not particularly comfortable talking about his many achievements – for the longest time none of his photographs even had a place on the walls of his home – he was more than happy to discuss photography, movies, music and all aspects of art and design, pointing out what was good or not and why, also suggesting alternative points of view. Despite an archive stretching back to the 1950s, he much preferred looking forward; he was quietly proud of his photography and I think he would have been happy to see his work with McQueen published here. The last time I saw Barry, shortly before he passed away, I showed him some layouts for another project featuring his work. Flicking through the pages he told me to stop and go back a few pages. 'Don't crop that picture', he said, noticing a minor crop made on one photo that I am sure he had not viewed in almost forty years! I told him I didn't think he would notice. He smiled and his eyes twinkled. Of course he noticed; one of his gifts was an incredible eye for detail, another was his ability to capture it on film.

Great photographs, great artists and great friends, Barry Feinstein and Steve McQueen, kings of cool, doing what they loved doing most and doing it better than most!

Dave Brolan
London, 2013

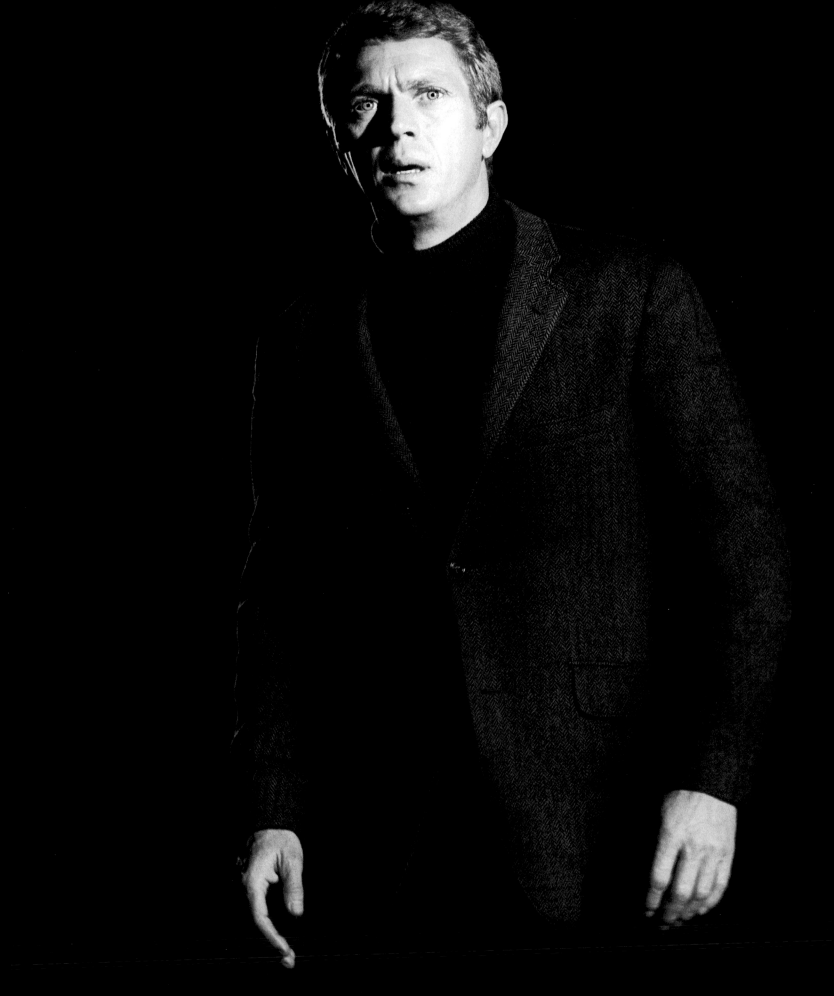

Steve McQueen

None Cooler on the Coast, 1968

Ironically Steve McQueen, a kid from the wrong side of the tracks who at the age of fourteen did time in a Californian reform school for stealing hubcaps, went on to star as the proto-cool cop in the 1968 movie *Bullitt.*

Movies have always had a habit of elevating everyday objects and clothes to cult status. On the big screen, even the smallest details become as glamorous and desirable as the stars that wear them. *Bullitt* was certainly no exception. With unfailing taste and the hipster's innate sense of correctness, McQueen wore probably the most influential set of Ivy threads in movie history.

In the role of San Francisco police lieutenant Frank Bullitt, McQueen wore an unusual combination of Ivy and English styles. His fine three button brown herringbone jacket had the natural shoulders and raised seams of traditional Ivy style but our man's jacket had two side back vents instead of the classic centre back vent and a ticket pocket plus elbow patches – a nice Anglo-American touch. Accepted, these may be minor details but interestingly could have resulted, if the jacket was custom made, from McQueen's love of English clothes, in particular the Savile Row tailoring of Dougie Hayward.

Under the jacket is a navy blue cashmere turtleneck sweater. At the bottom of the narrow, plain front trousers are a pair of the brown suede Playboy chukka boots that are still sought after today. Over the total outfit is a tan, fly front raglan sleeved single-breasted raincoat. Oh yes, and for those off-duty moments he wore that iconic, brown, shawl-collared cardigan. However, what really makes these classic Ivy clothes work is the McQueen swagger – for which, unfortunately, there are no guide books. That, plus he knew there is no substitute for digging the clothes you wear.

Steve McQueen had the coolest way of doing the most mundane things to such an extent that every actor seeing *Bullitt* has studied the way he got in and out of a car. The thing is, cars and McQueen are inextricably linked, none more so than in *Bullitt* where he got to drive a modified, Highland Green 1967 Ford Mustang GT fastback with 390 cubic inch (6.4 litre) engine. For its time it was a seriously fast, street legal car – it was the Ivy look on speed. This car was the work of the talented Carroll Shelby. He was an American automotive designer, racing driver and entrepreneur, best known for his involvement with AC Cobra and later the Mustang-based performance cars for the Ford Motor Company known as Shelby Mustangs. For petrol heads and car freaks, he was the kiddie.

Given the sobriquet, 'The King of Cool', McQueen set the standard for a new breed of anti-hero. Which at the height of the late 1960s counterculture, attracted millions of movie-going fans around the world, making him a top box-office draw. He had come a long way since once being described in a 1960 edition of *Look* magazine as being a member of the *squint-mumble-scratch-and-think* school of acting.

Graham Marsh
London, 2013

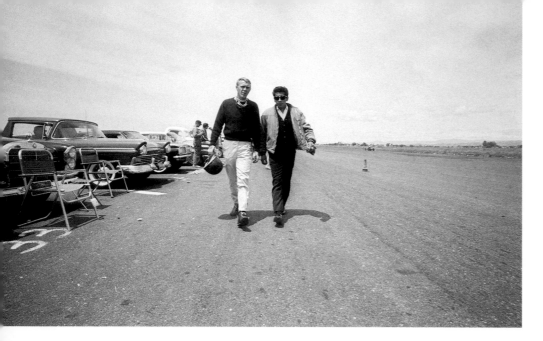

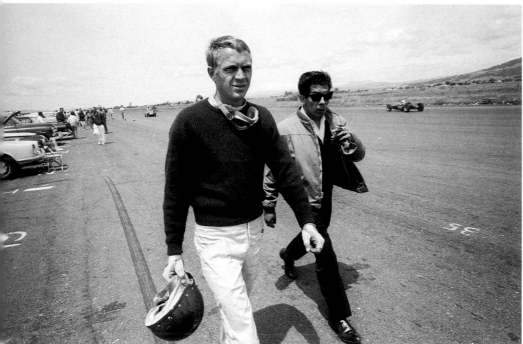

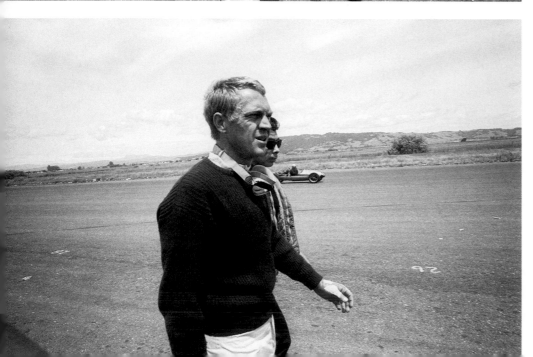

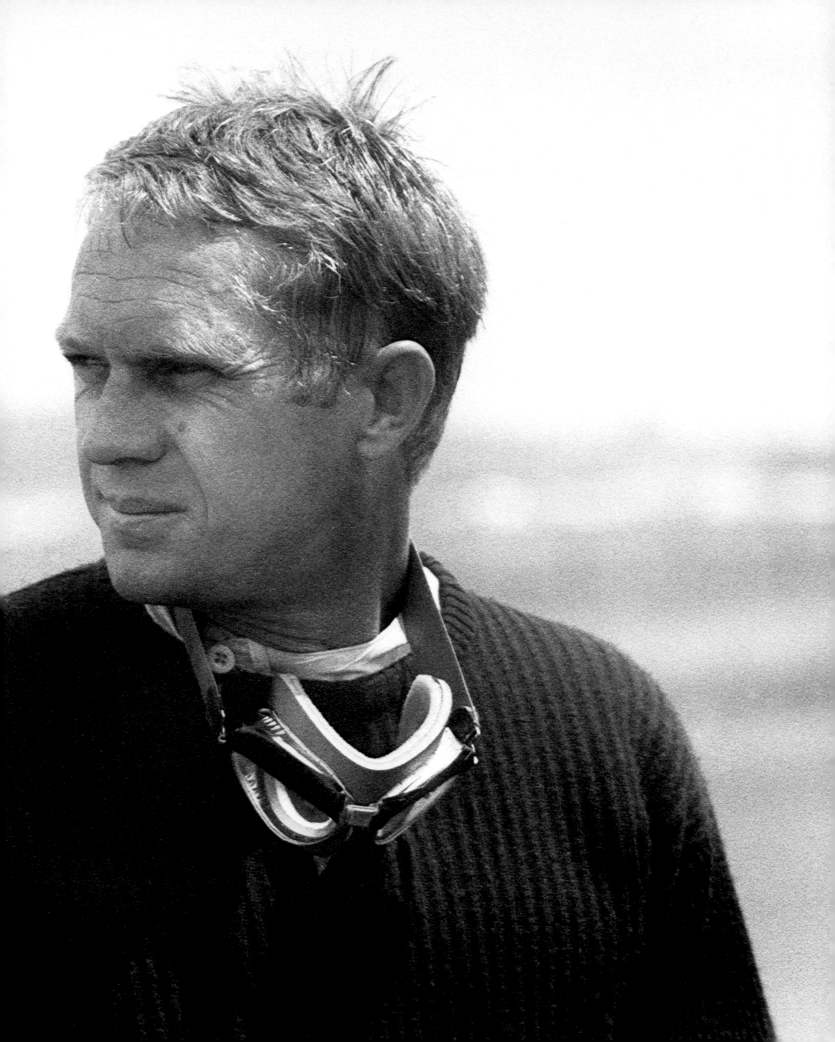

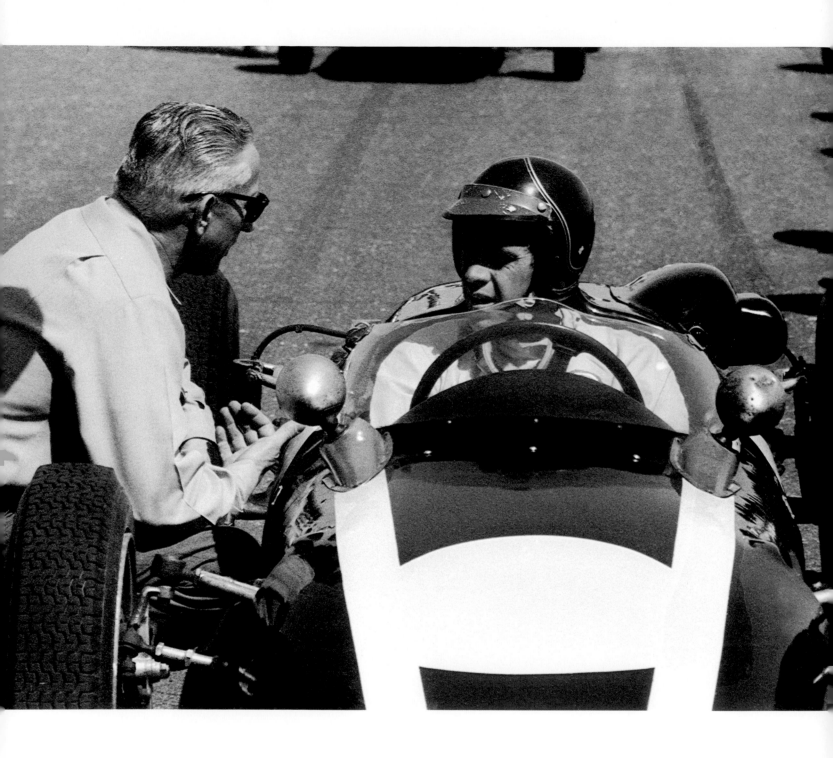

"I'm not sure whether I'm an actor who races or a racer who acts."

- Steve McQueen

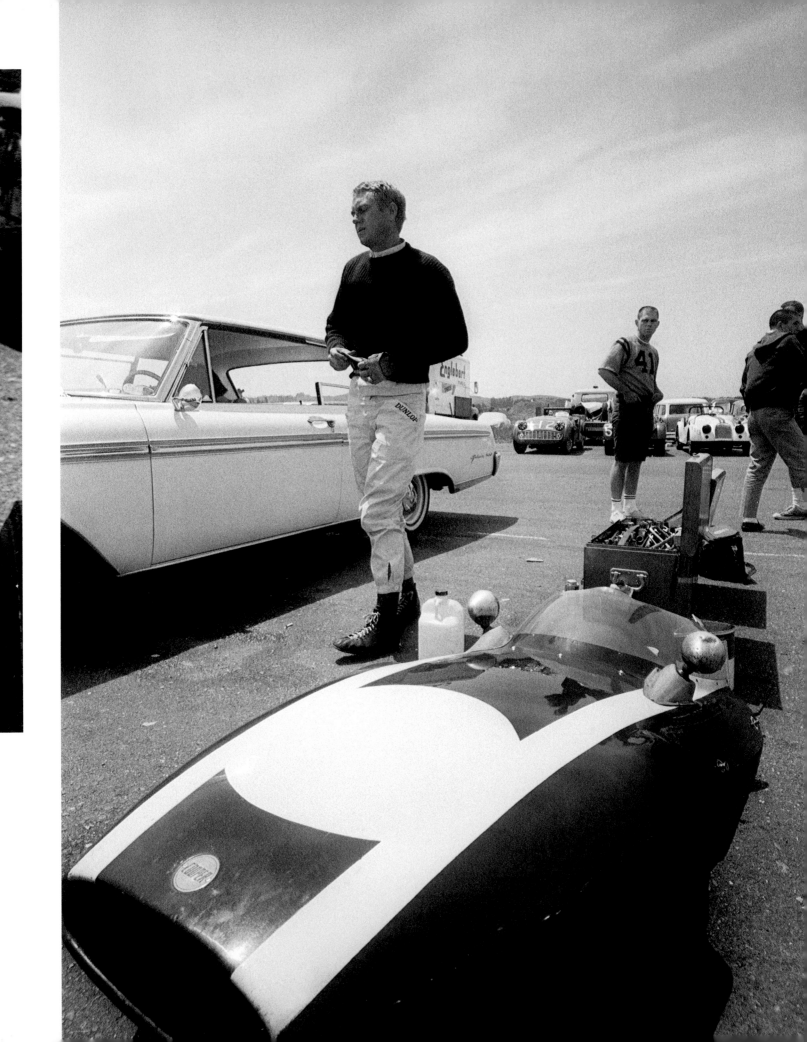

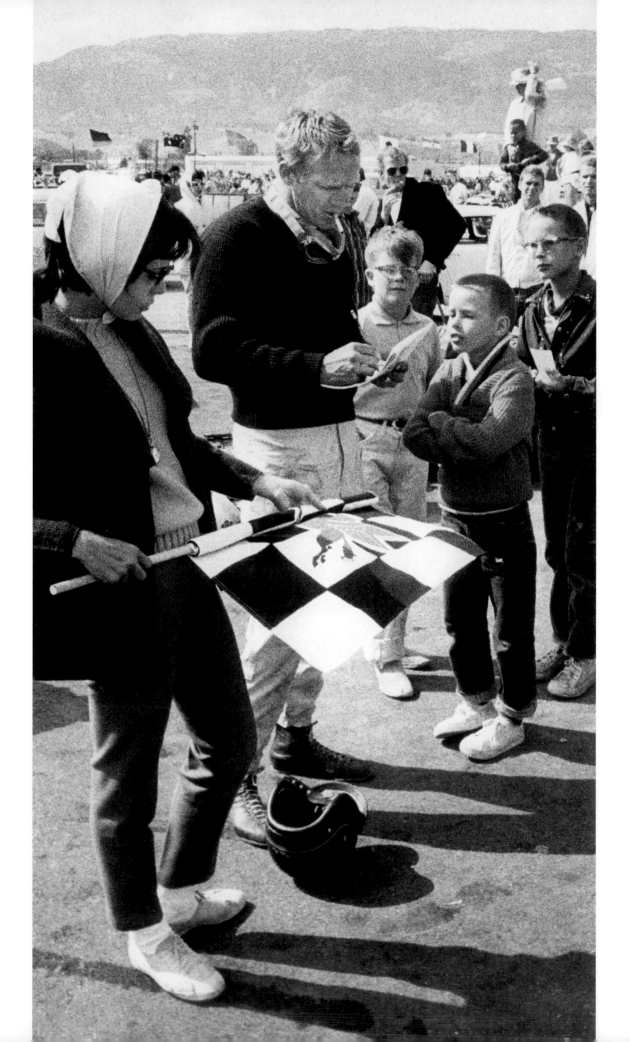

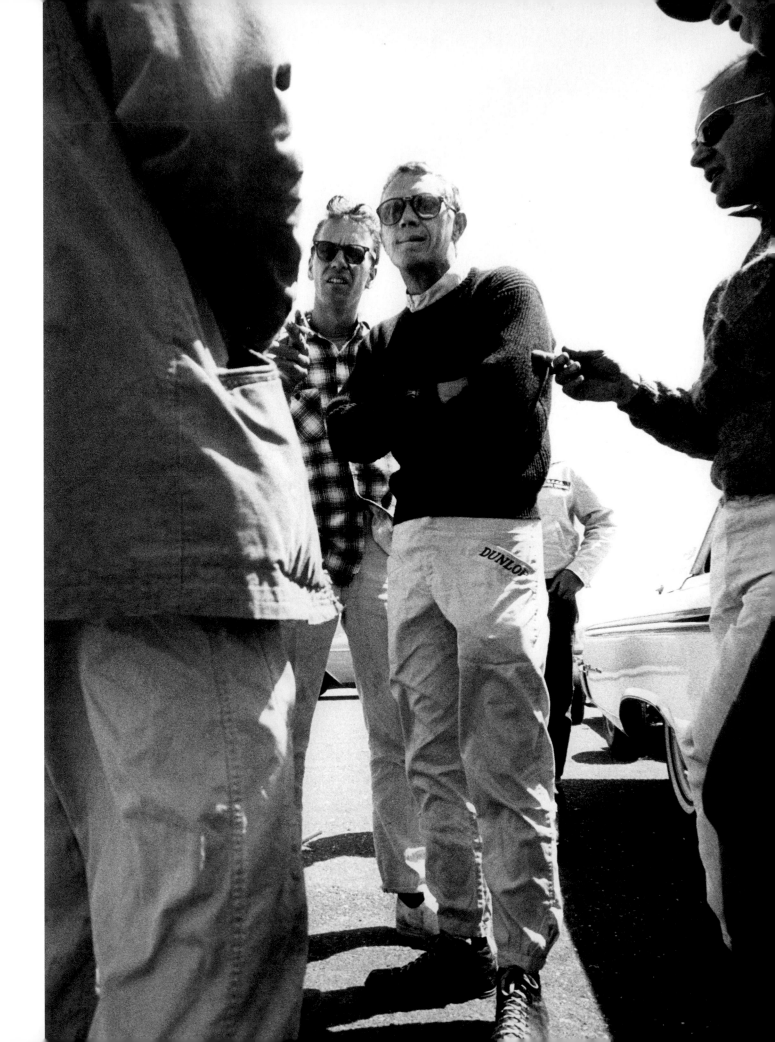

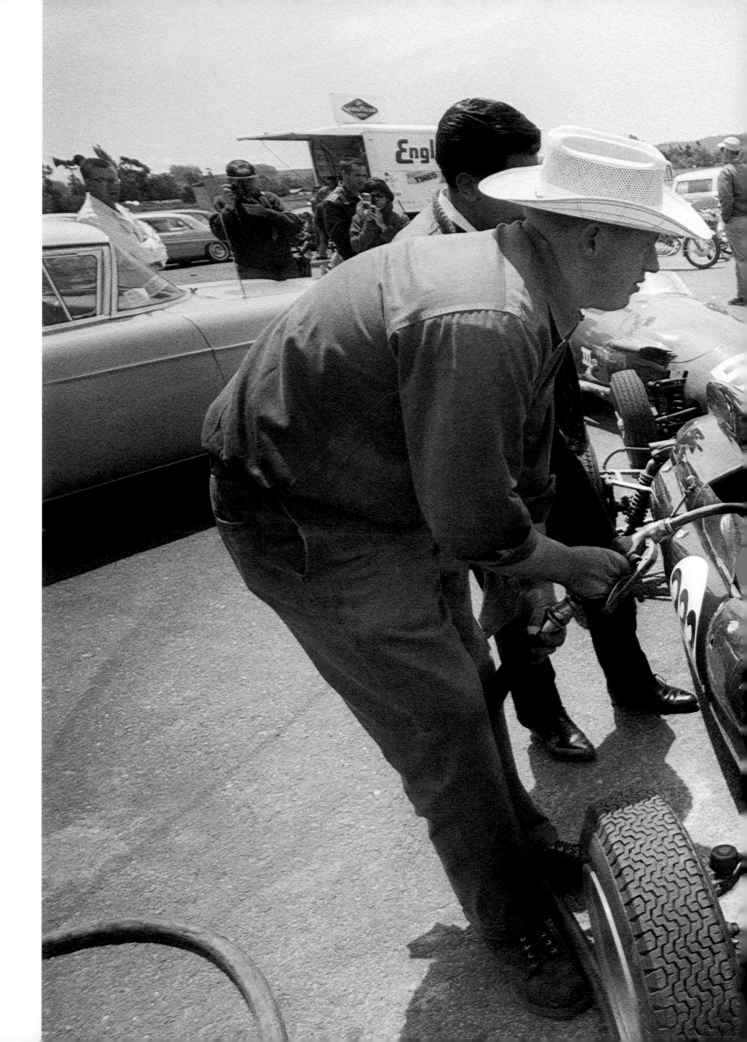

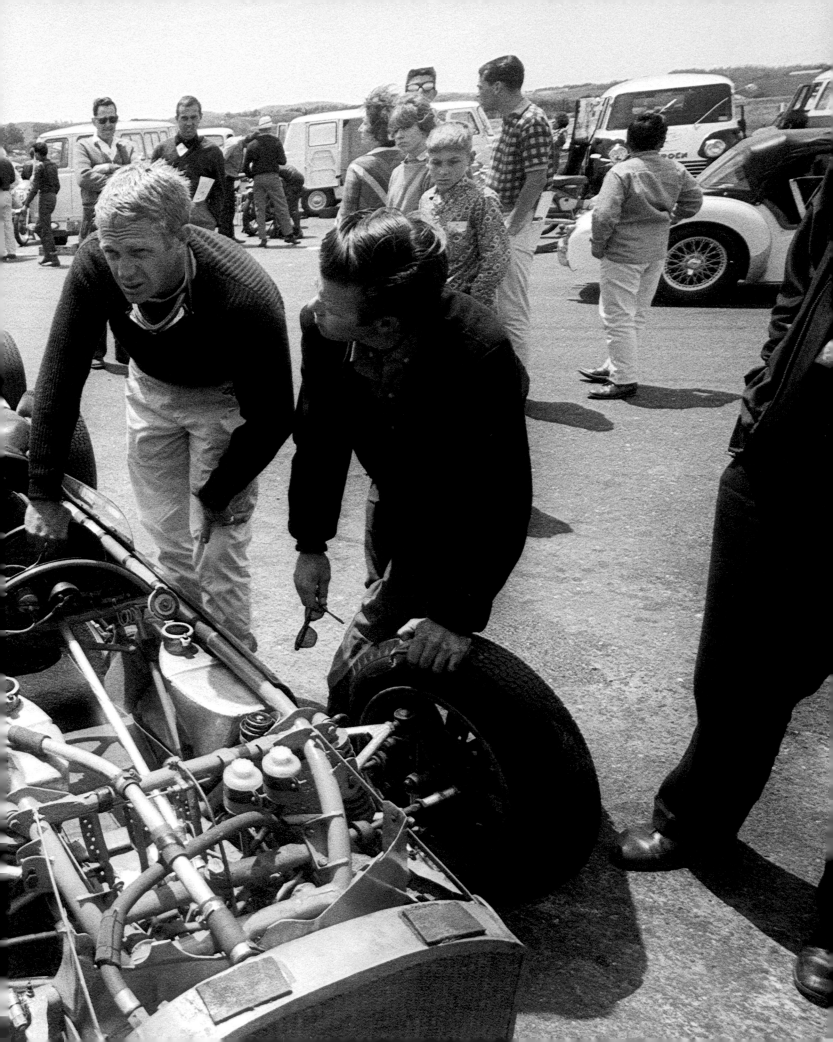

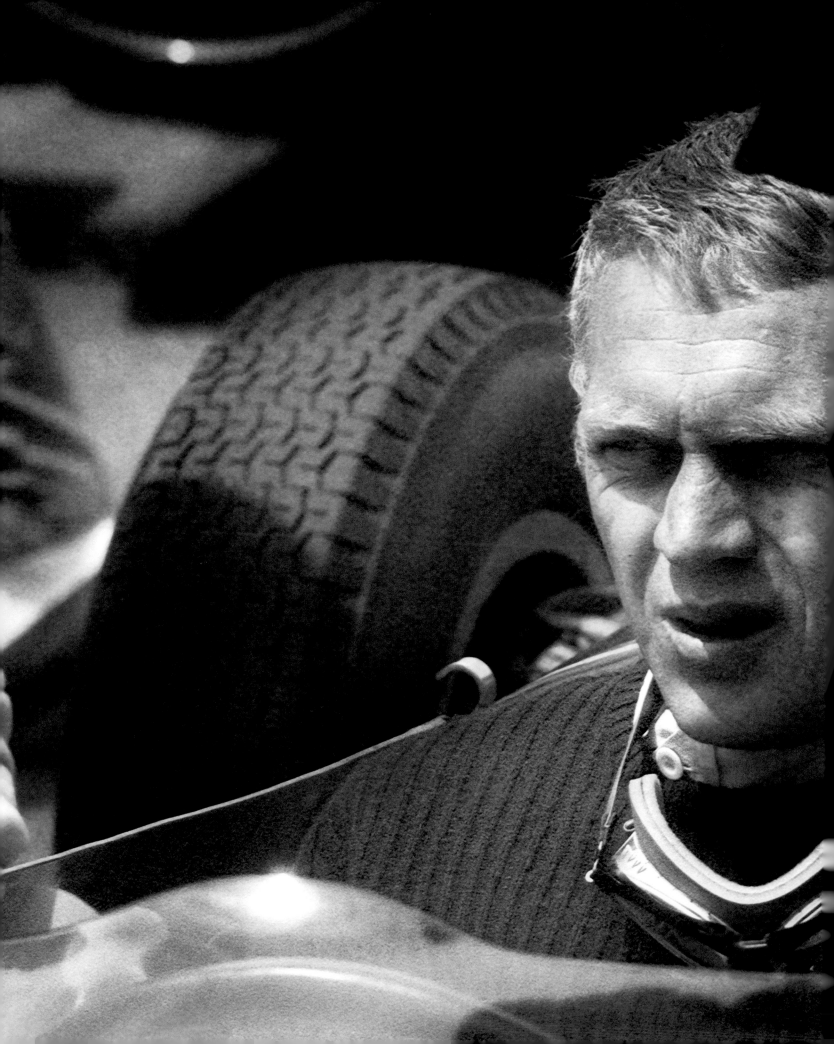

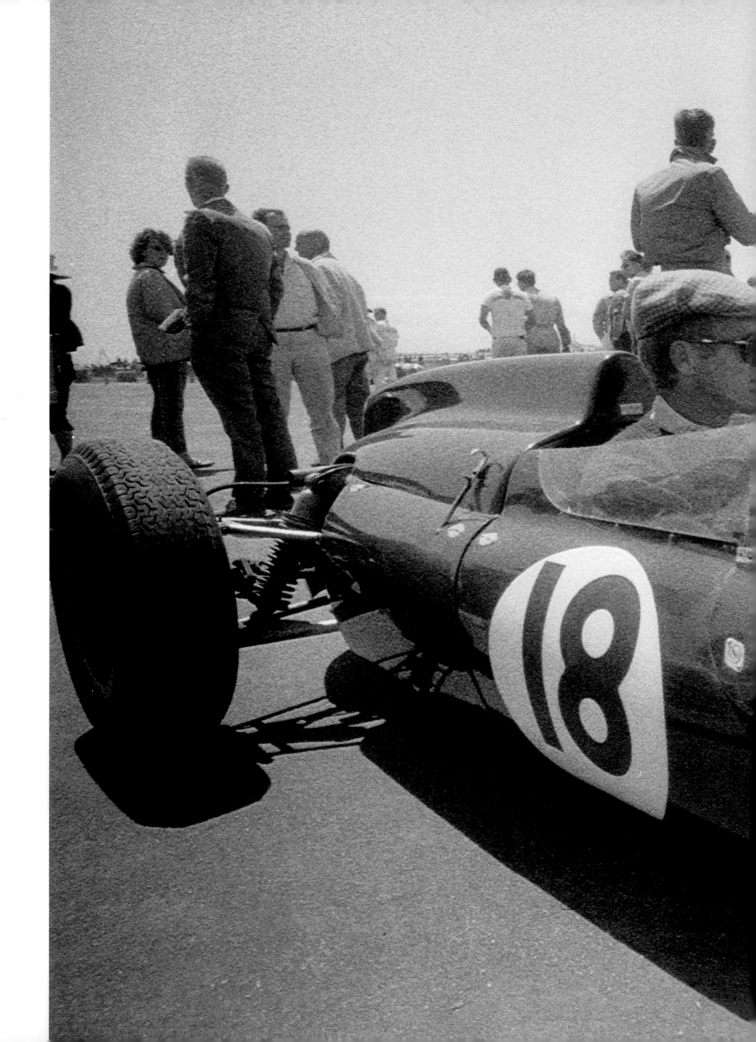

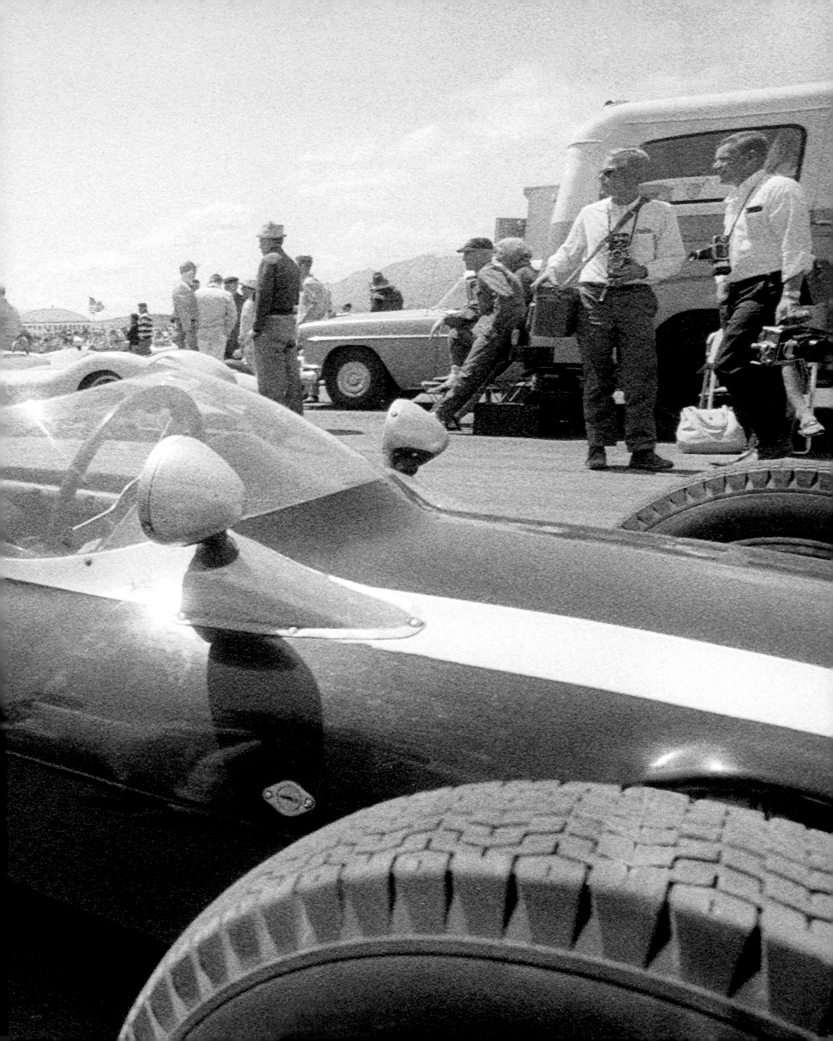

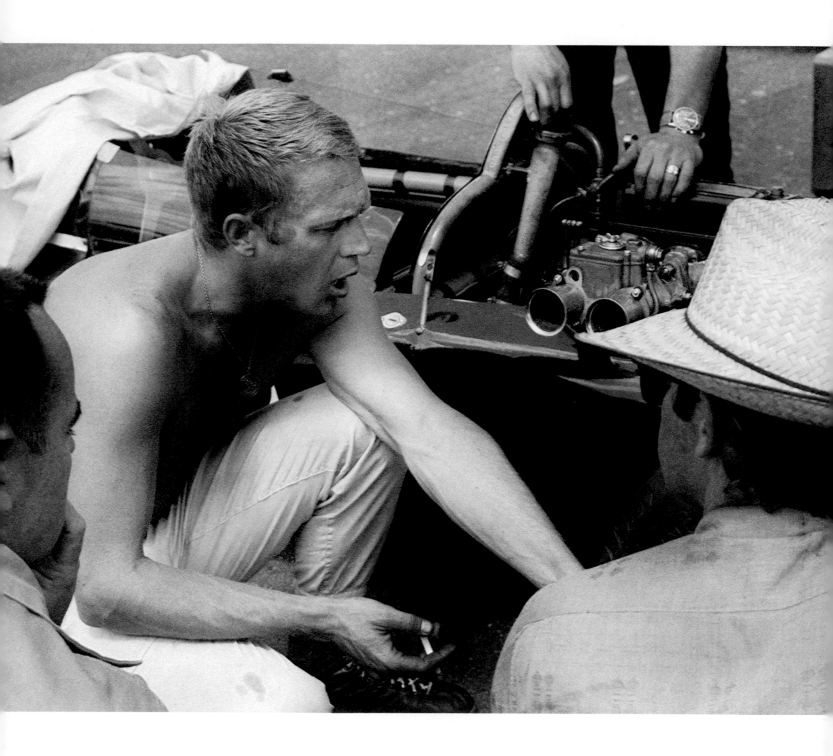

"The important thing is to have your identity, but never blow your obscurity. That's the key to the kingdom."

- Steve McQueen

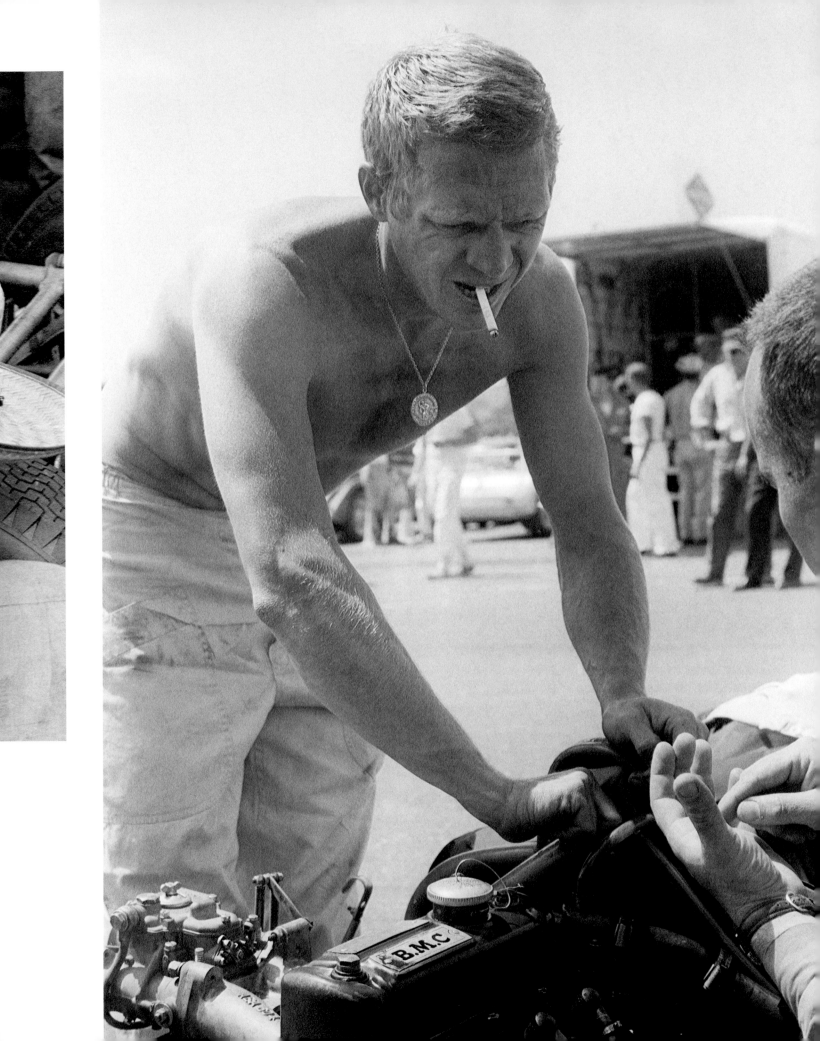

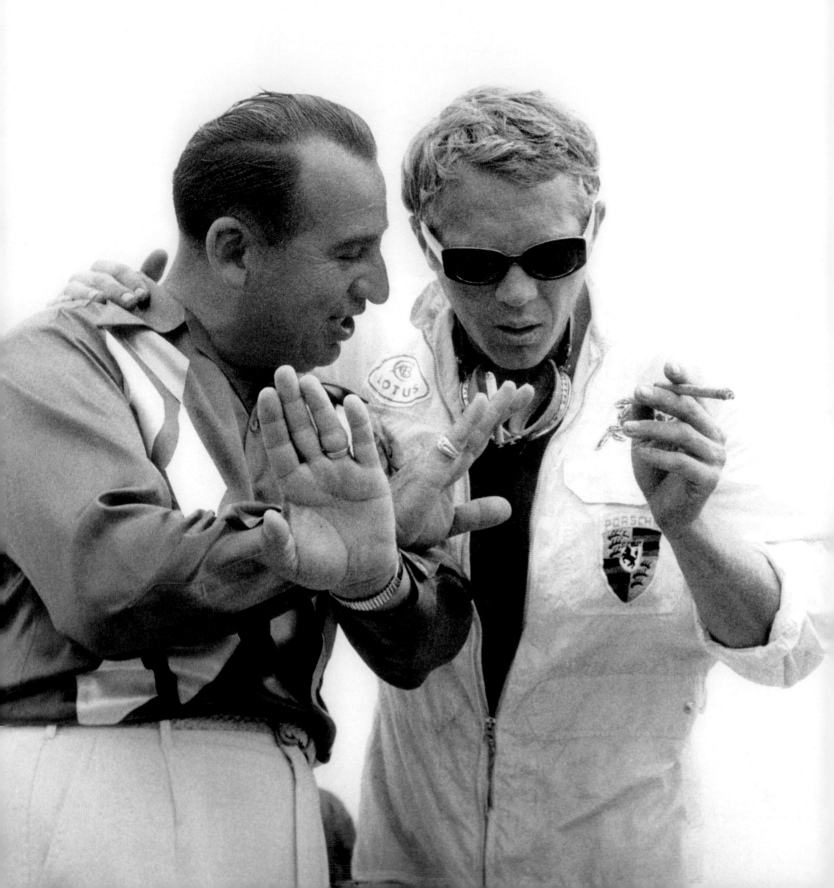

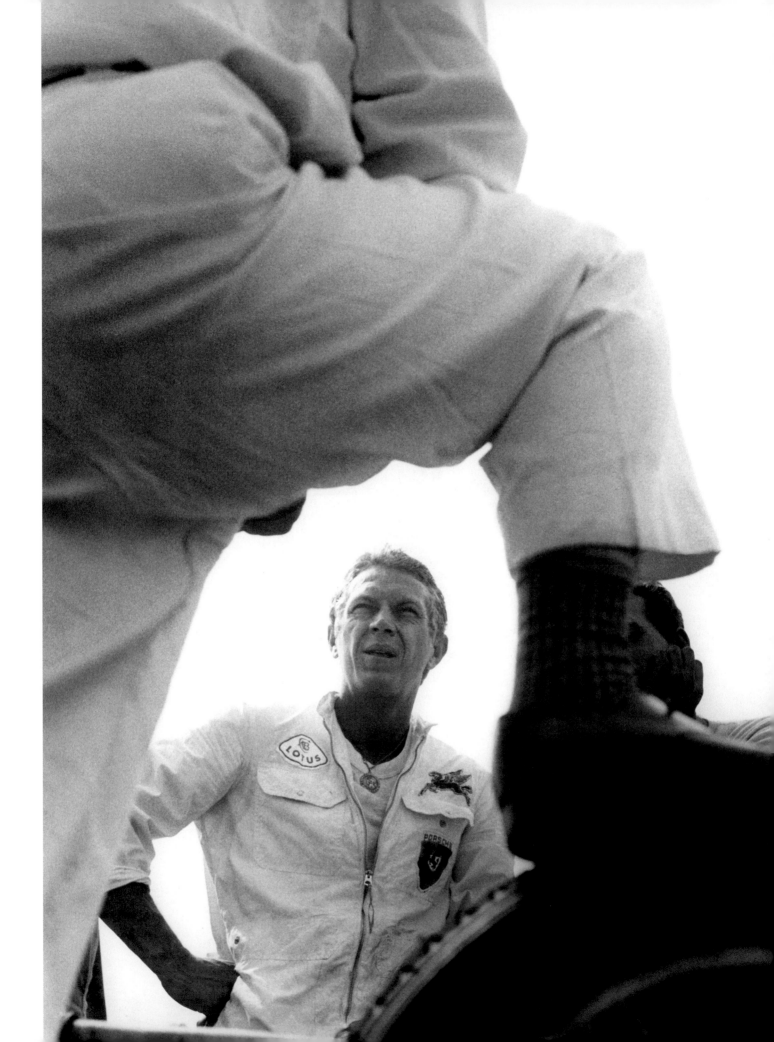

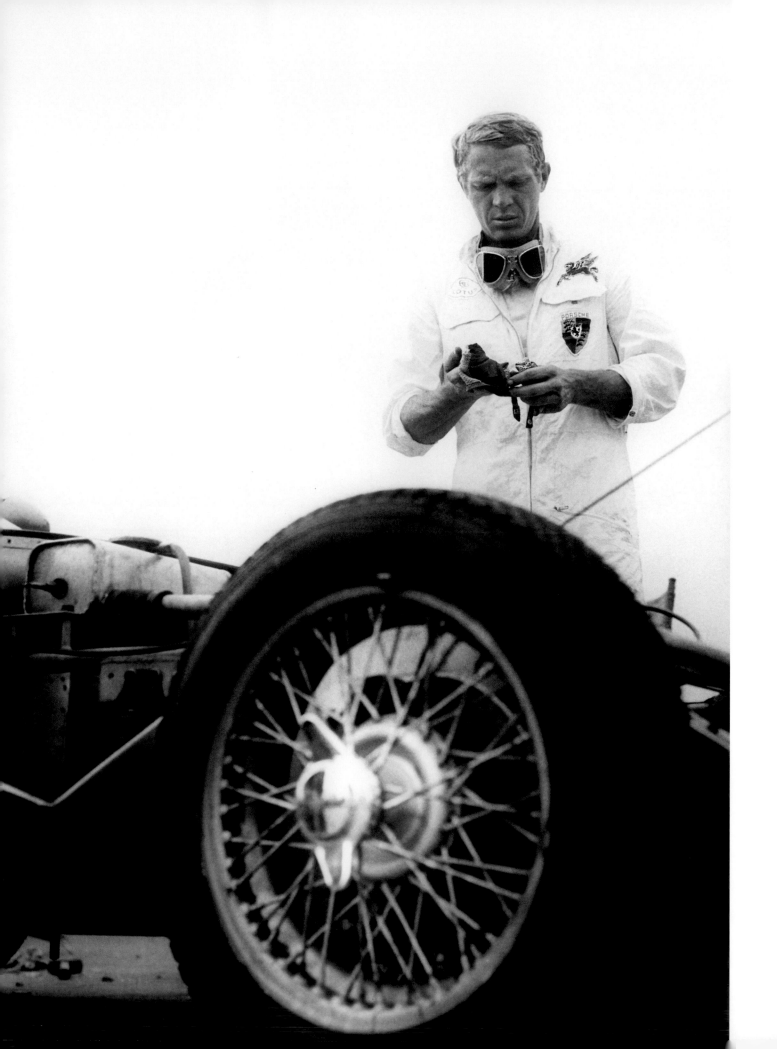

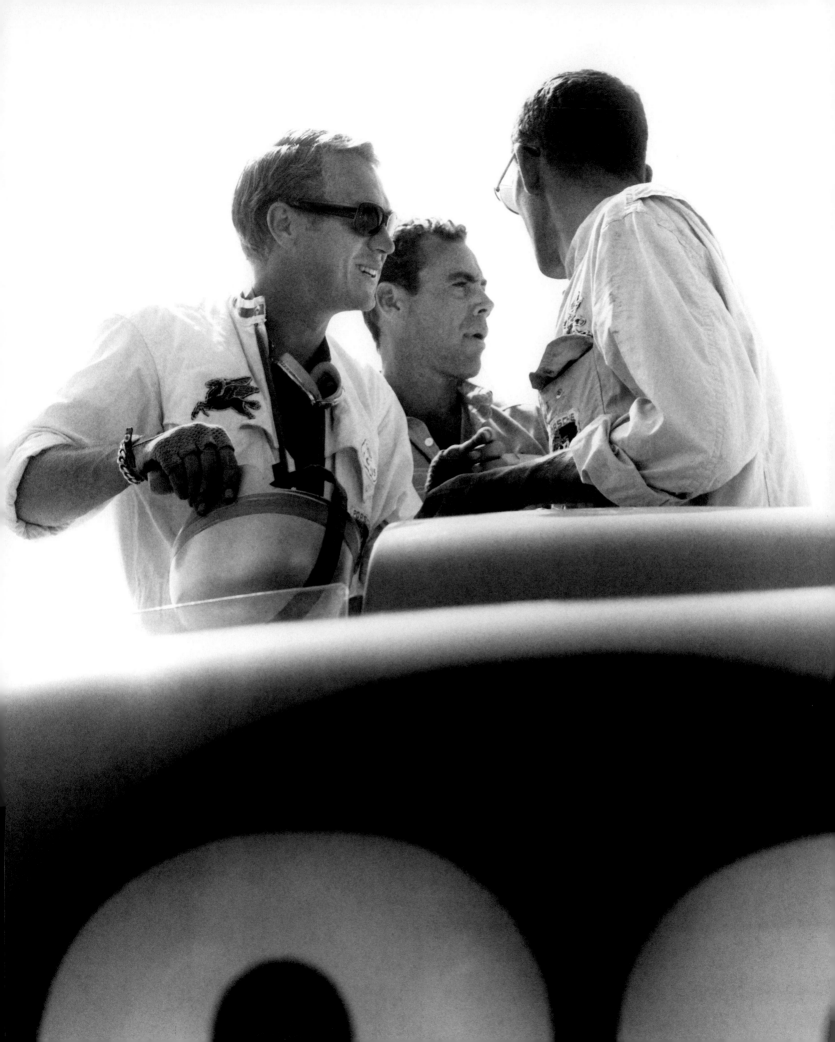

"There's nuthin' in the world I don't want to know."

- Steve McQueen

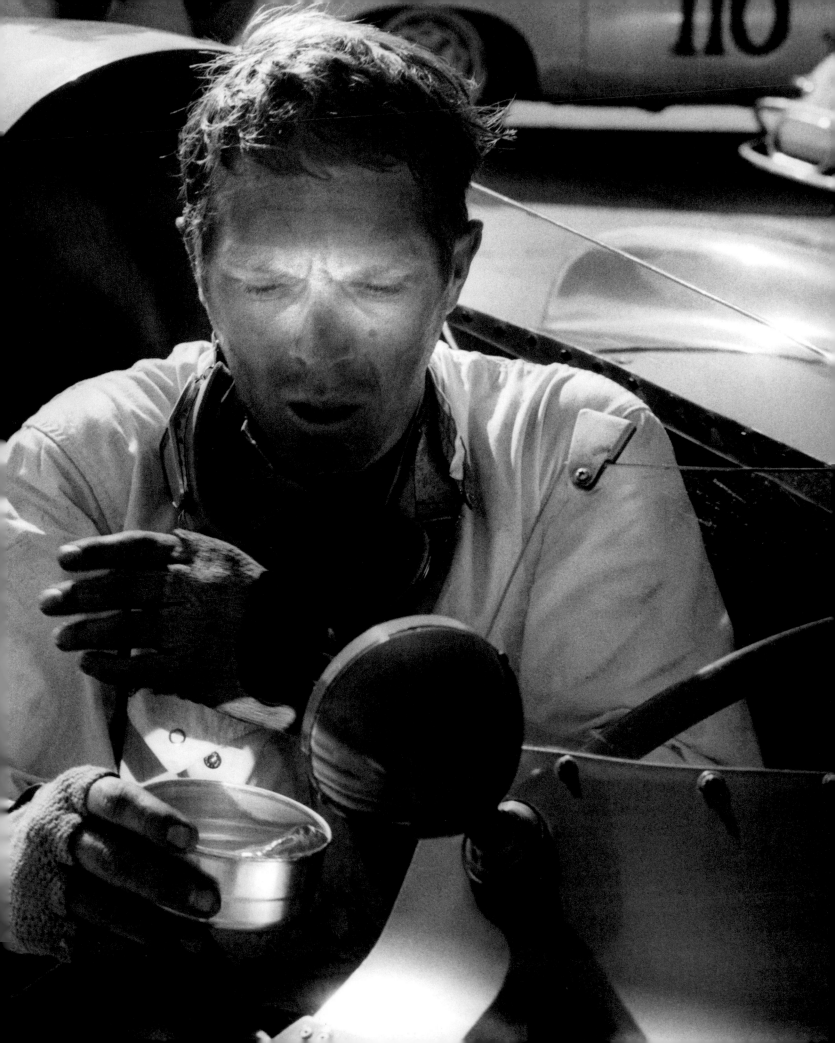

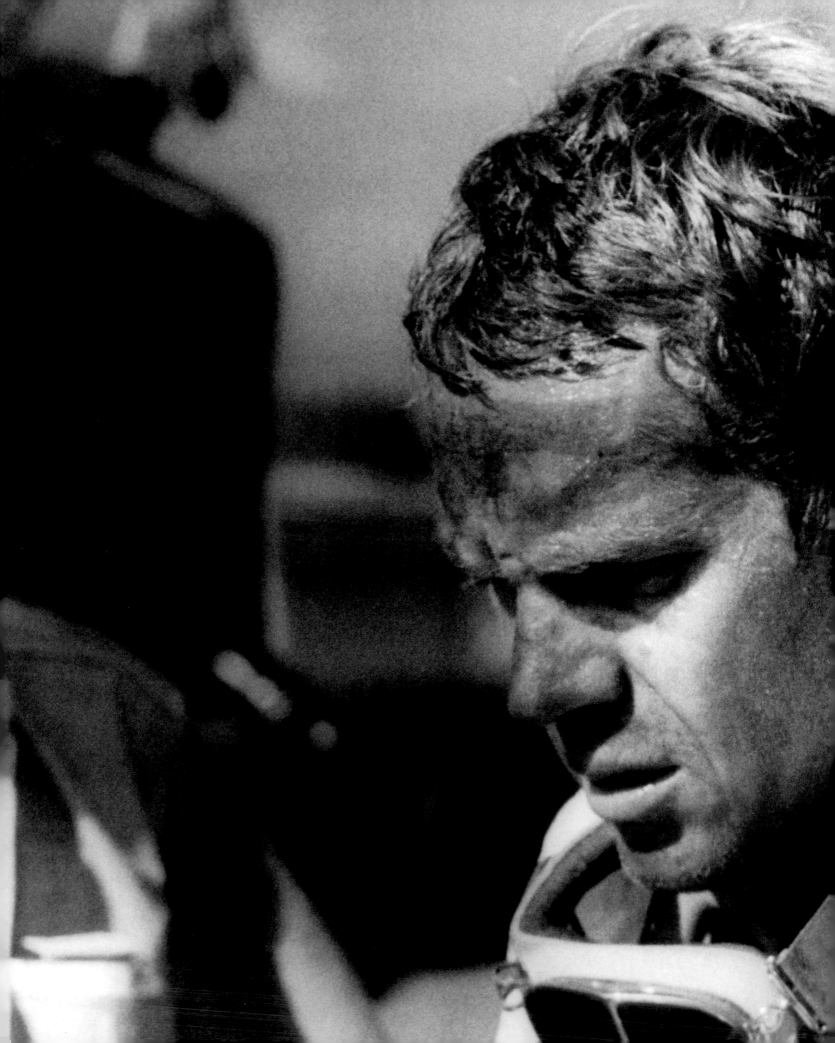

"Sometimes in life a little competition is good,
it makes you work harder."

- Steve McQueen

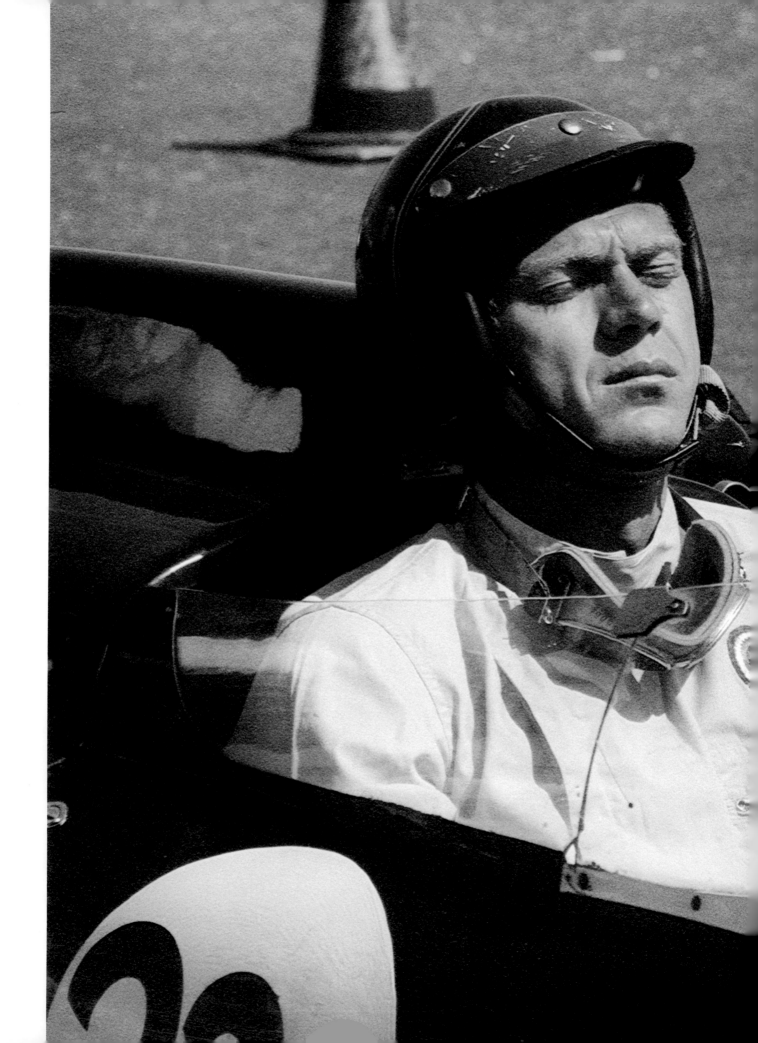

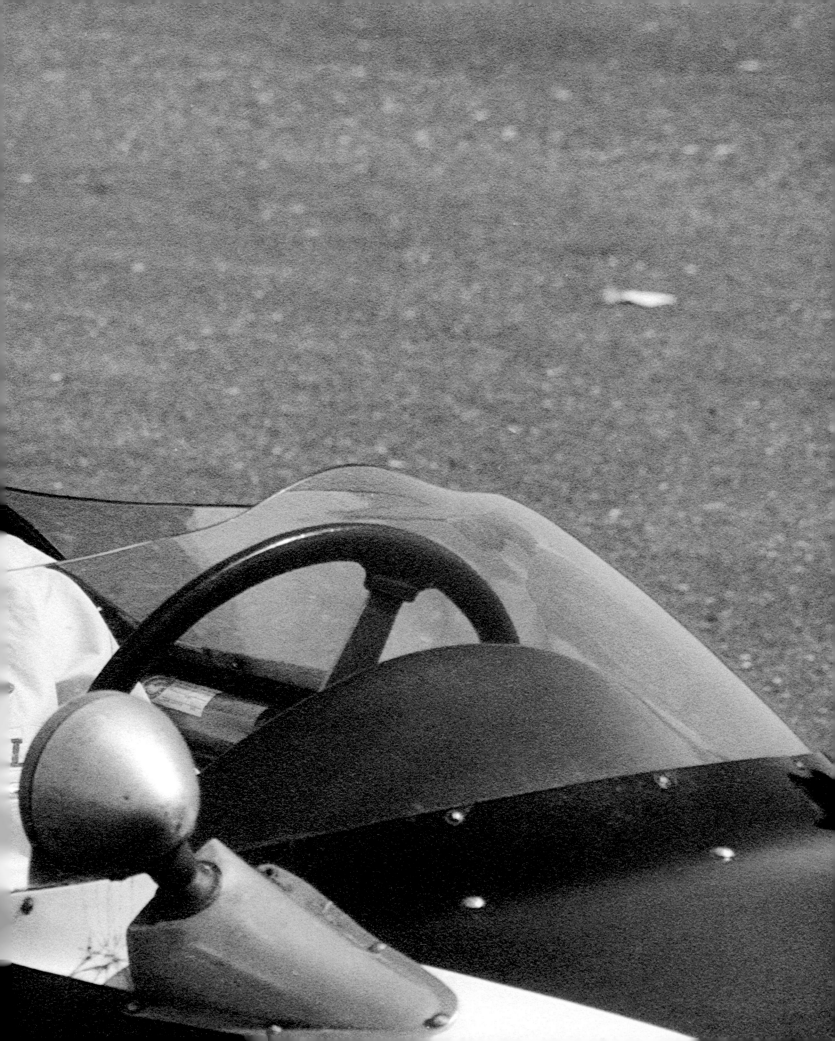

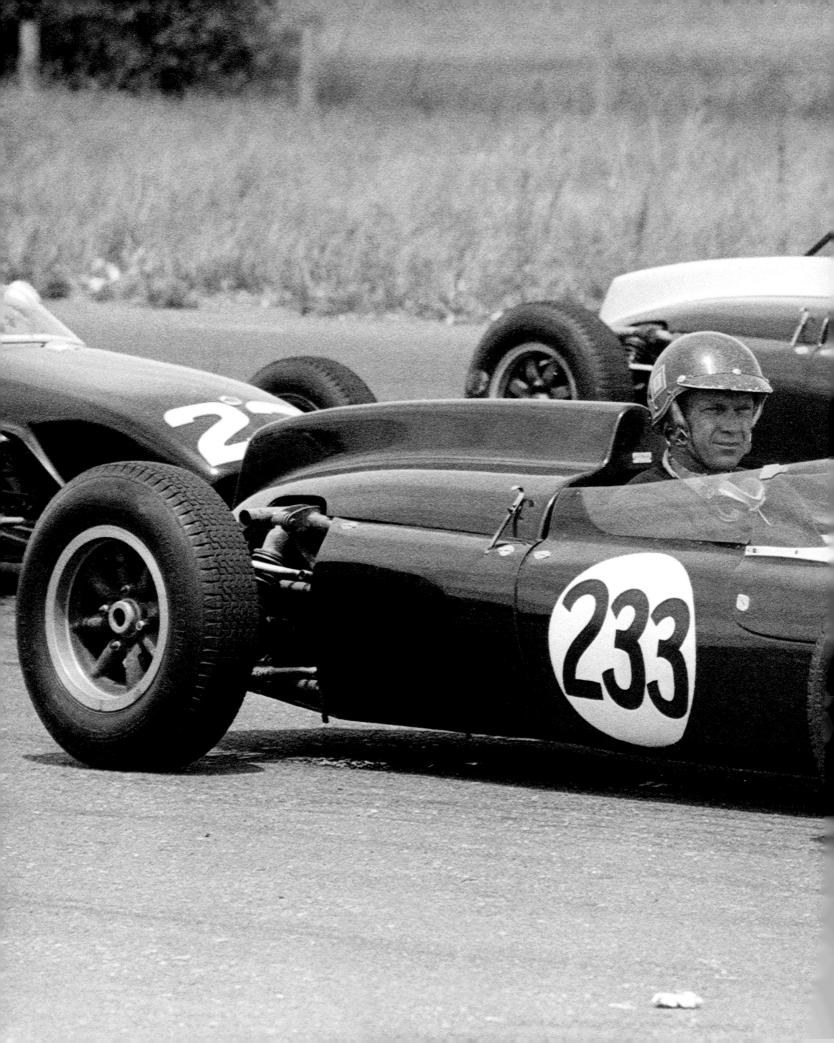

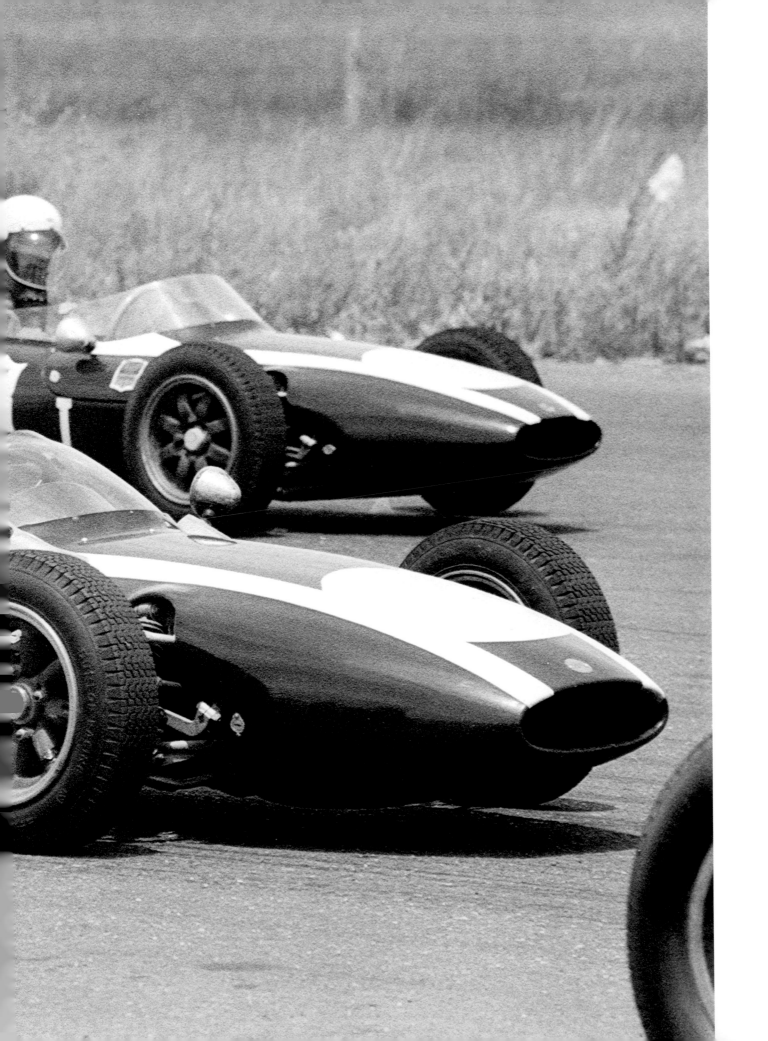

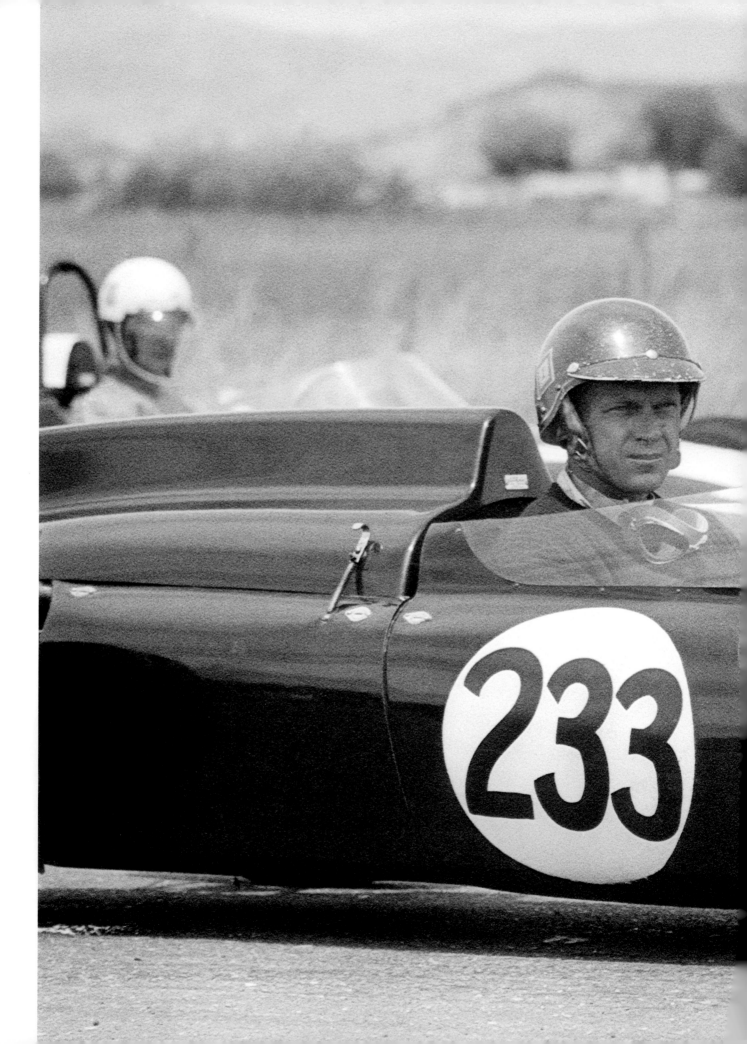

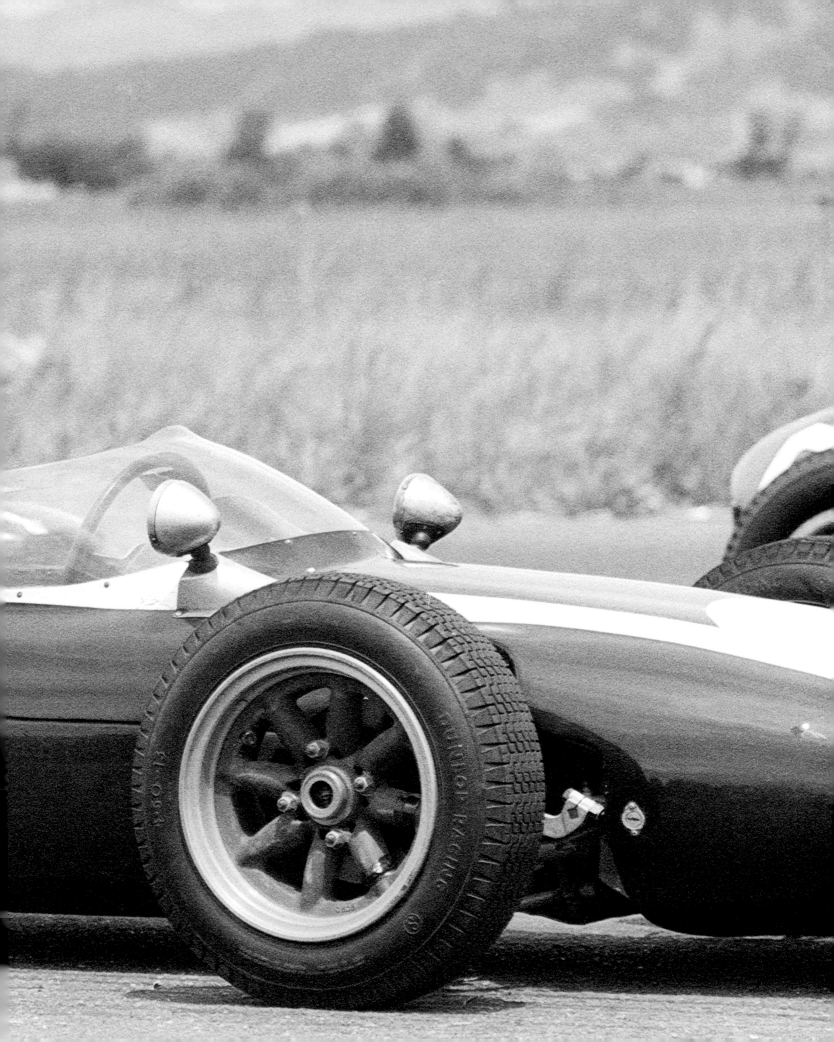

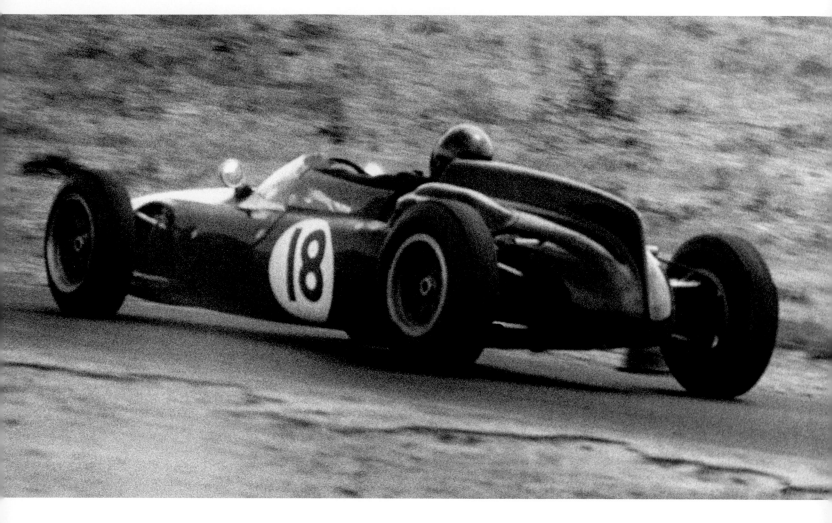

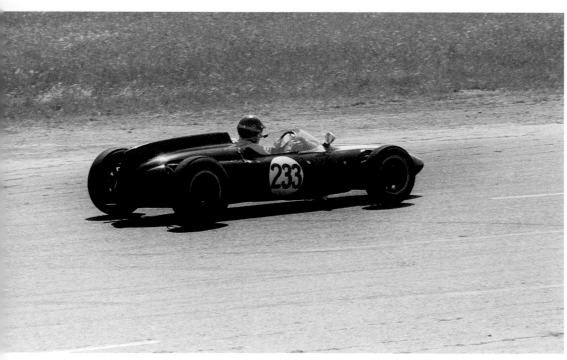

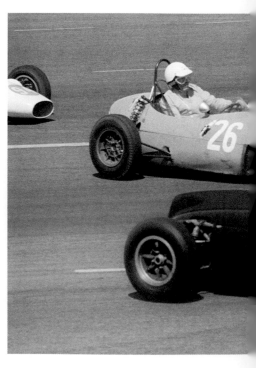

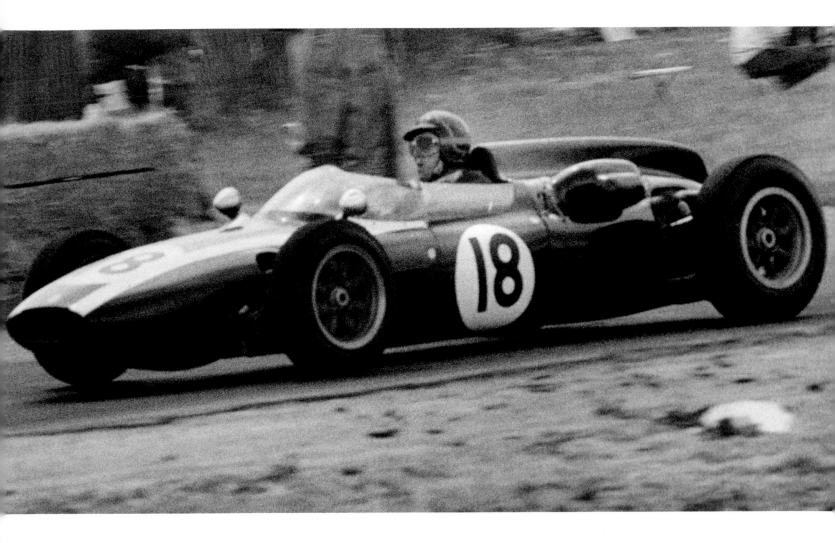

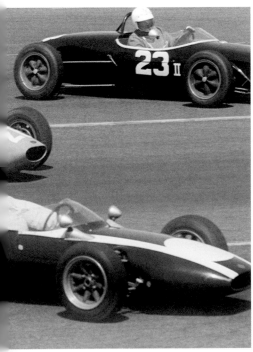

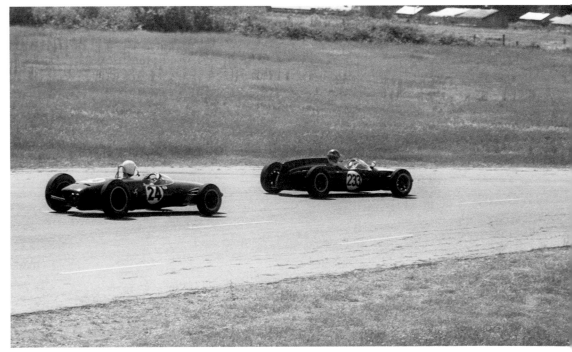

*"Racing is life.
Anything before or after is just waiting."*

- Steve McQueen

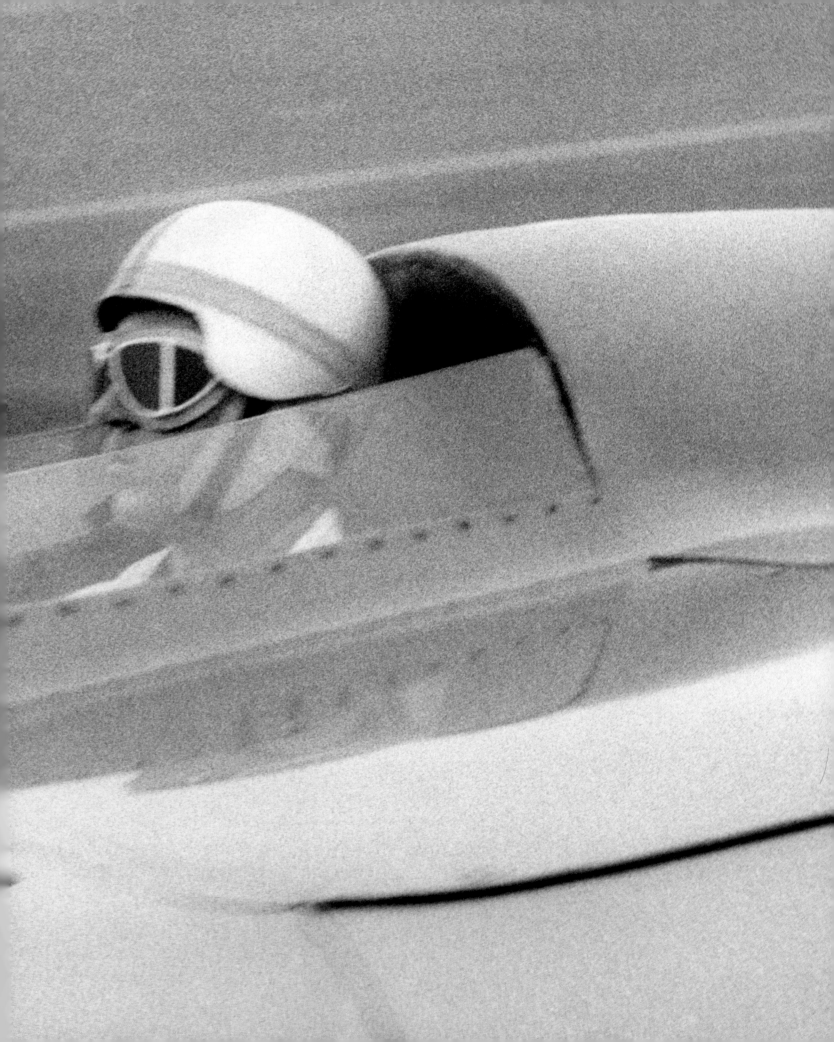

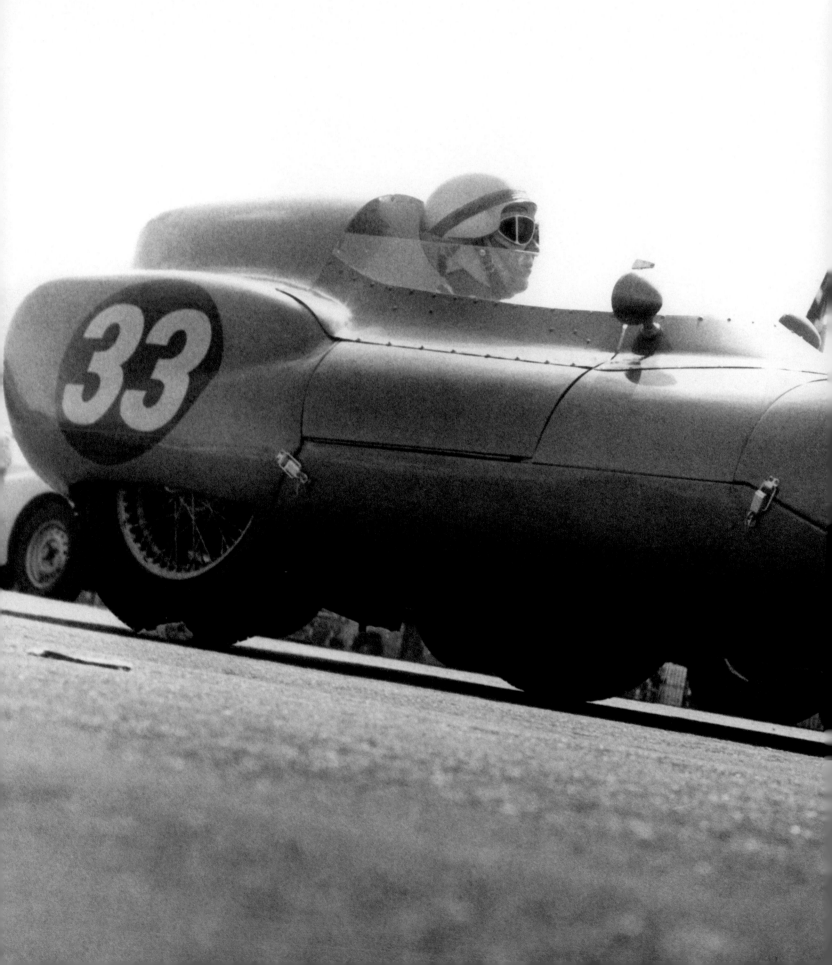

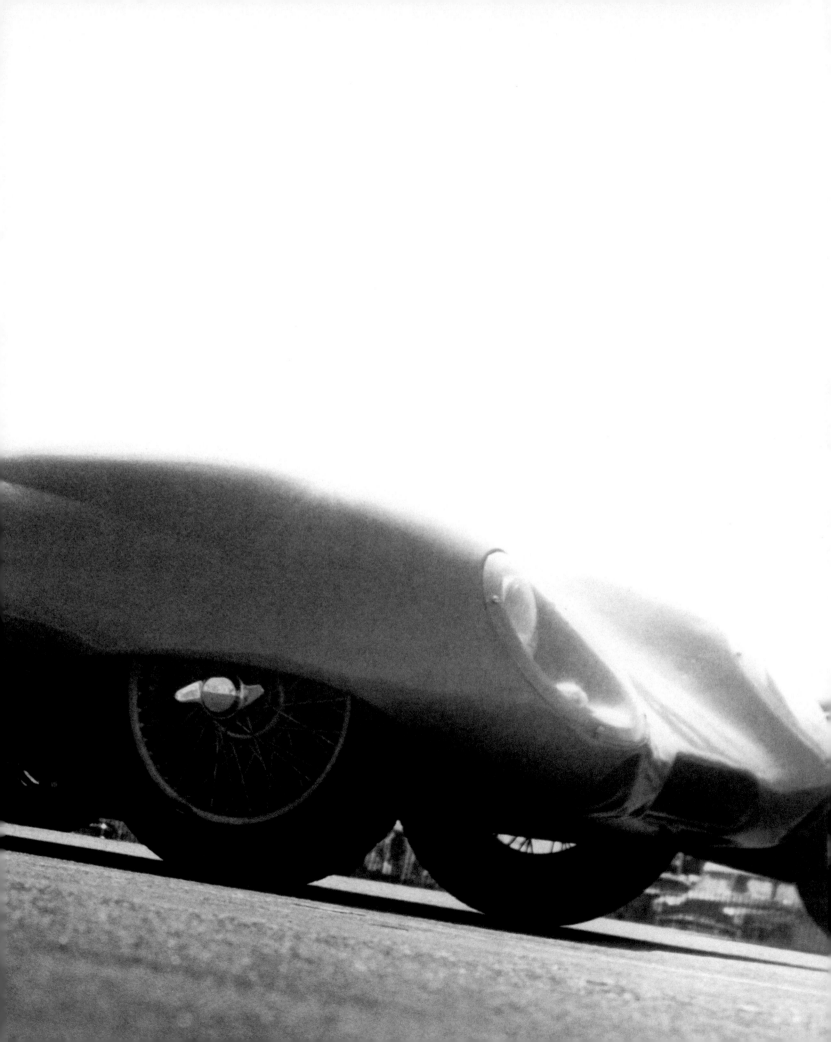

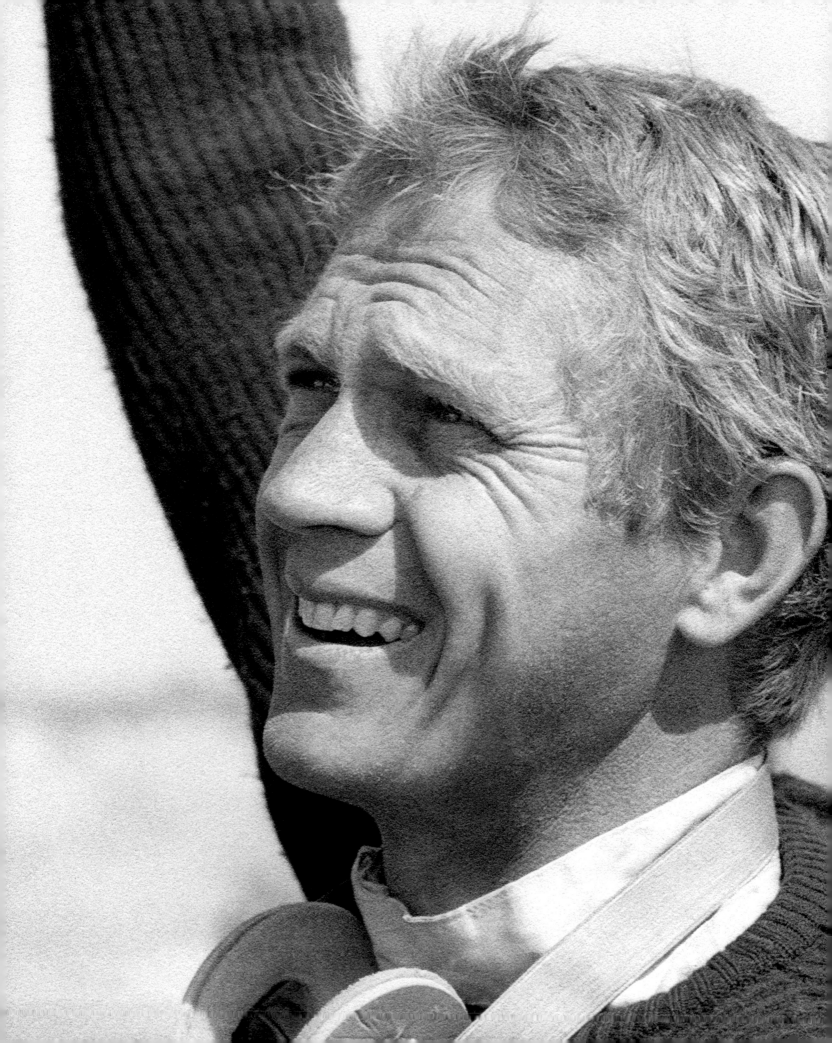

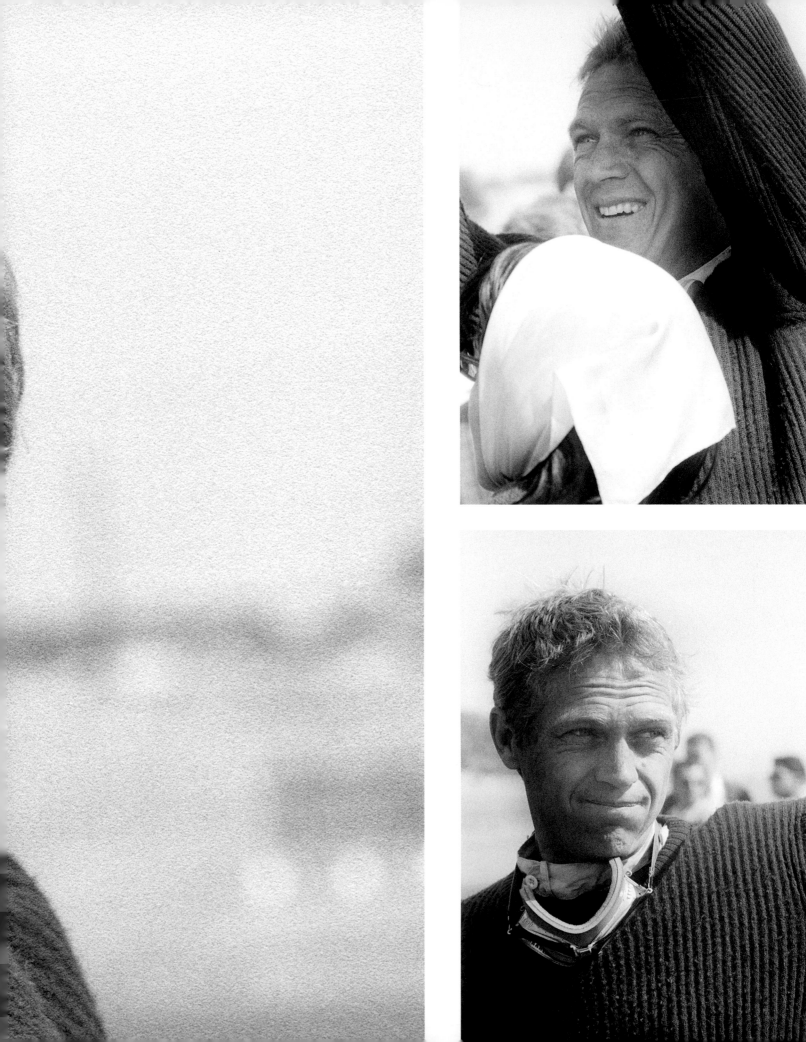

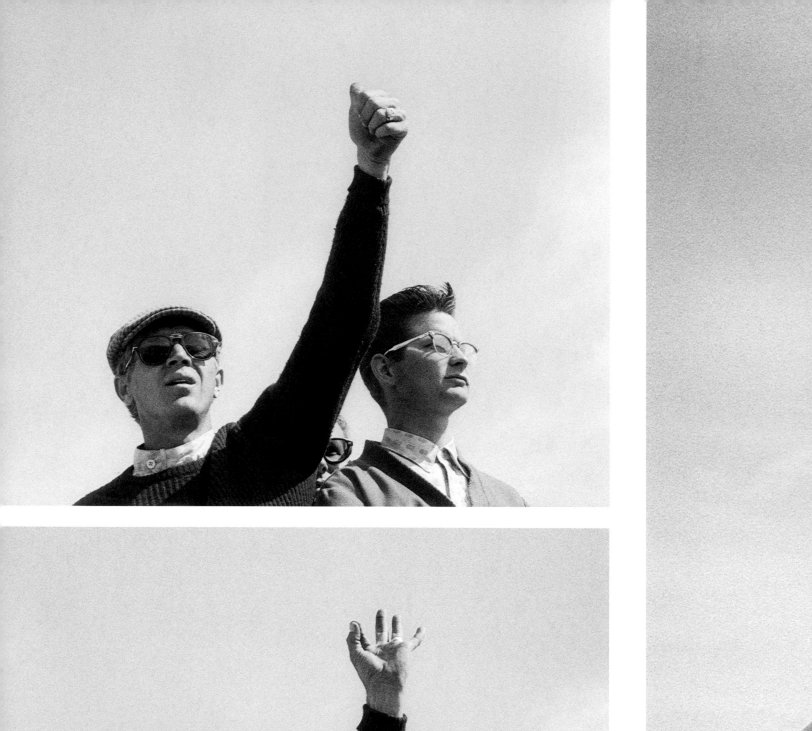
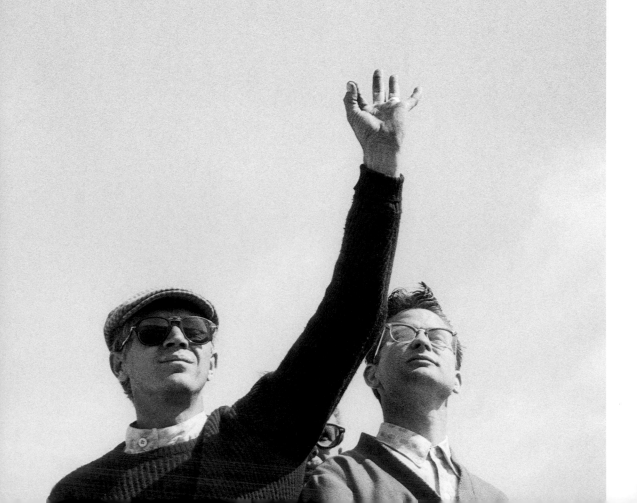

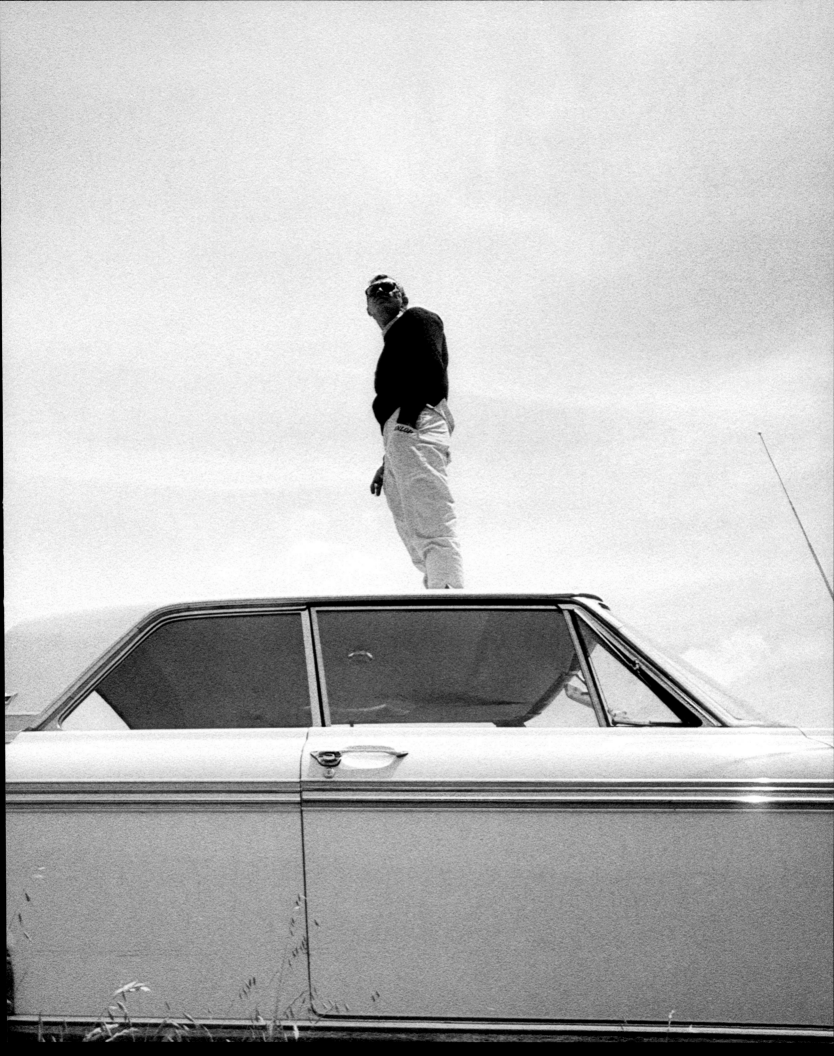

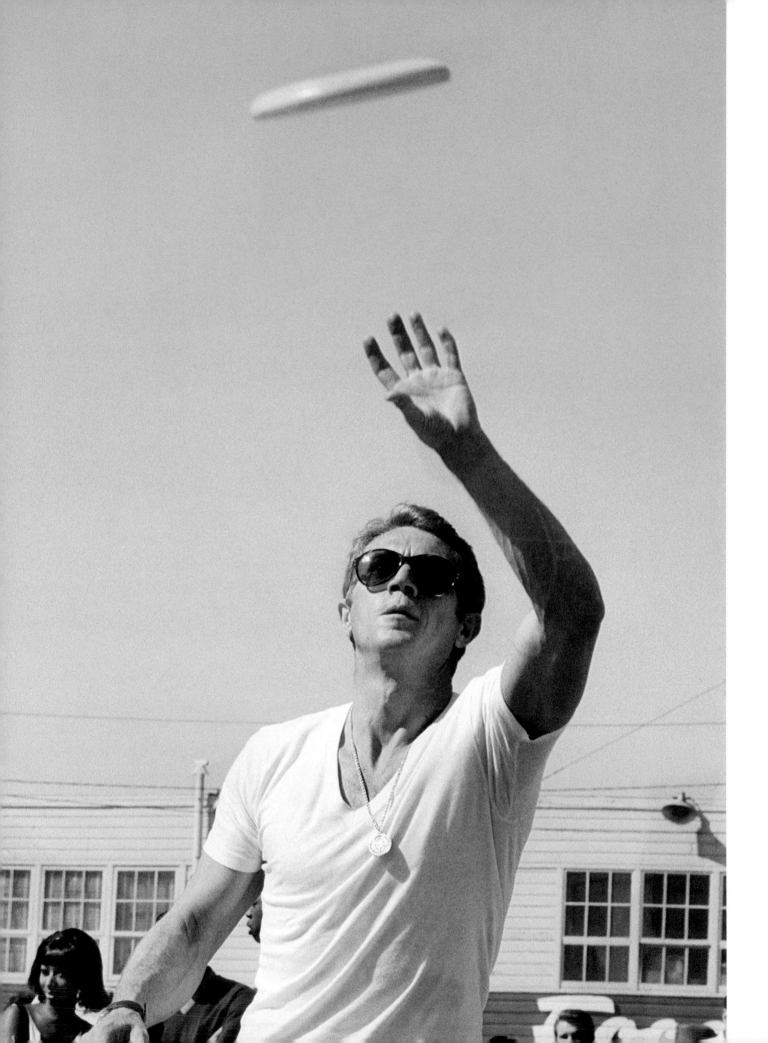

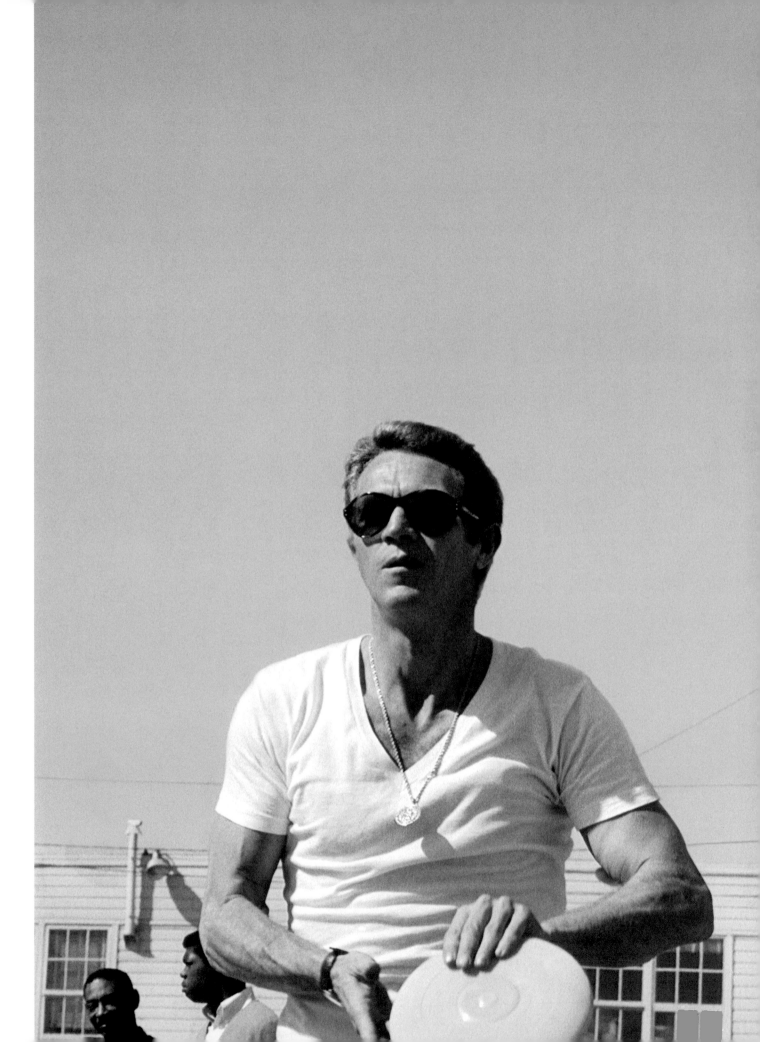

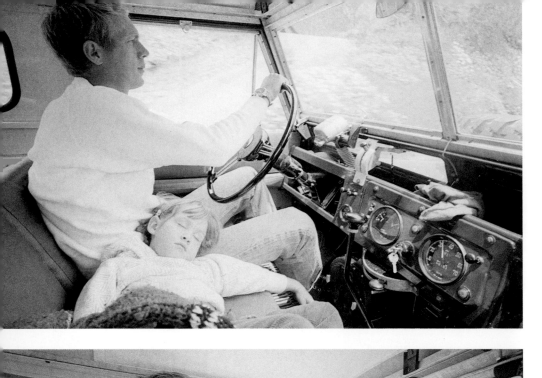
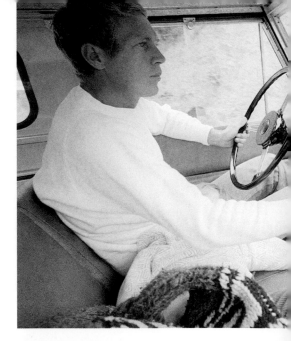
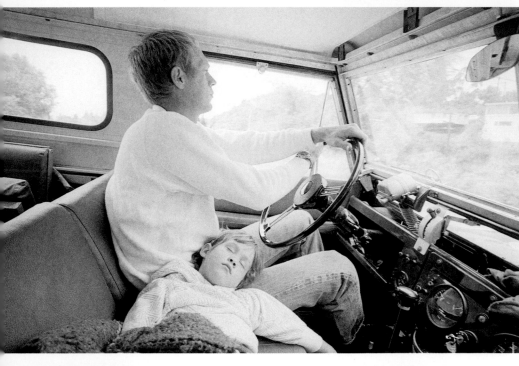
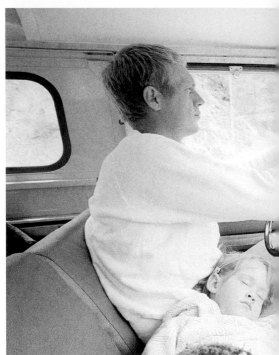
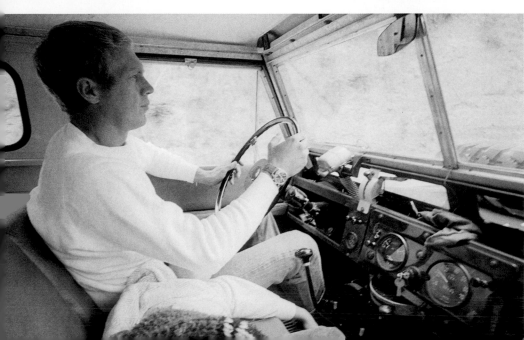
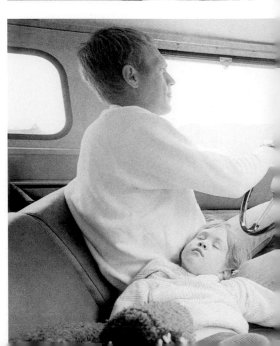

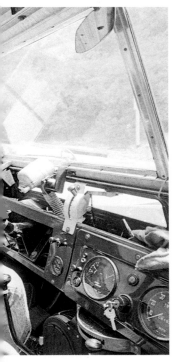

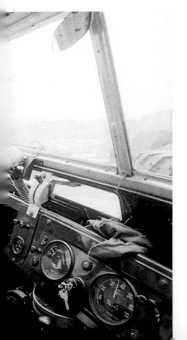

"I'm not a 'studied actor.'
You've got to be prepared to be rejected five times a day.
That's where the importance of family comes in."

- Steve McQueen

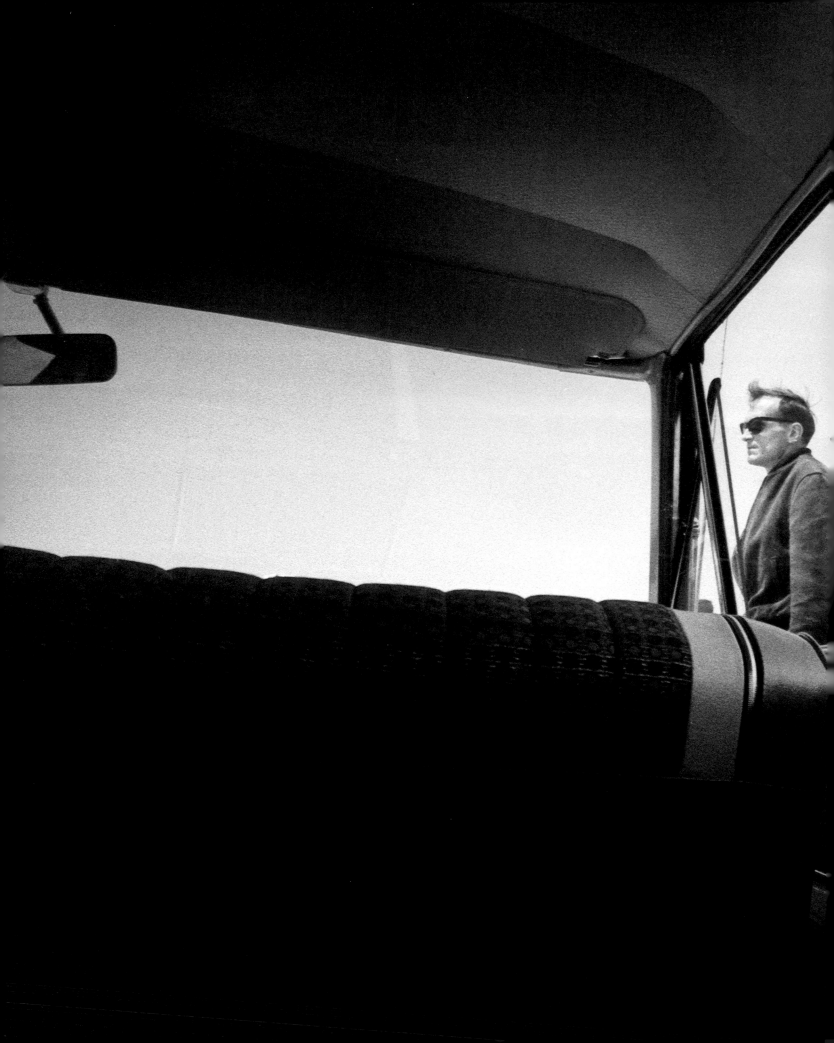

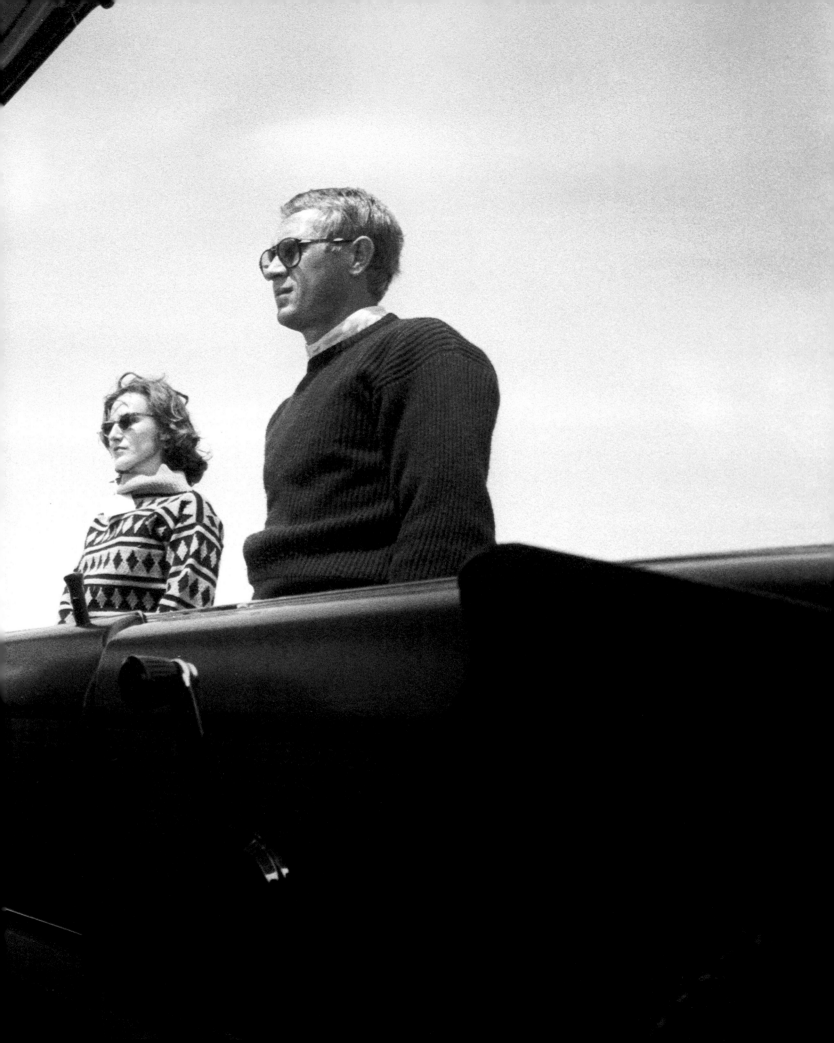

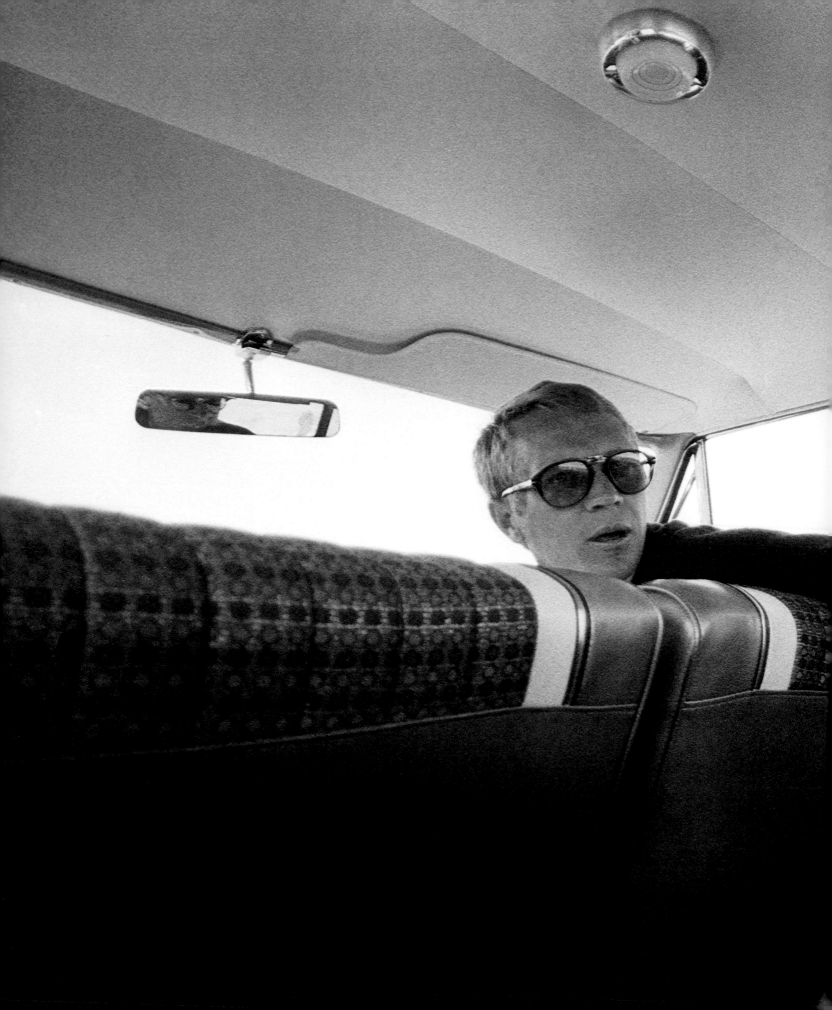

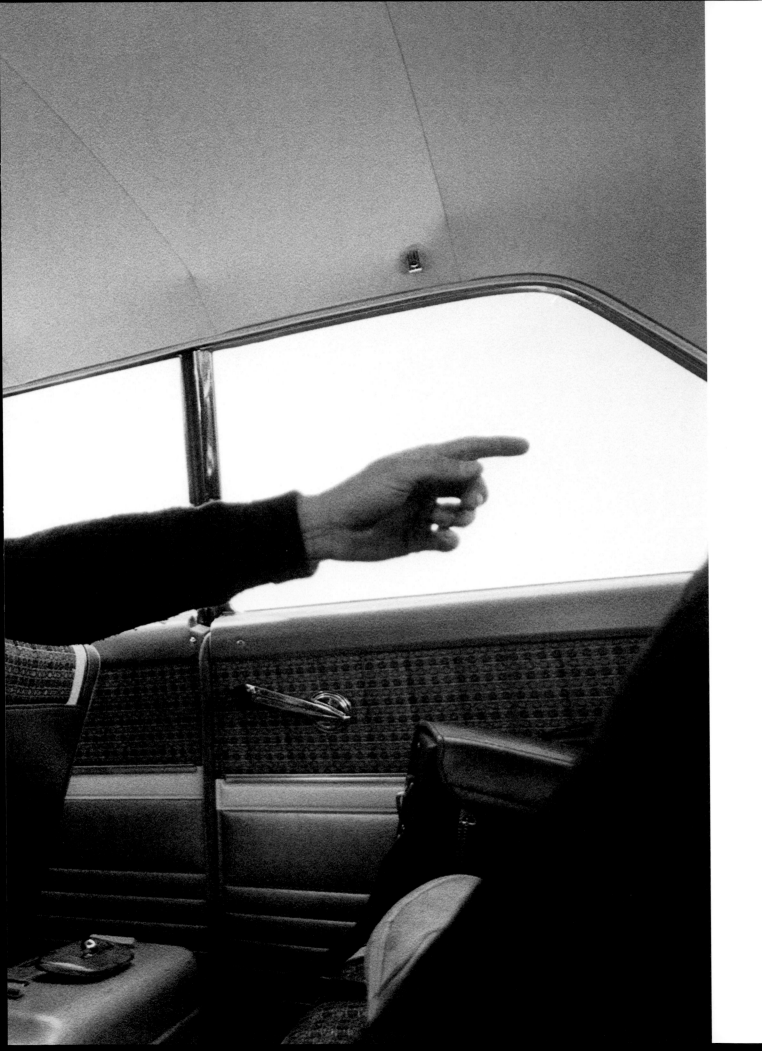

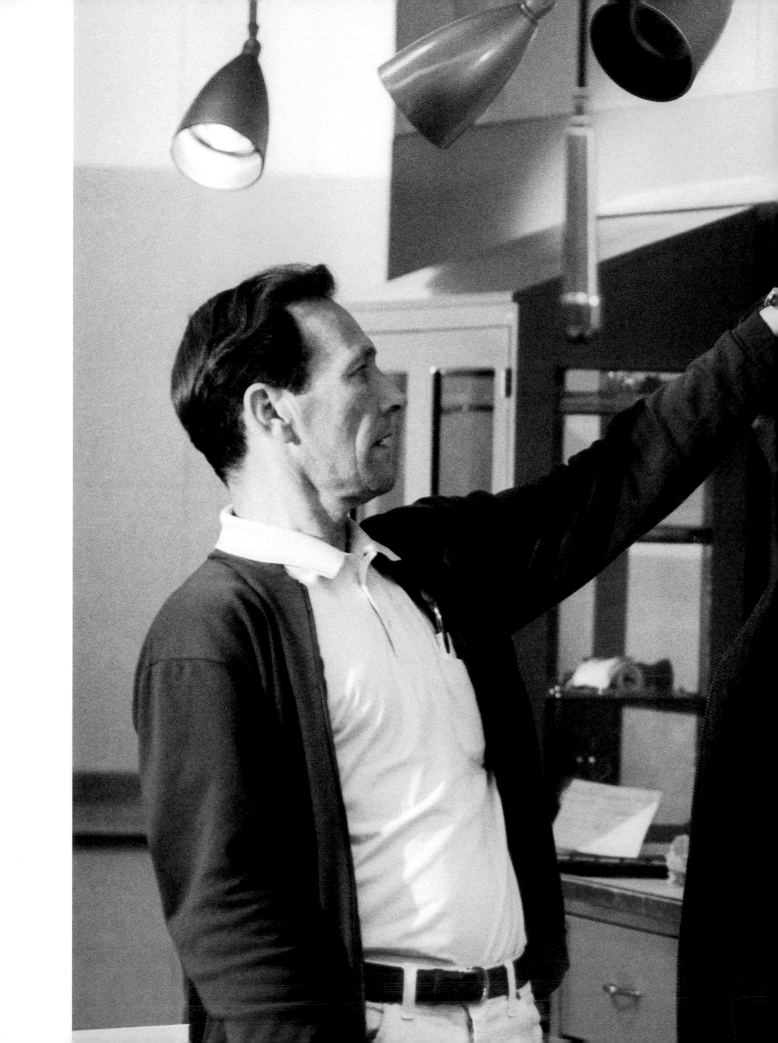

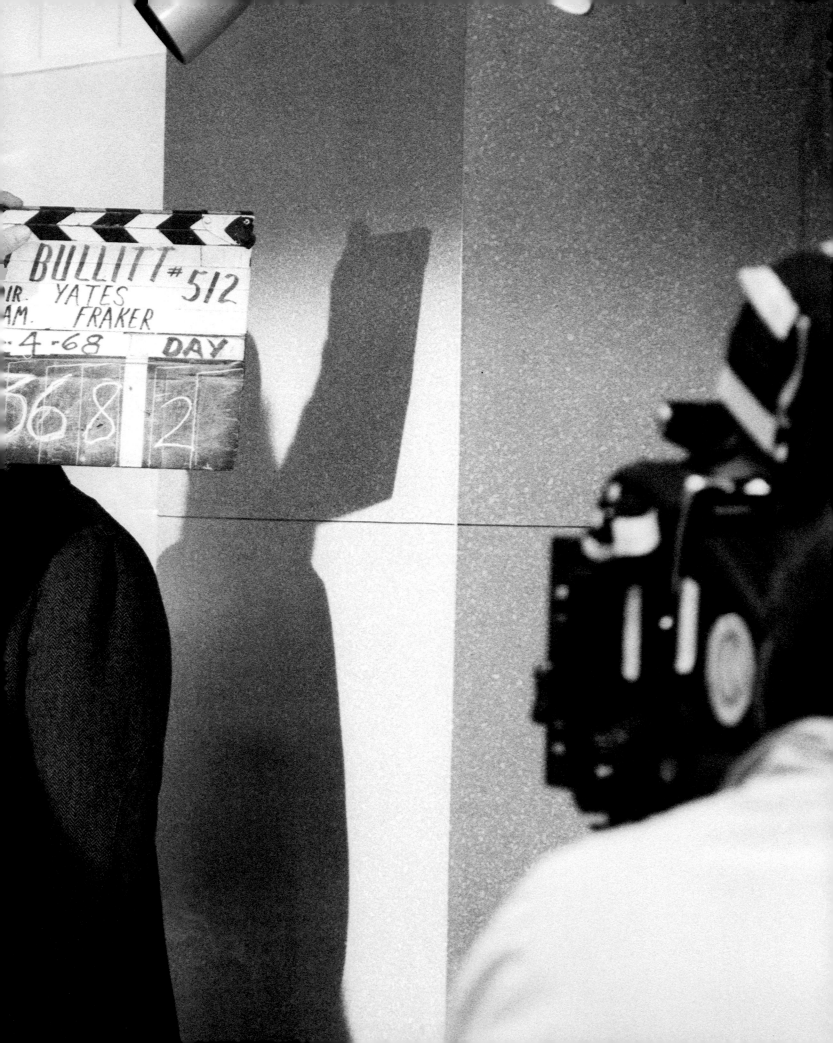

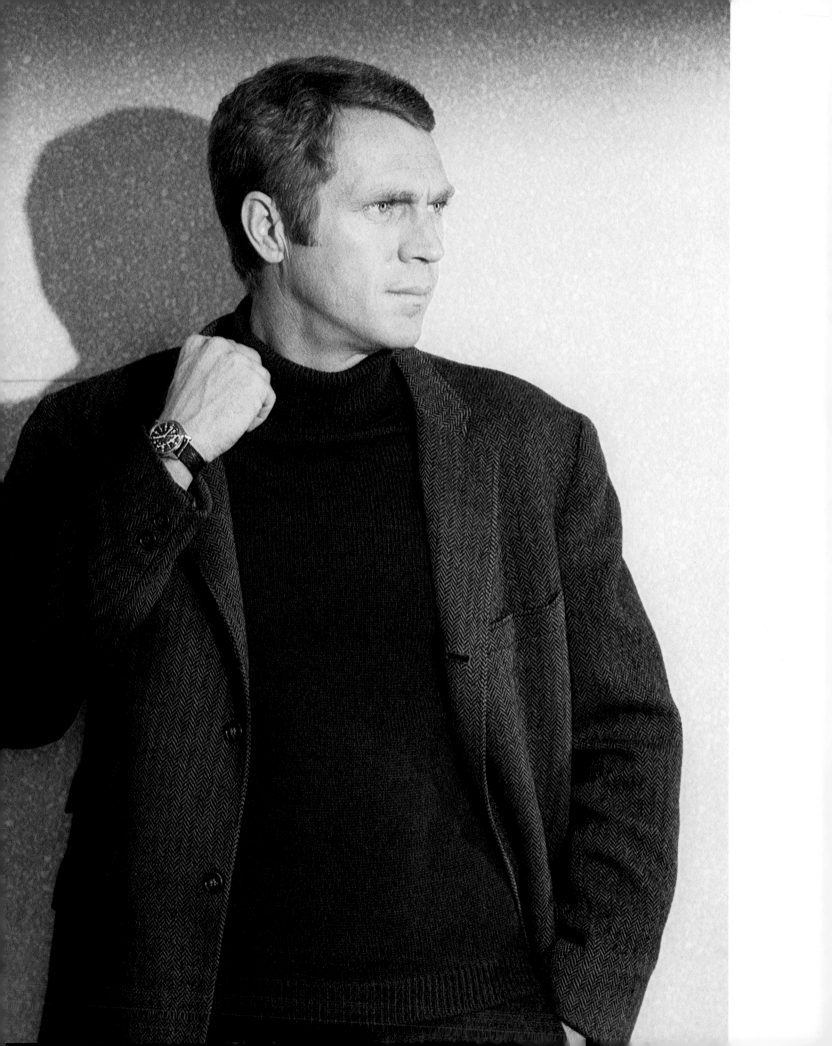

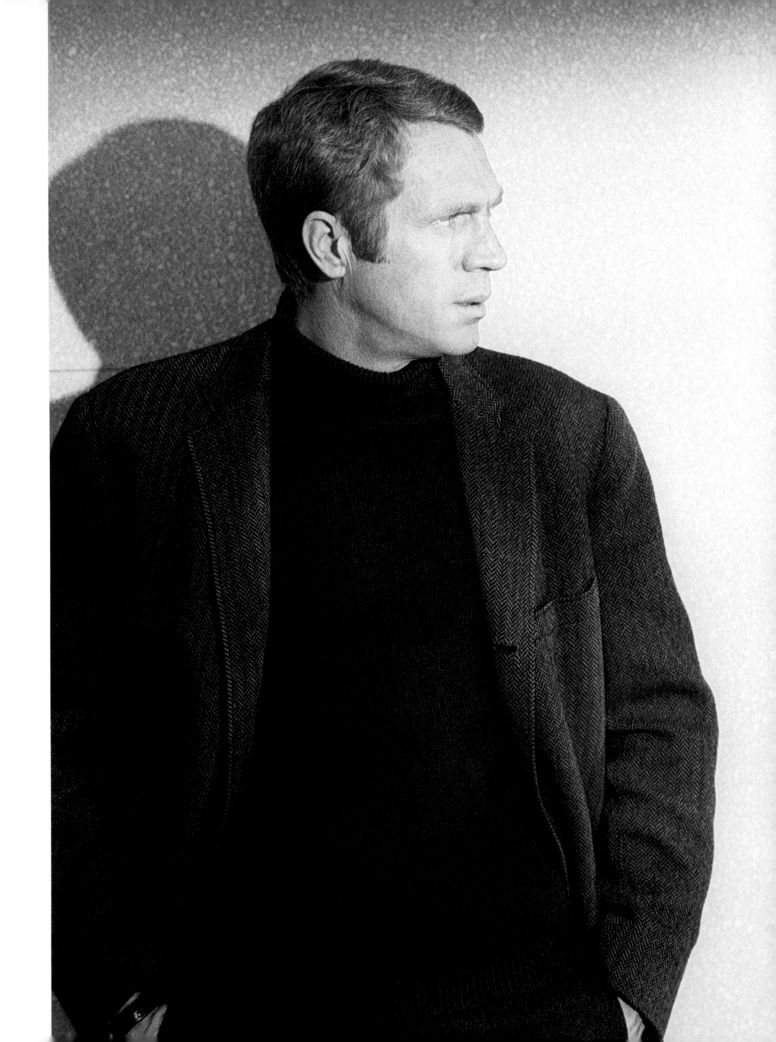

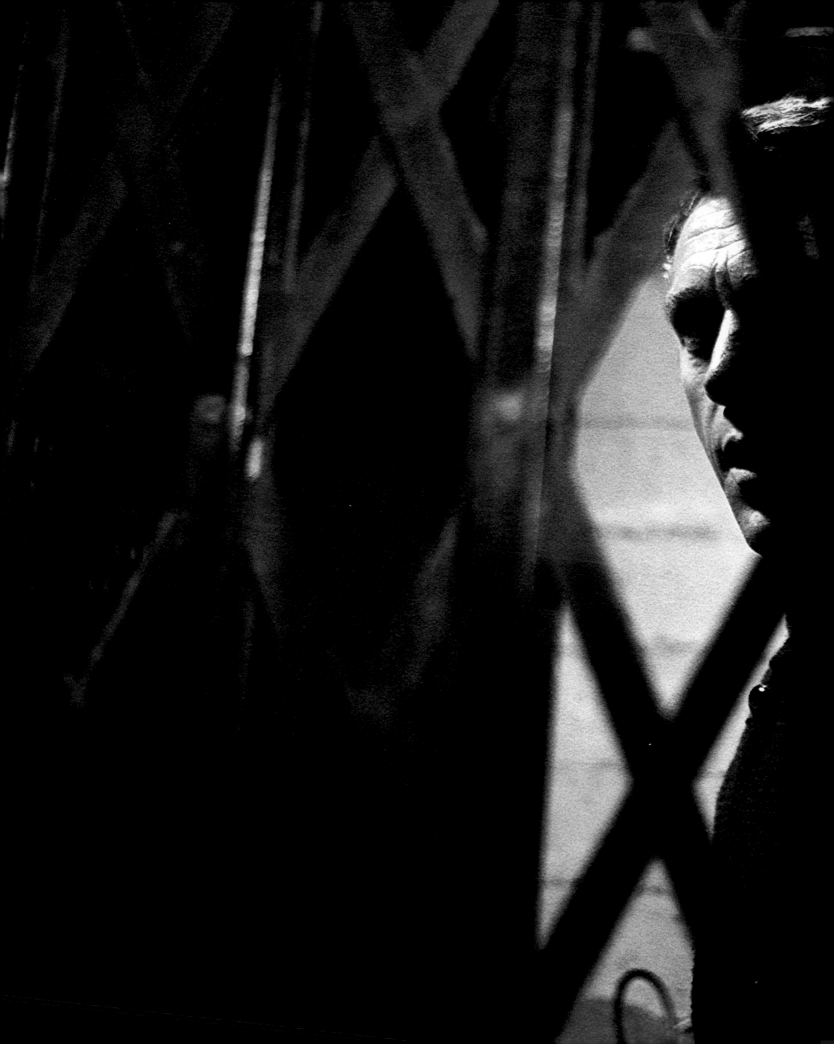

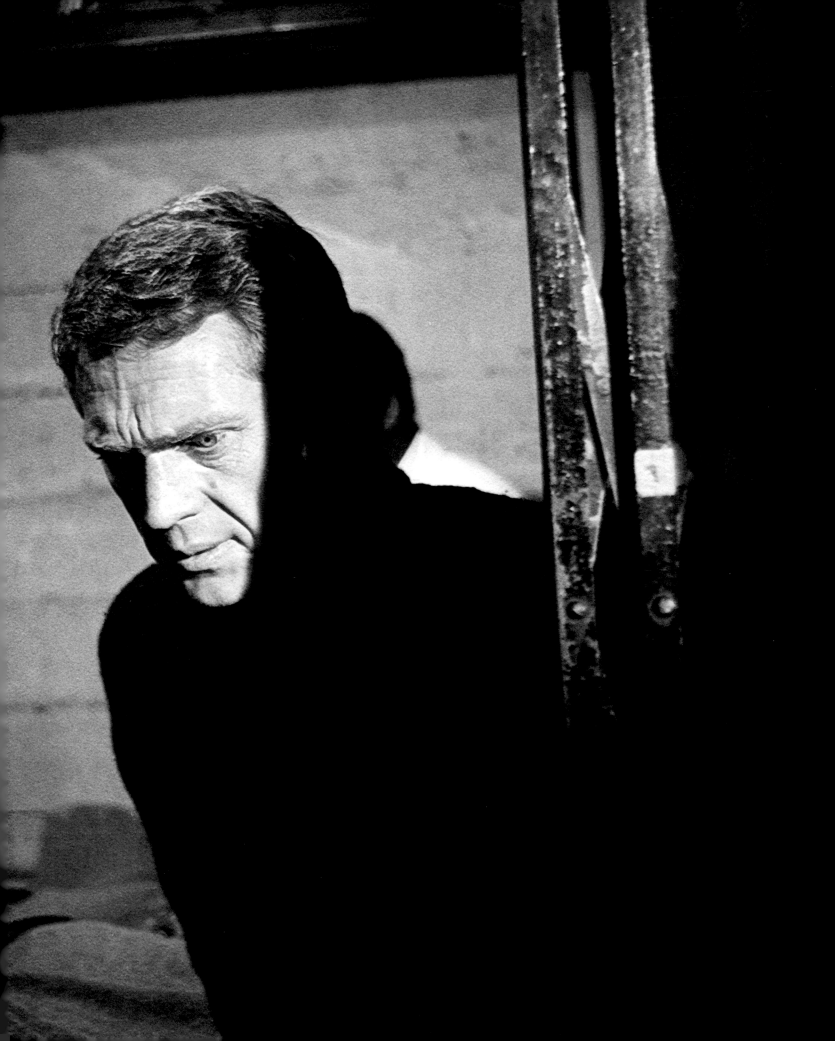

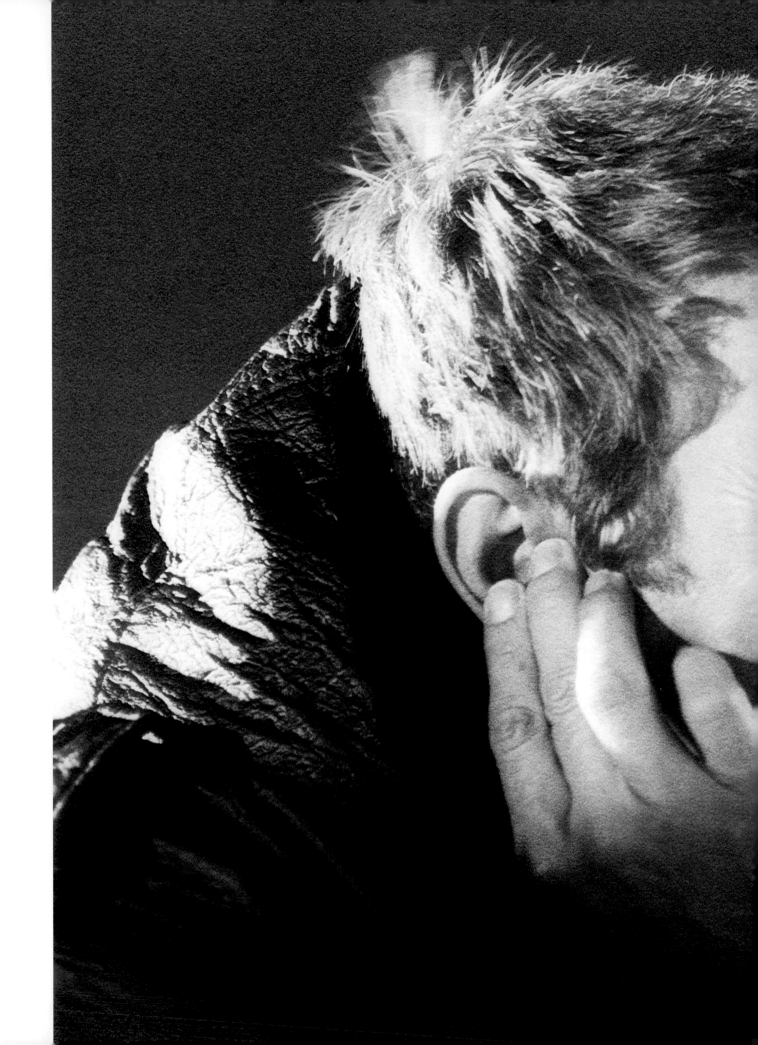

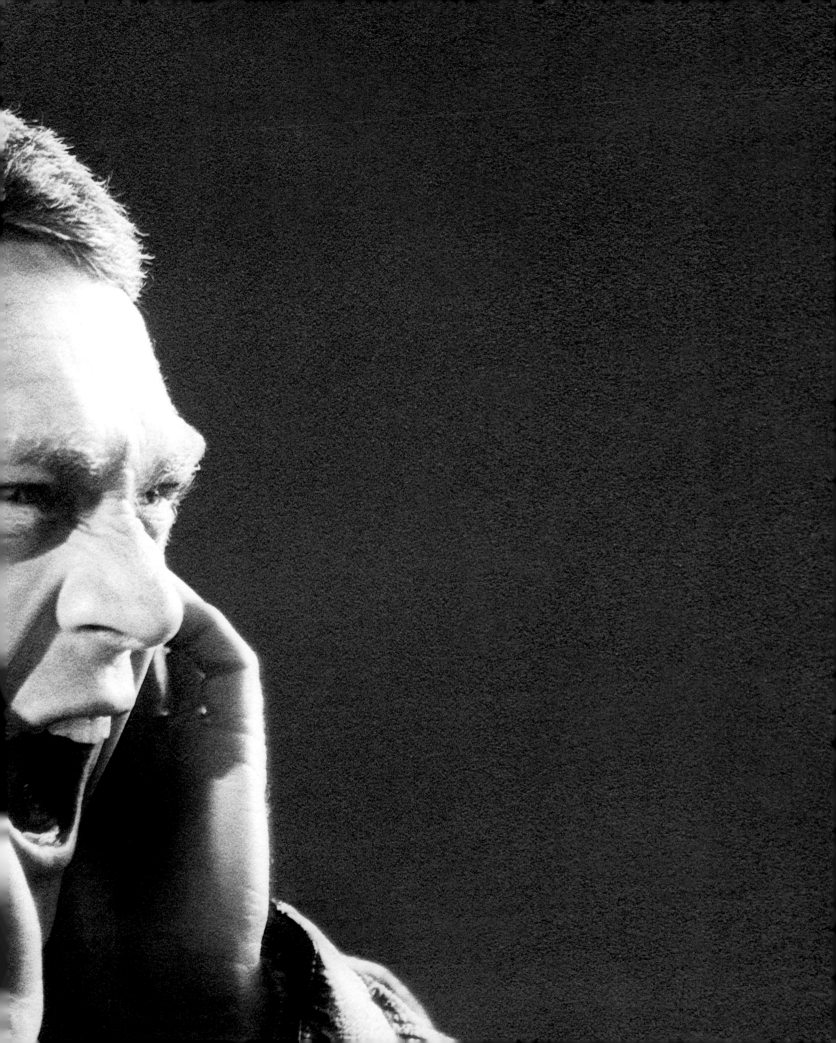

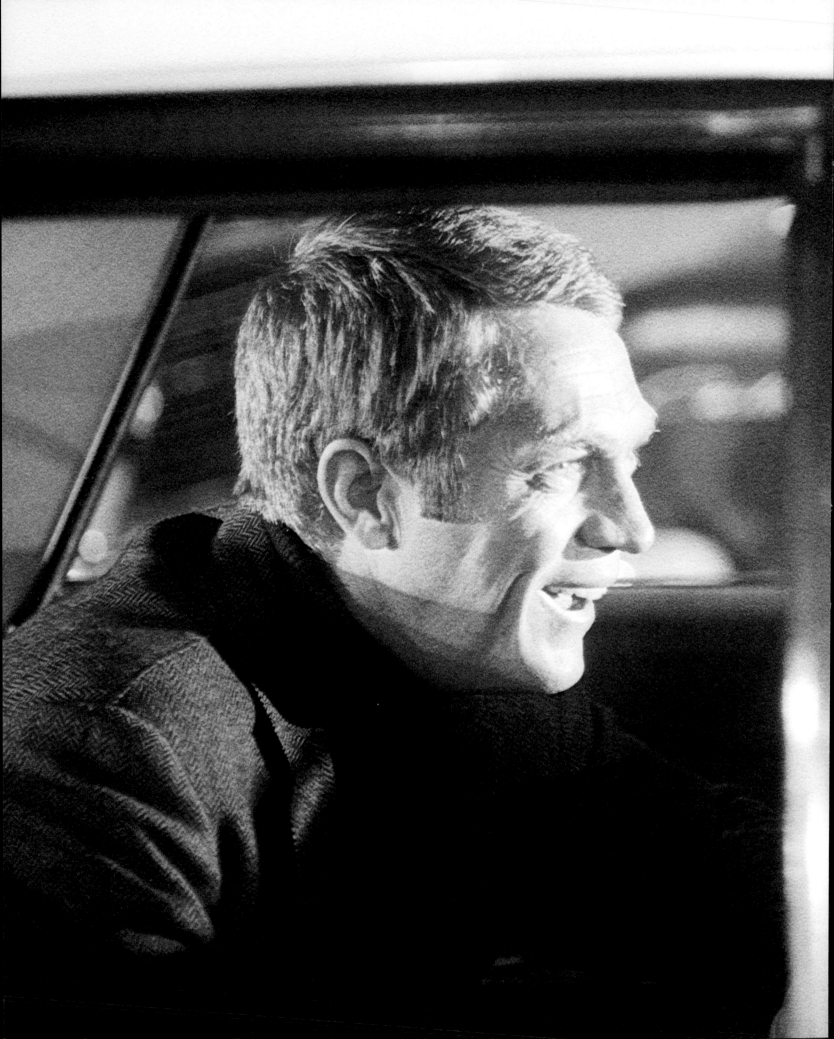

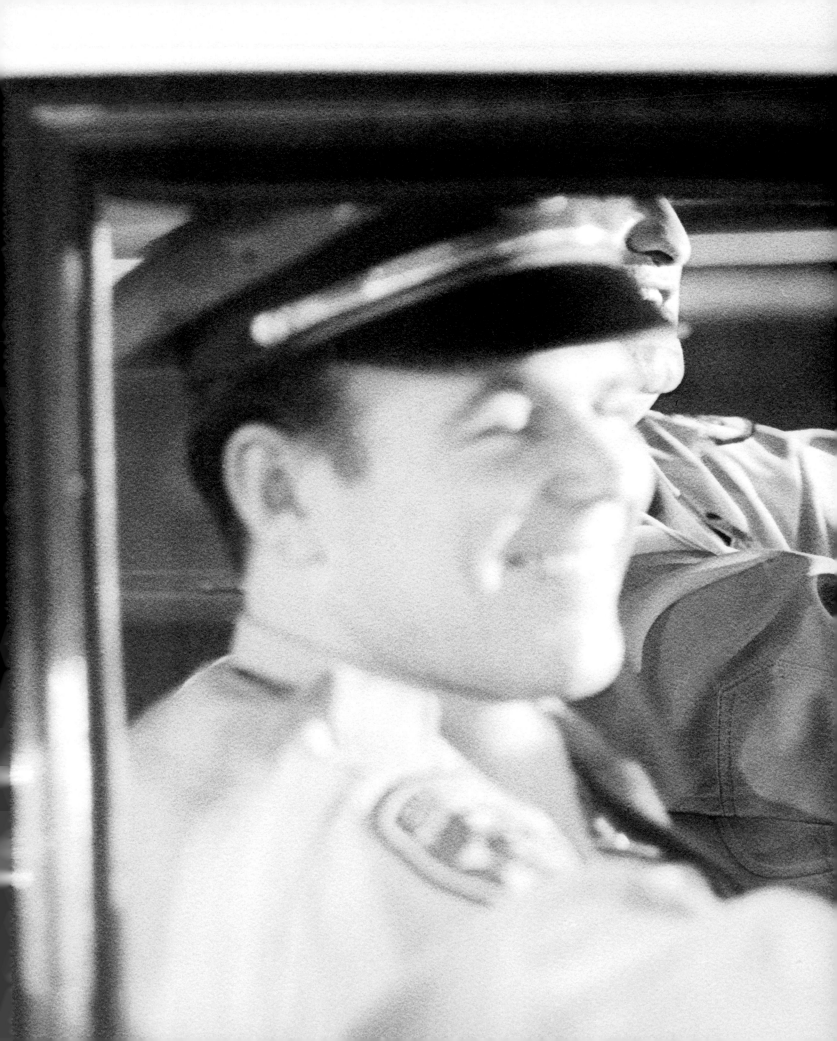

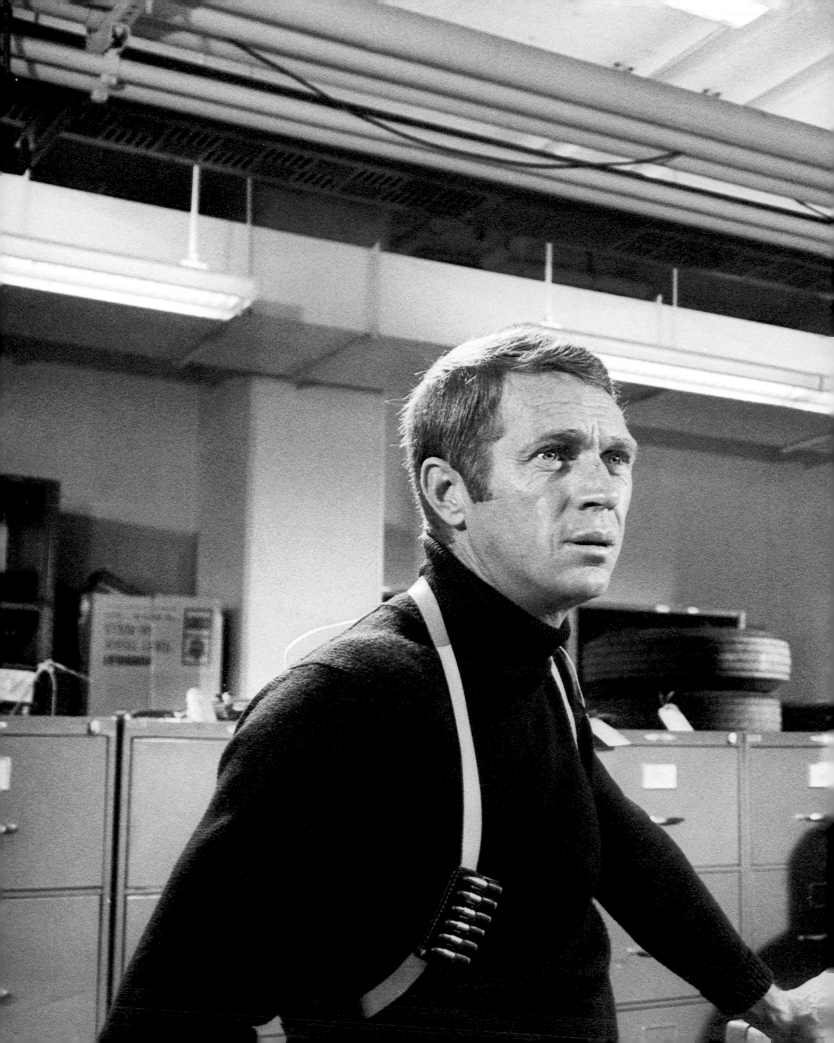

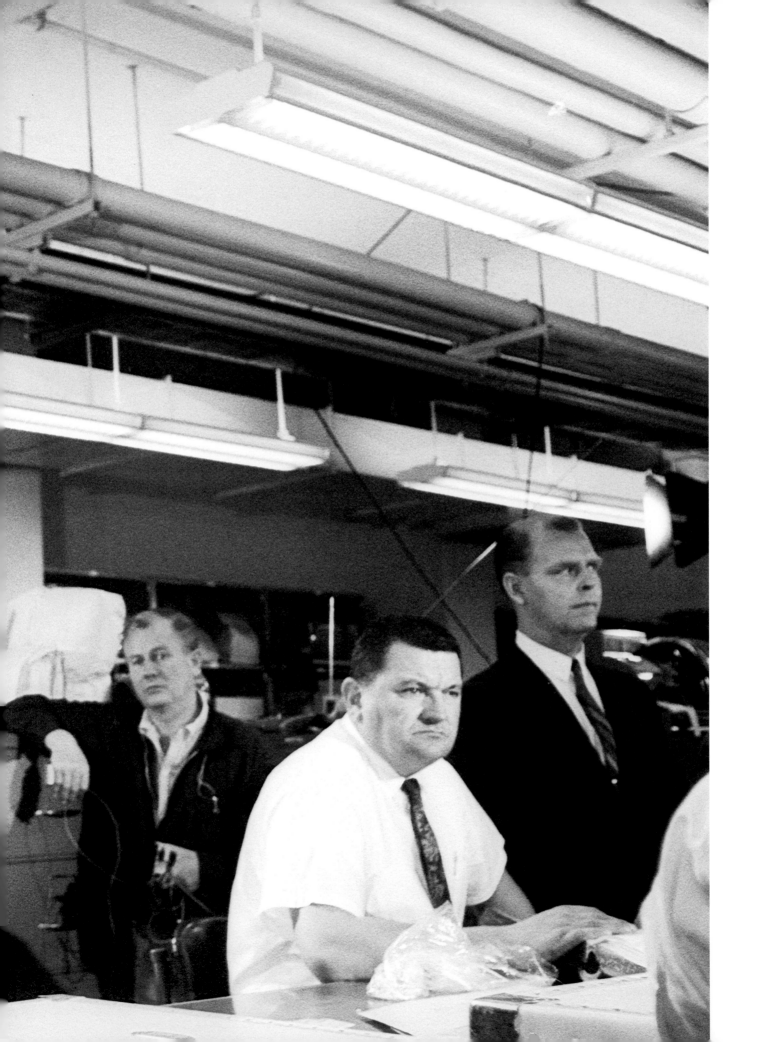

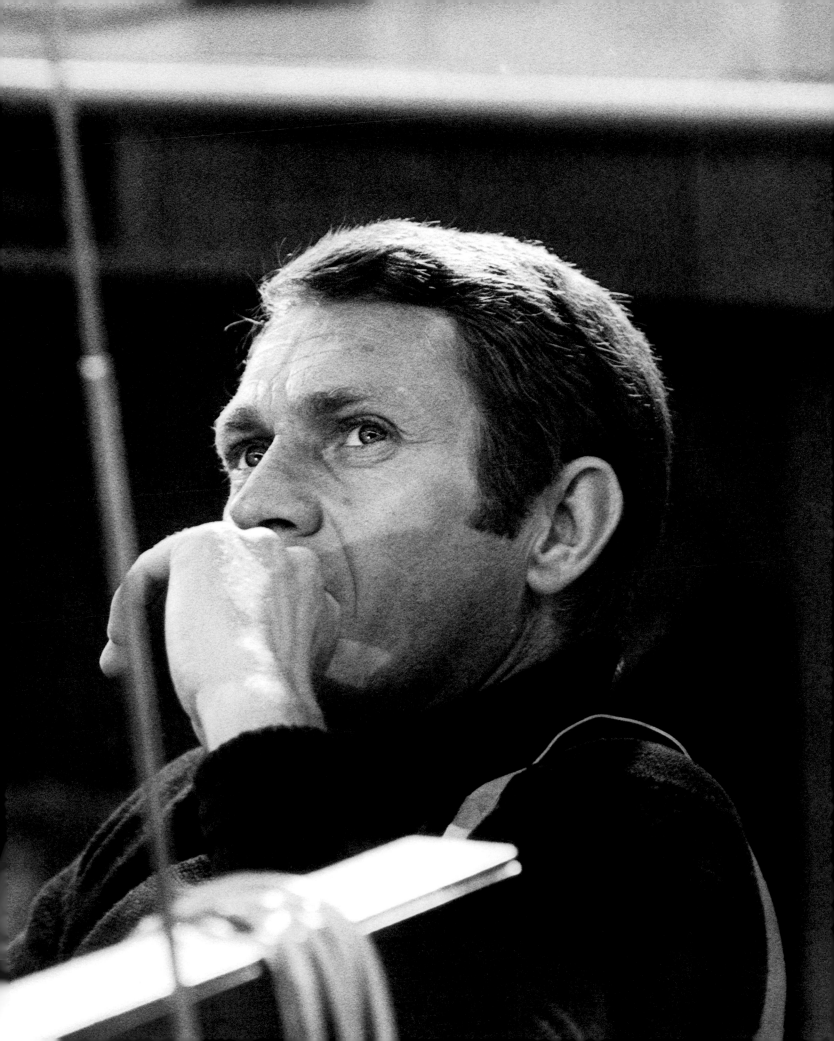

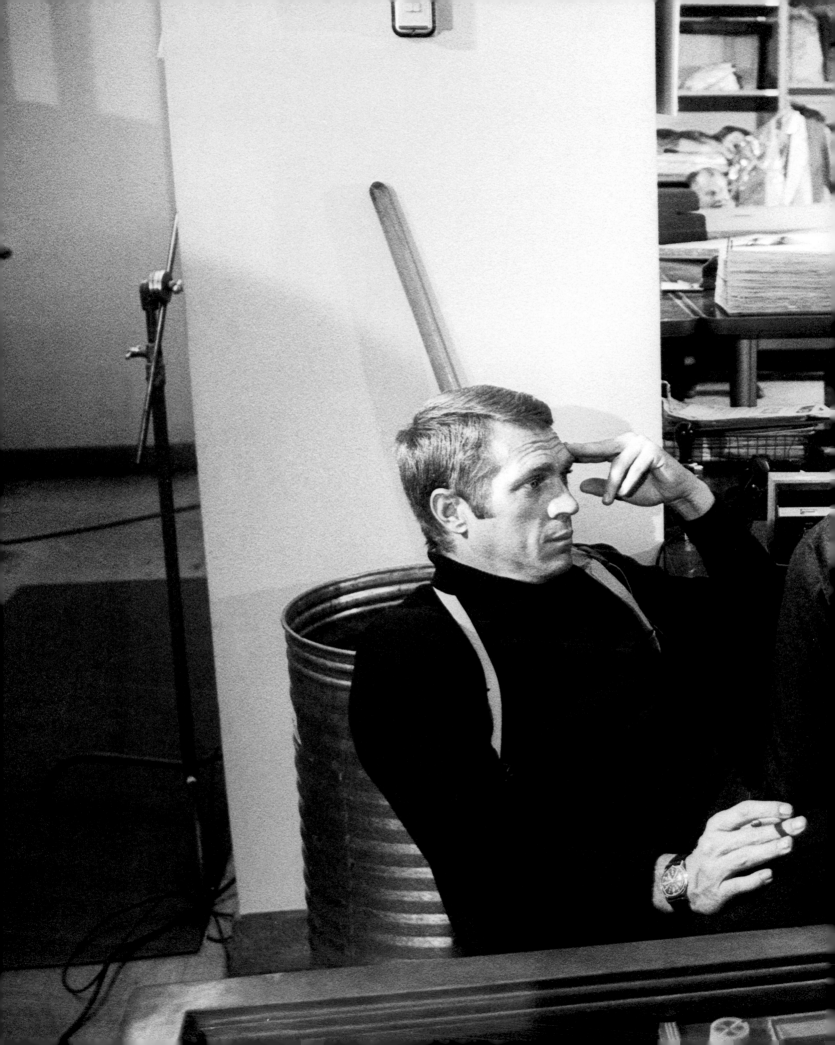

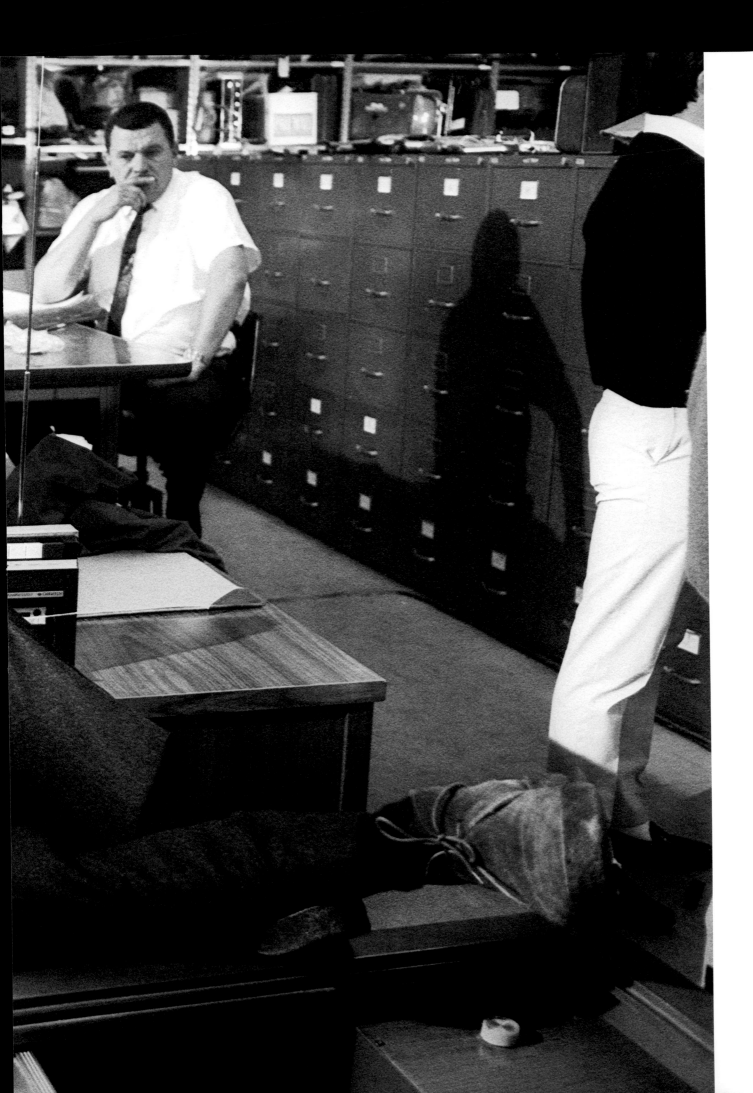

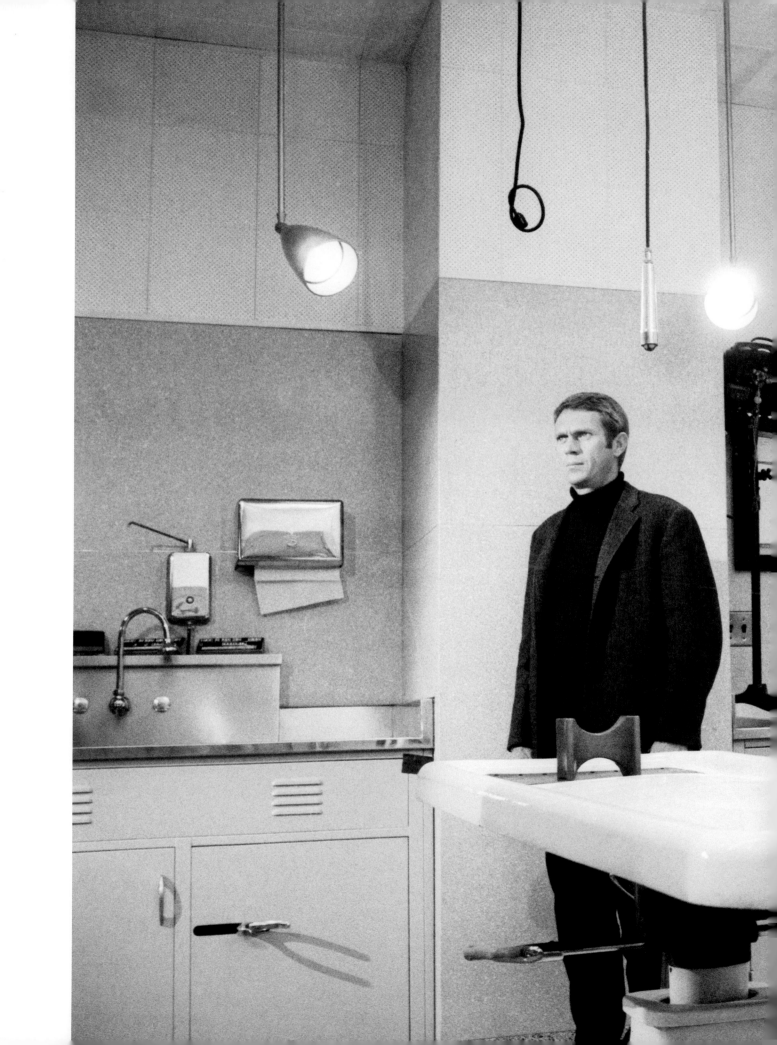

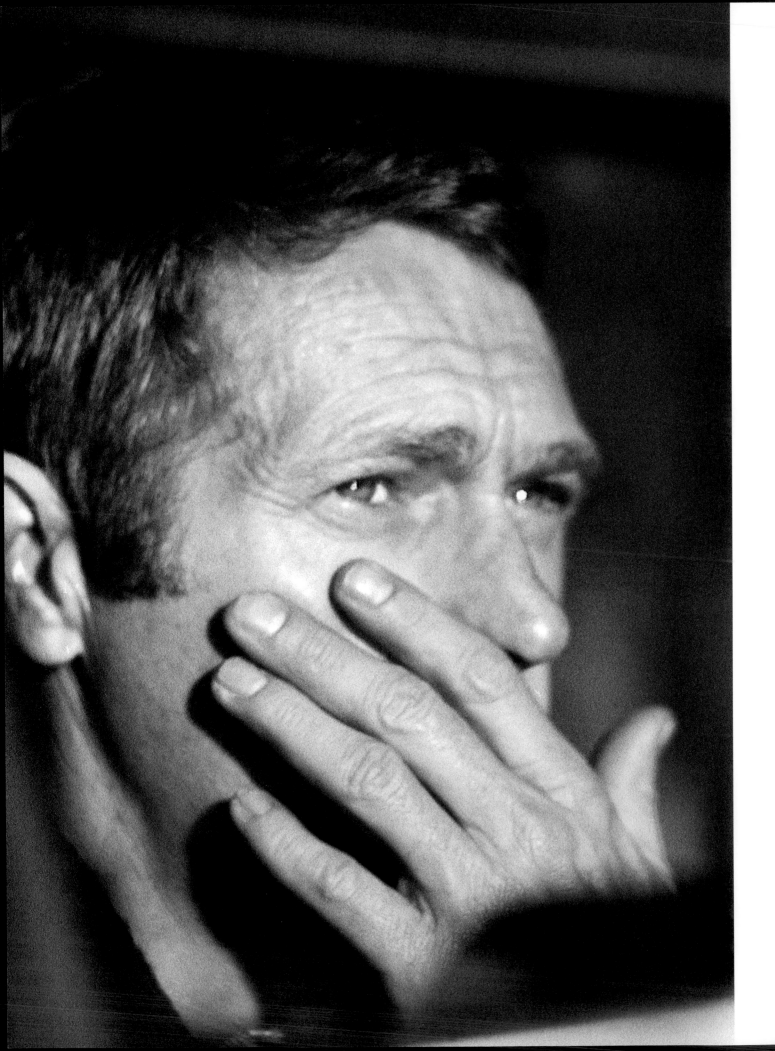

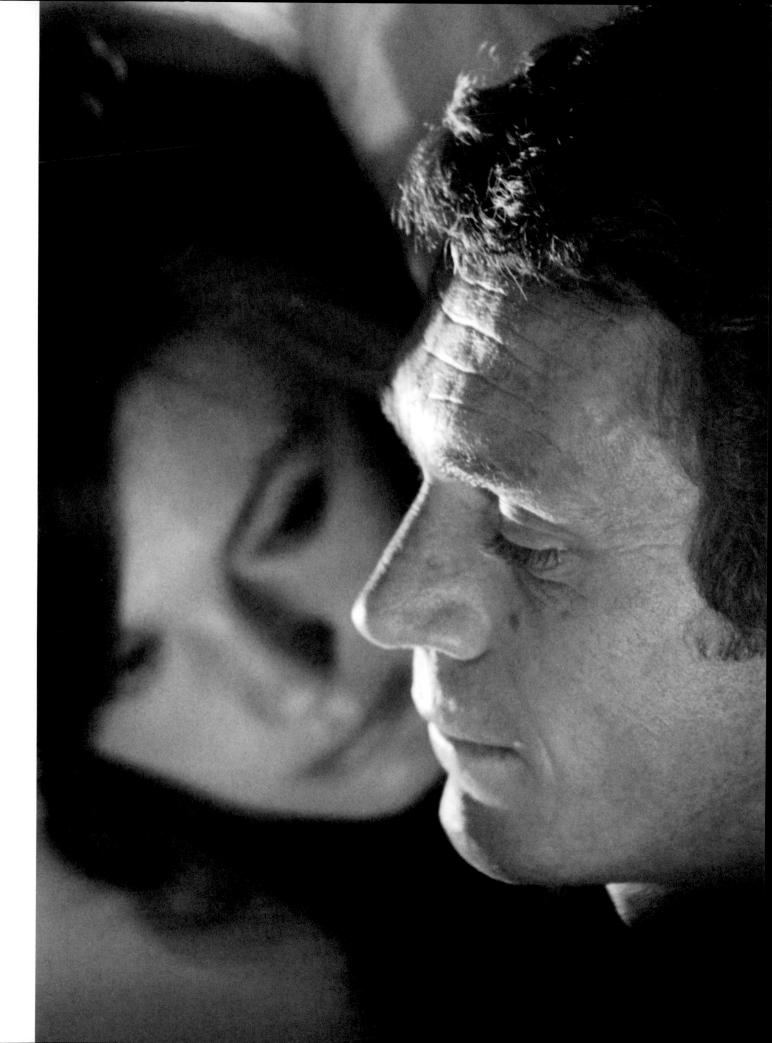

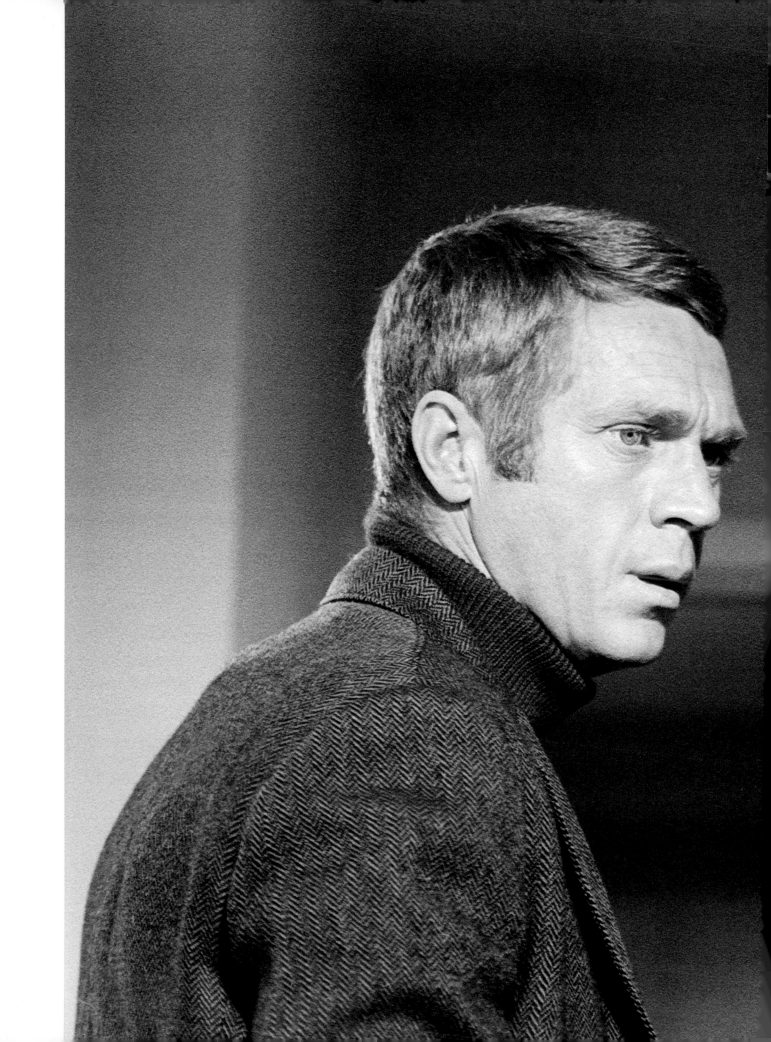

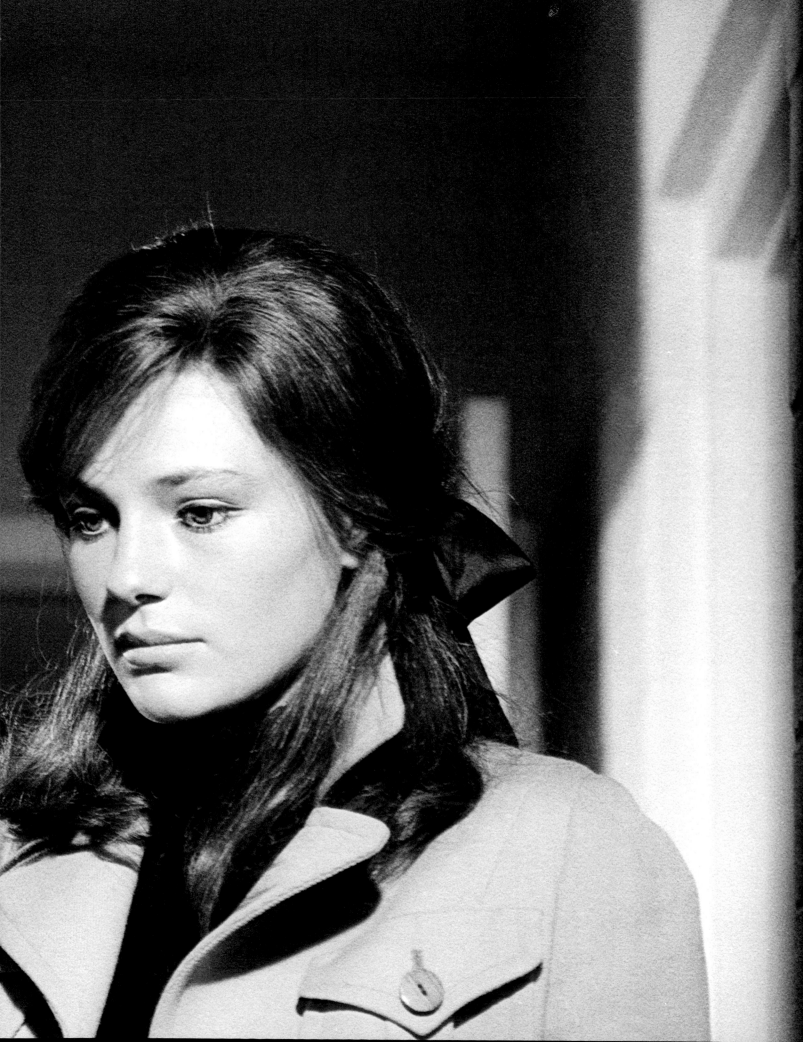

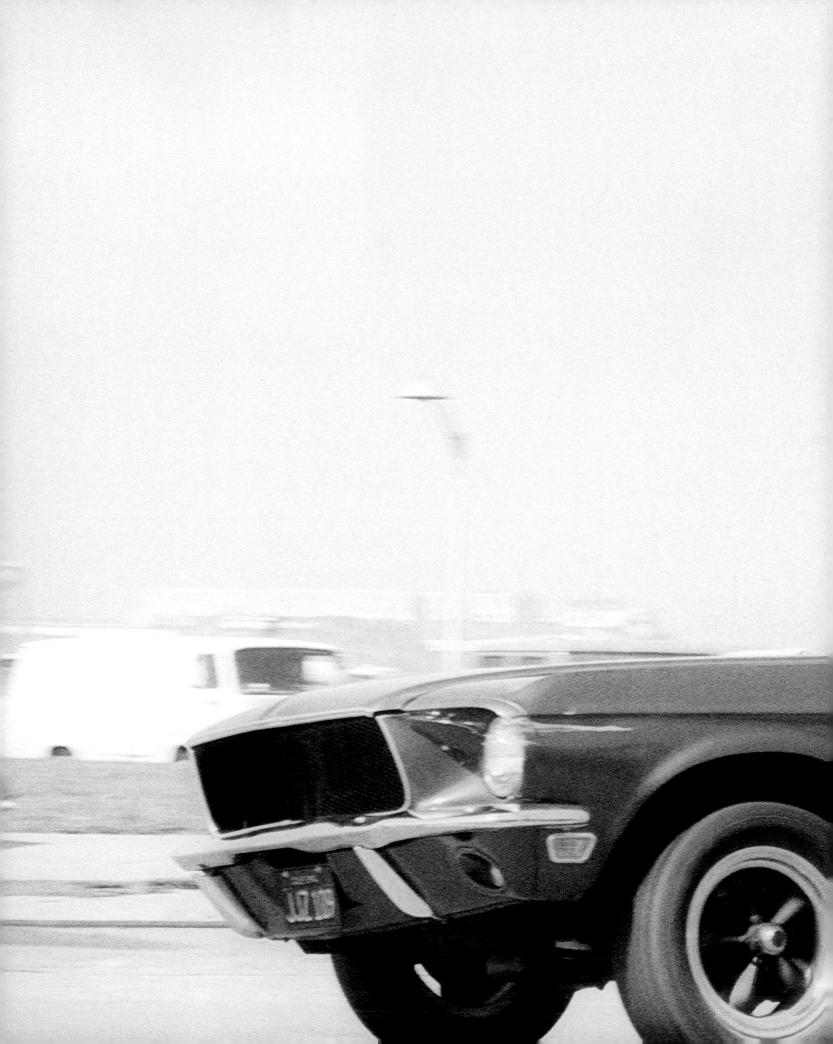

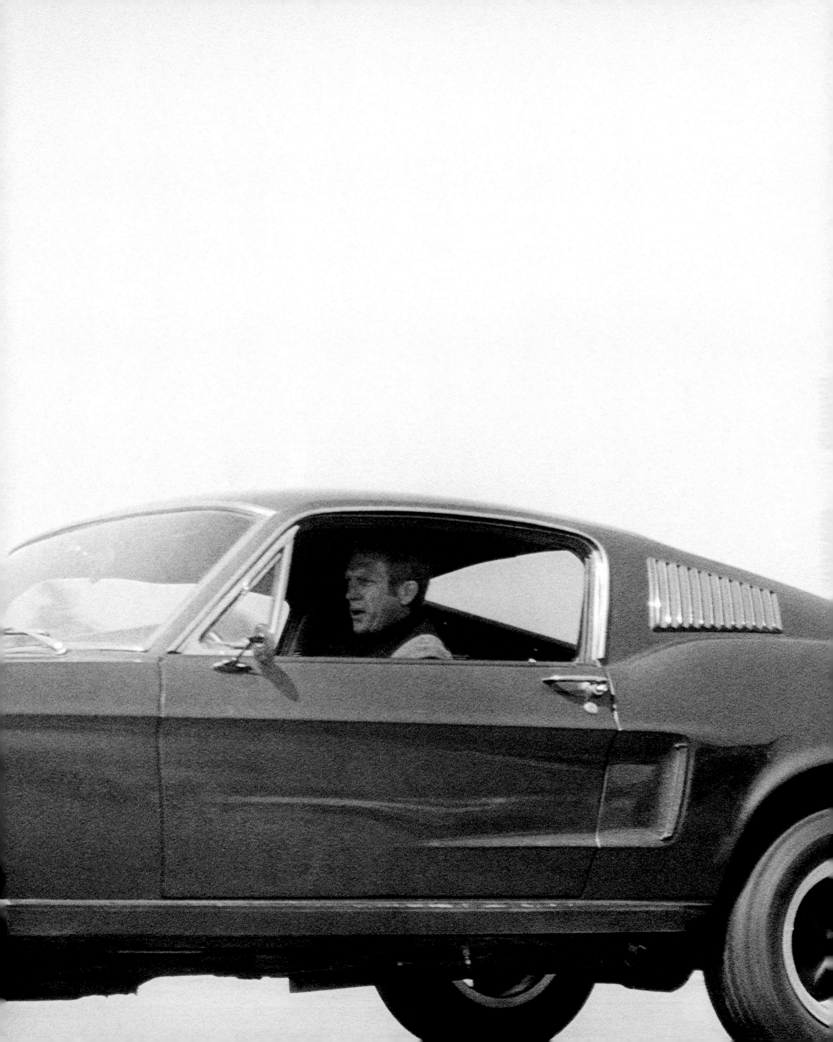

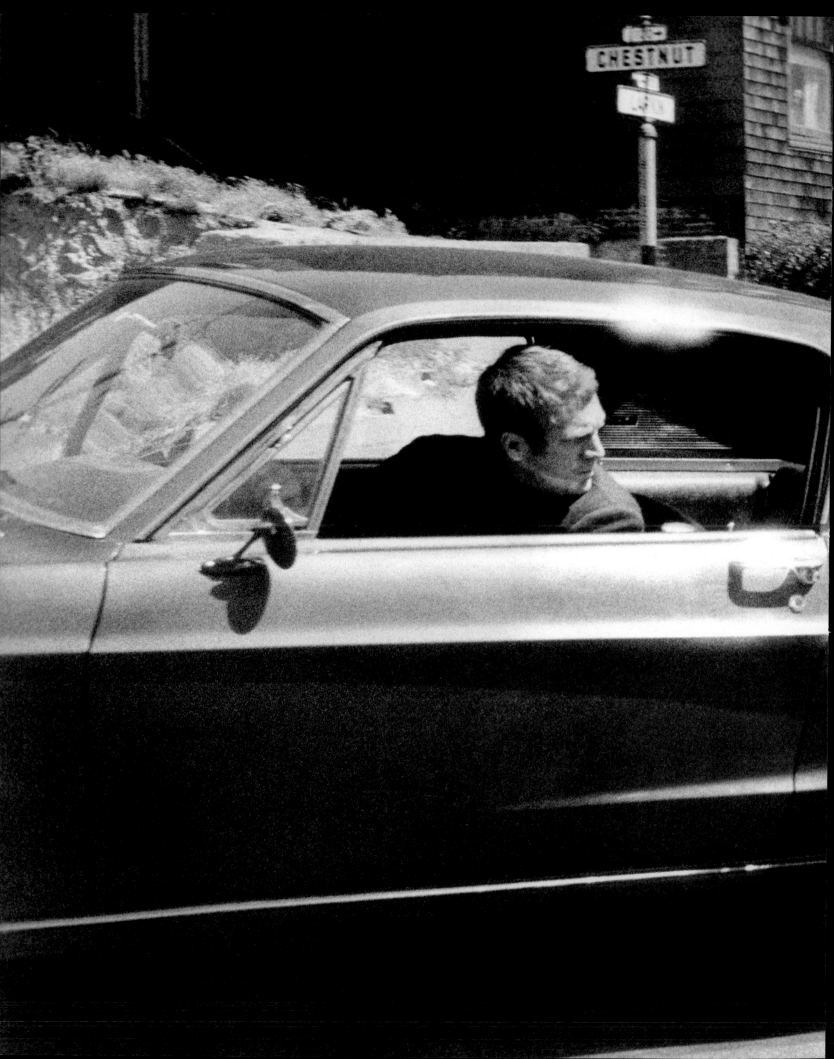

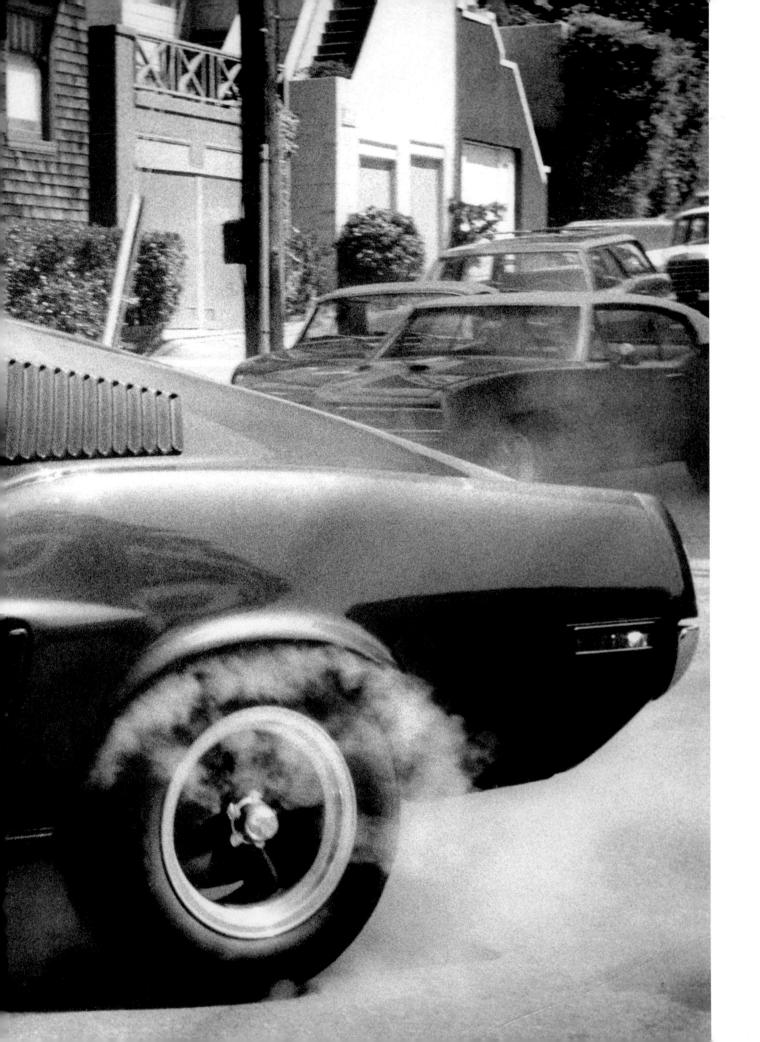

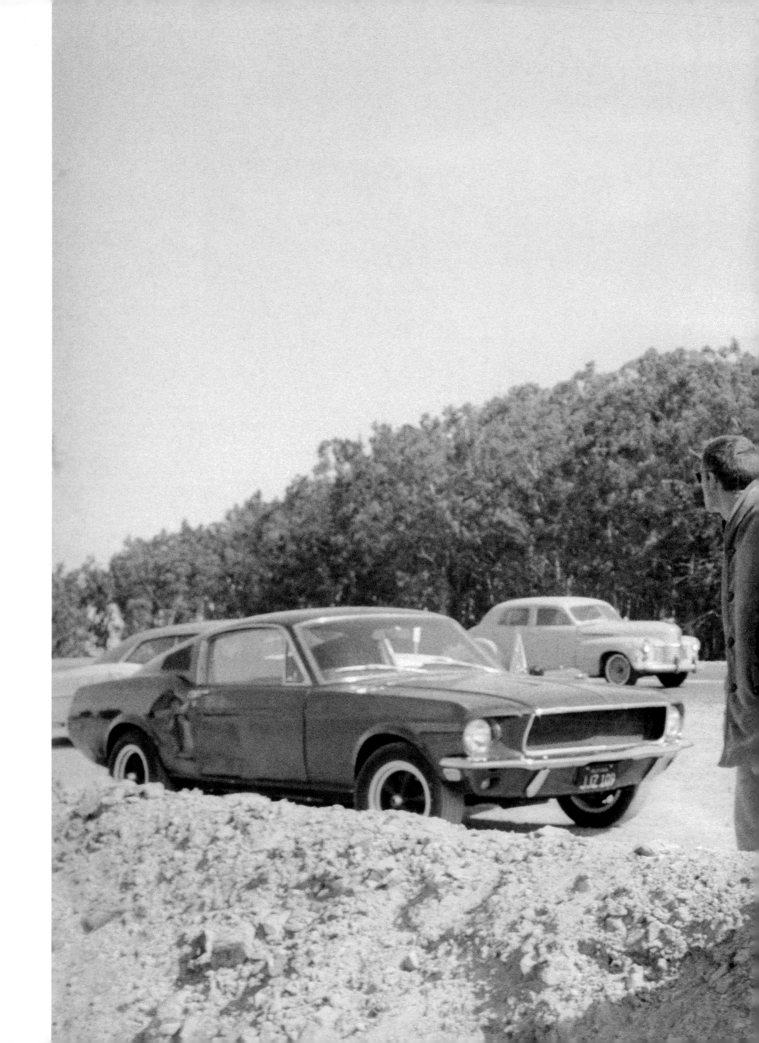

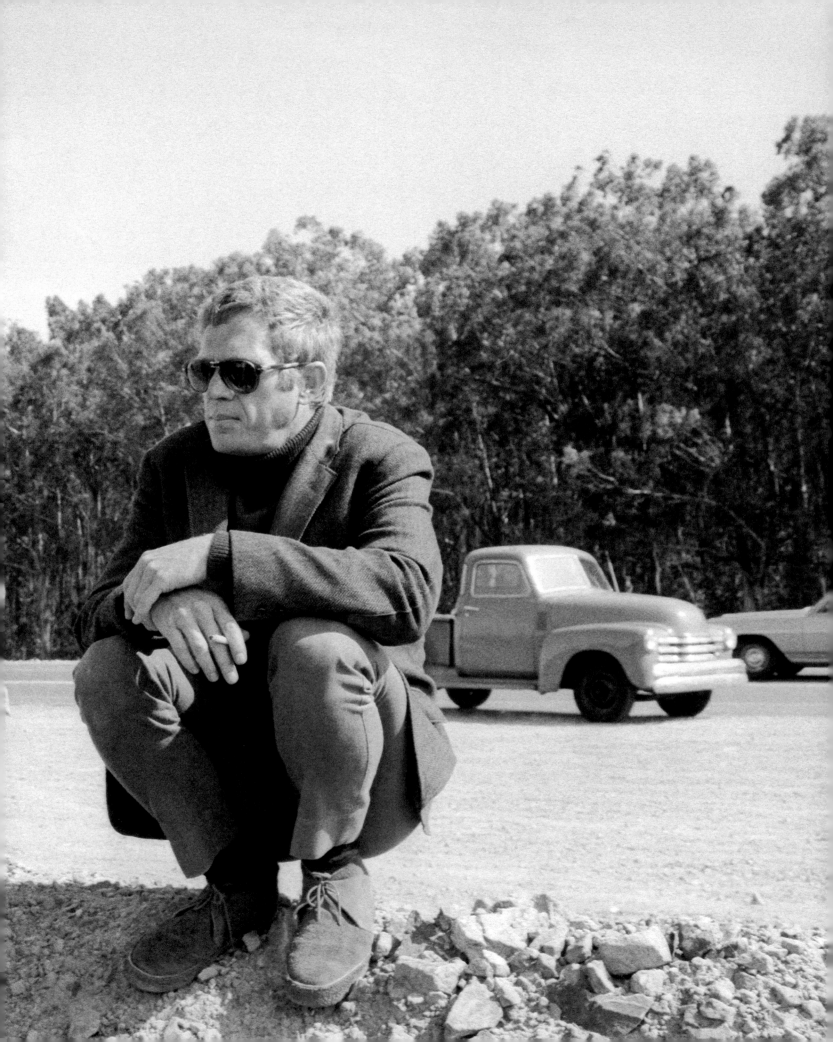

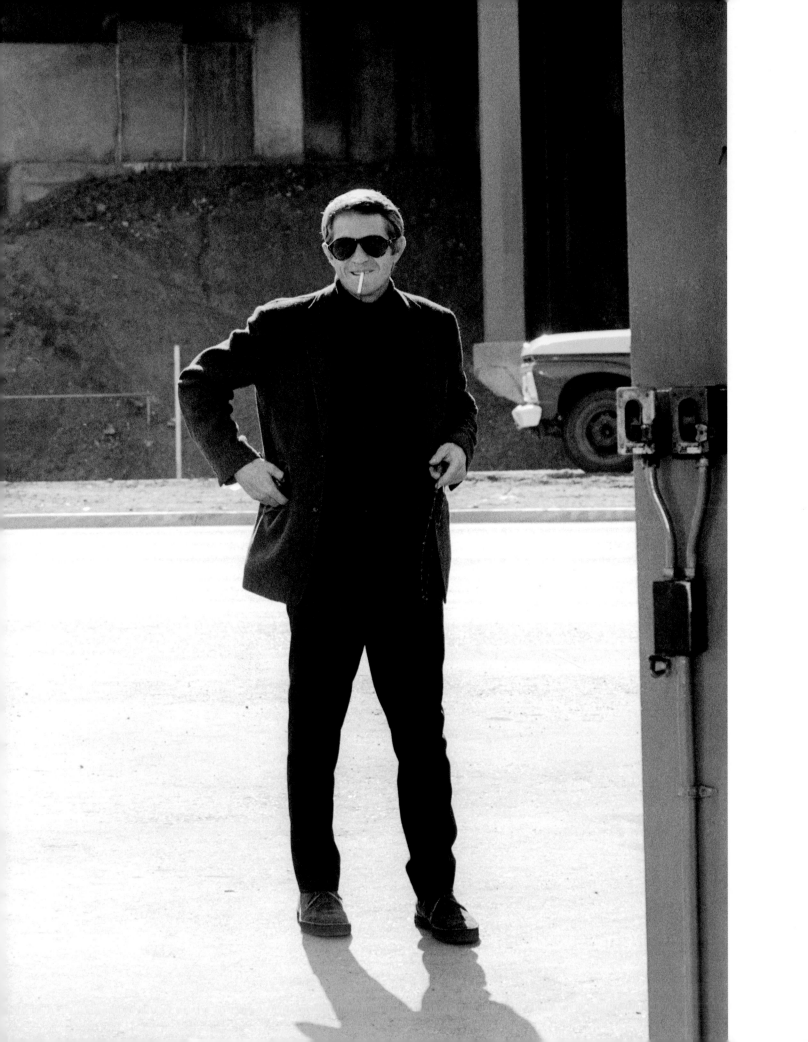

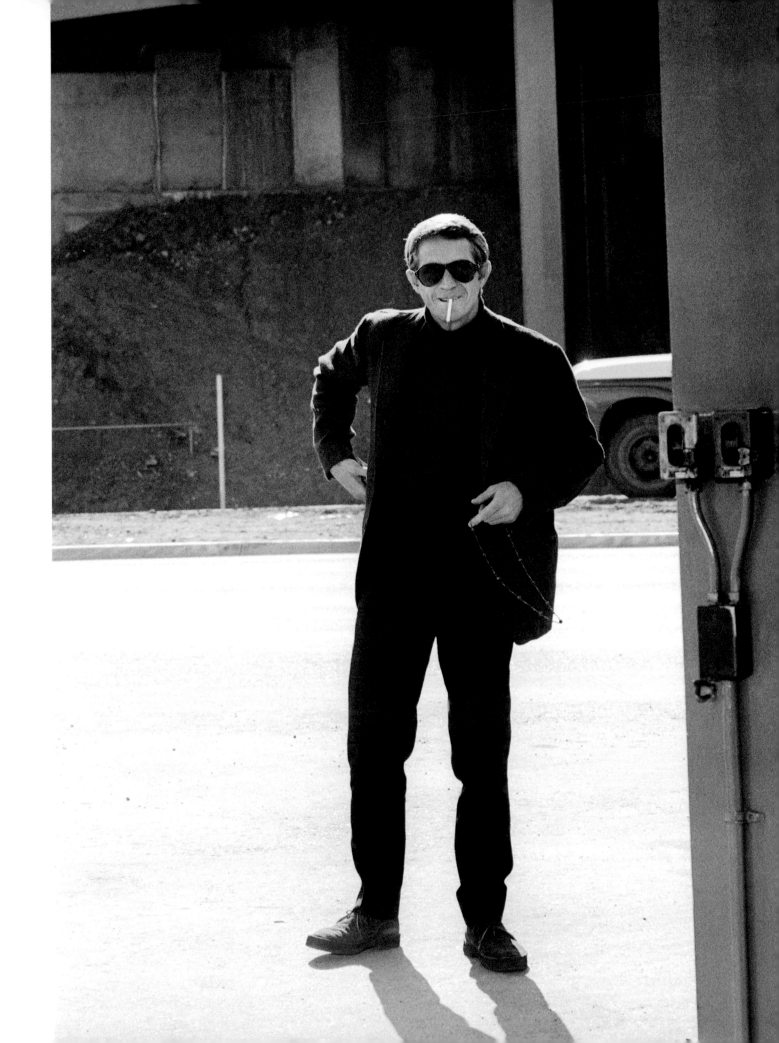

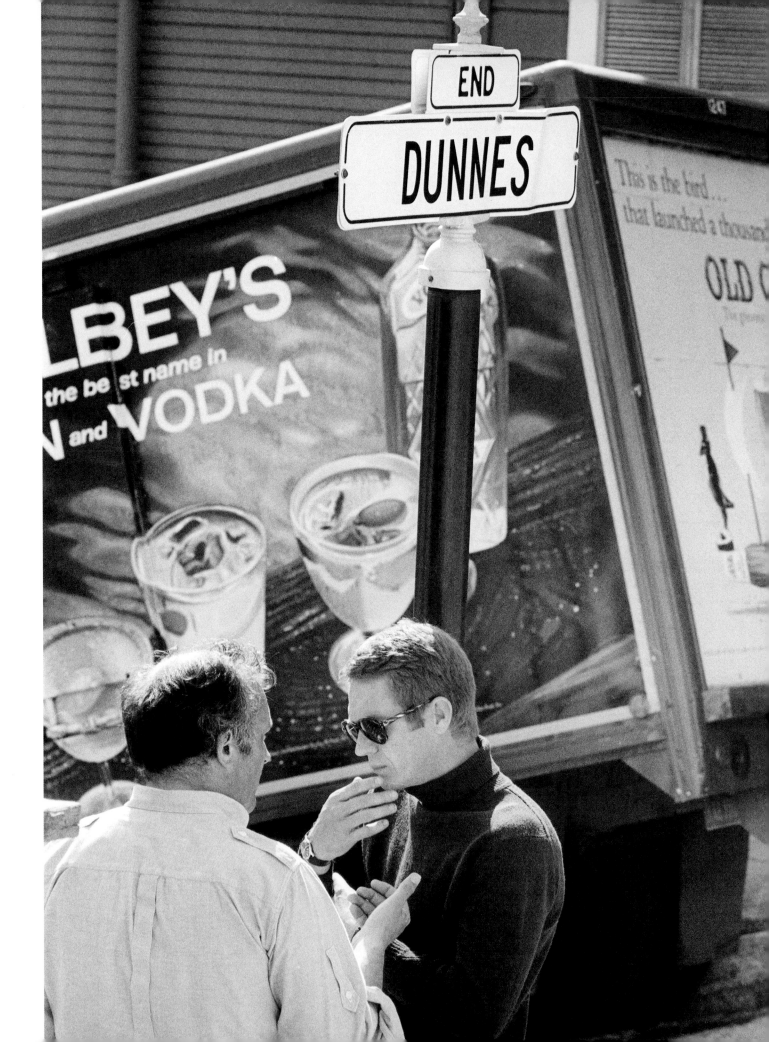

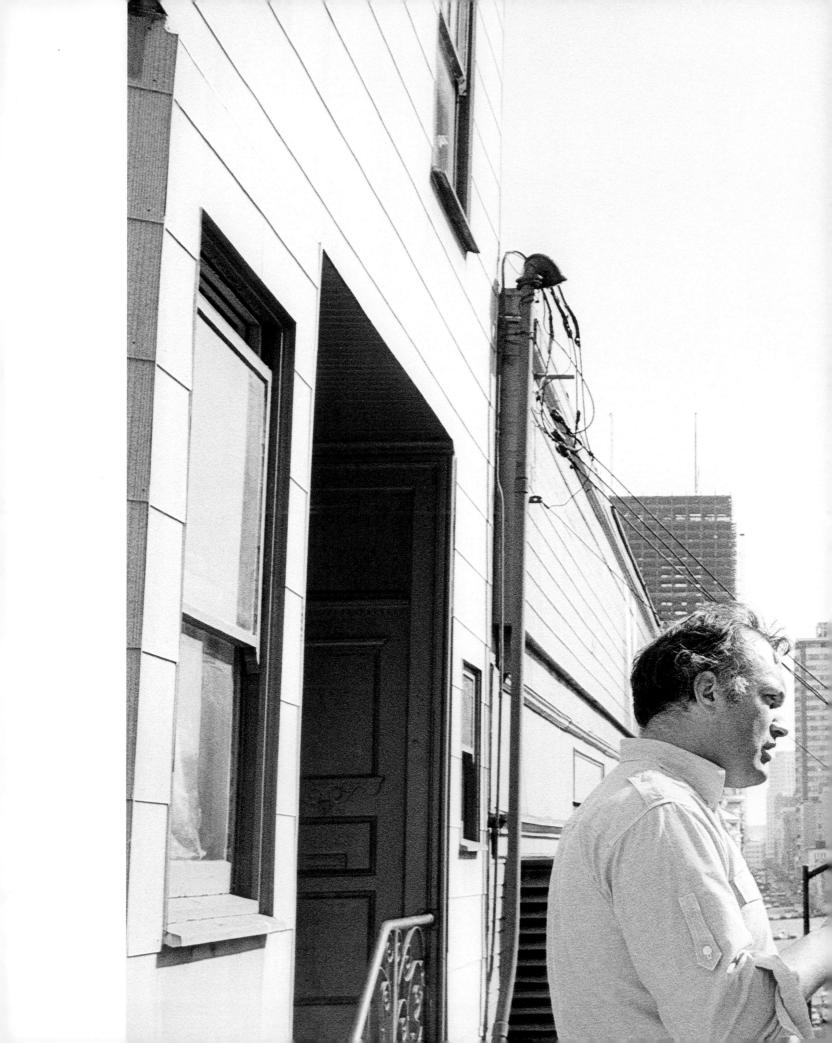

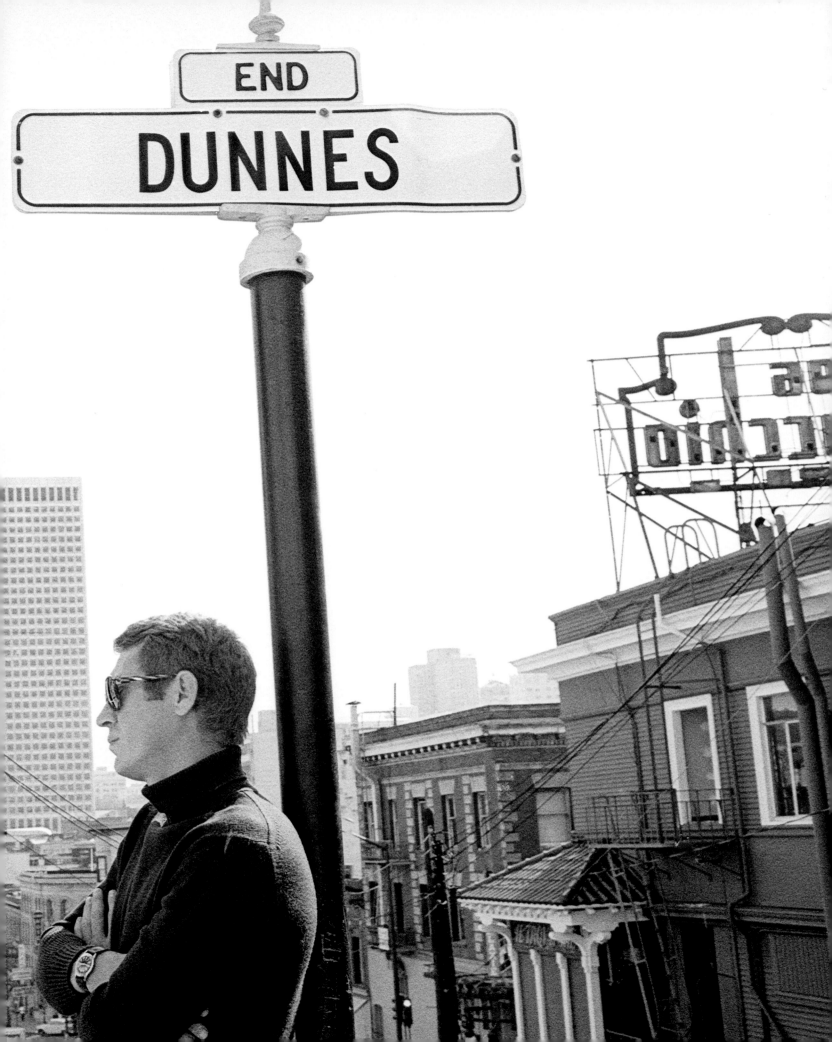

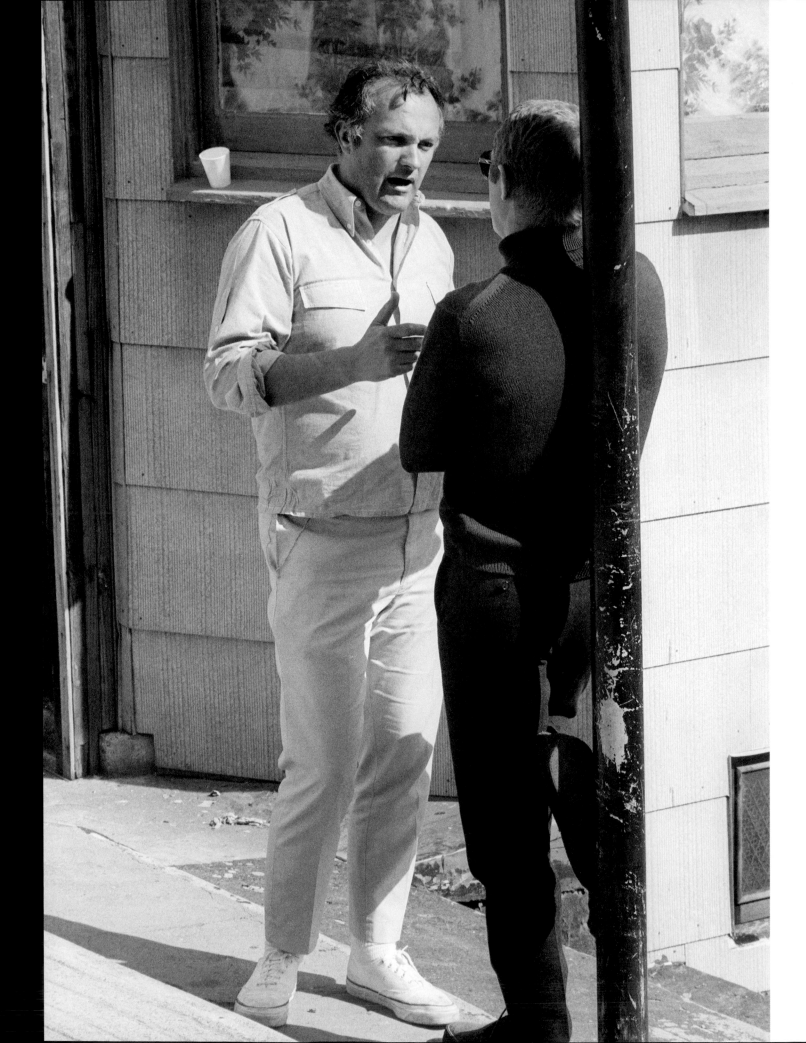

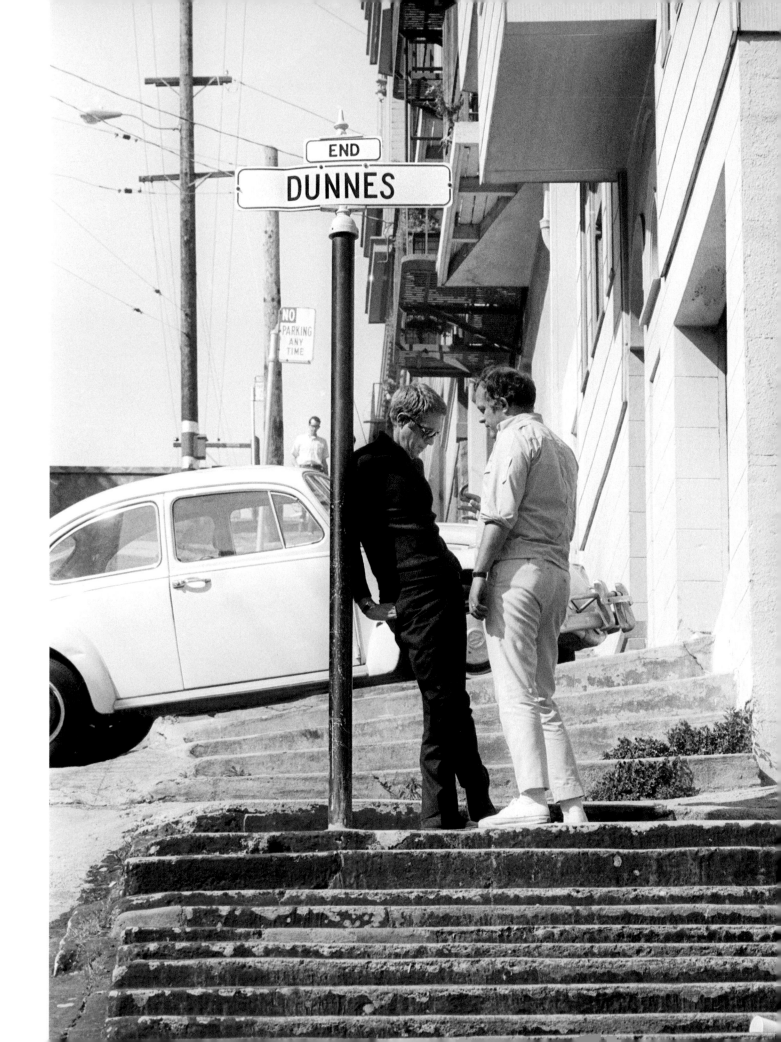

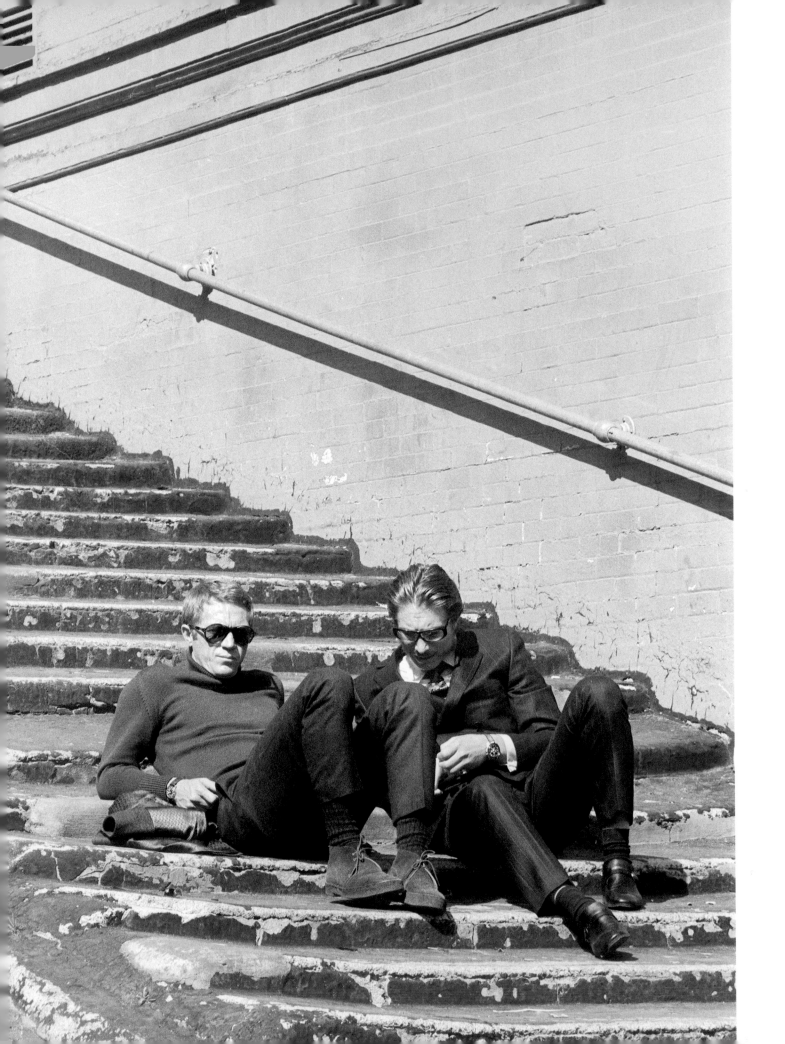

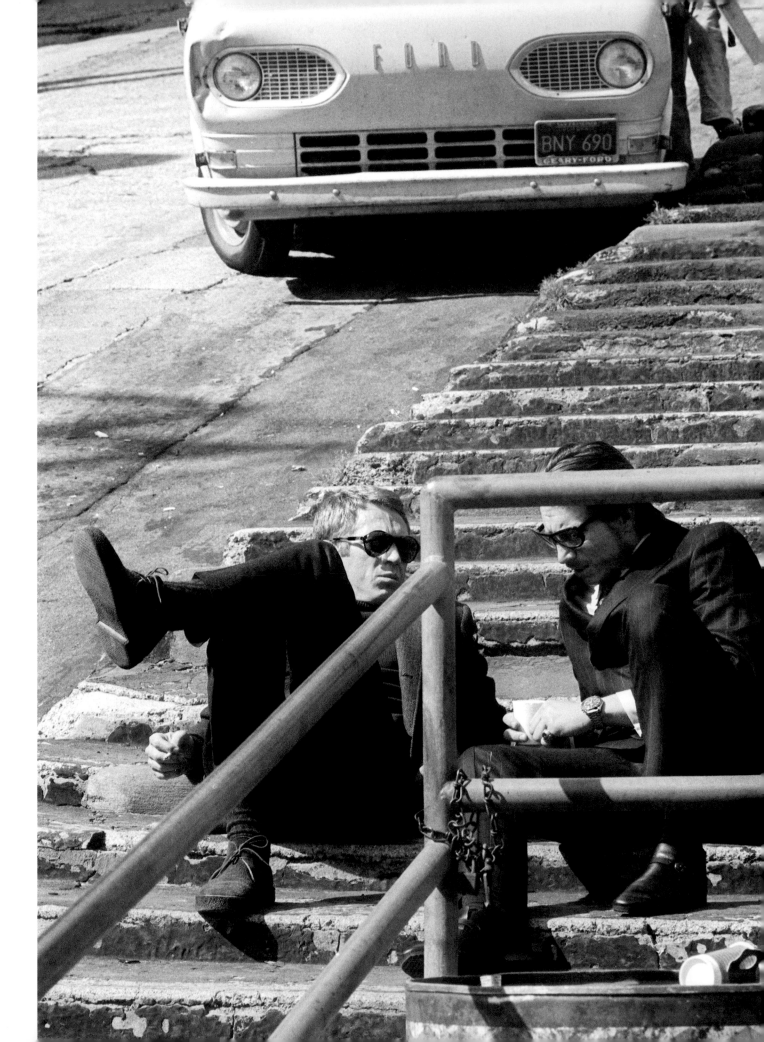

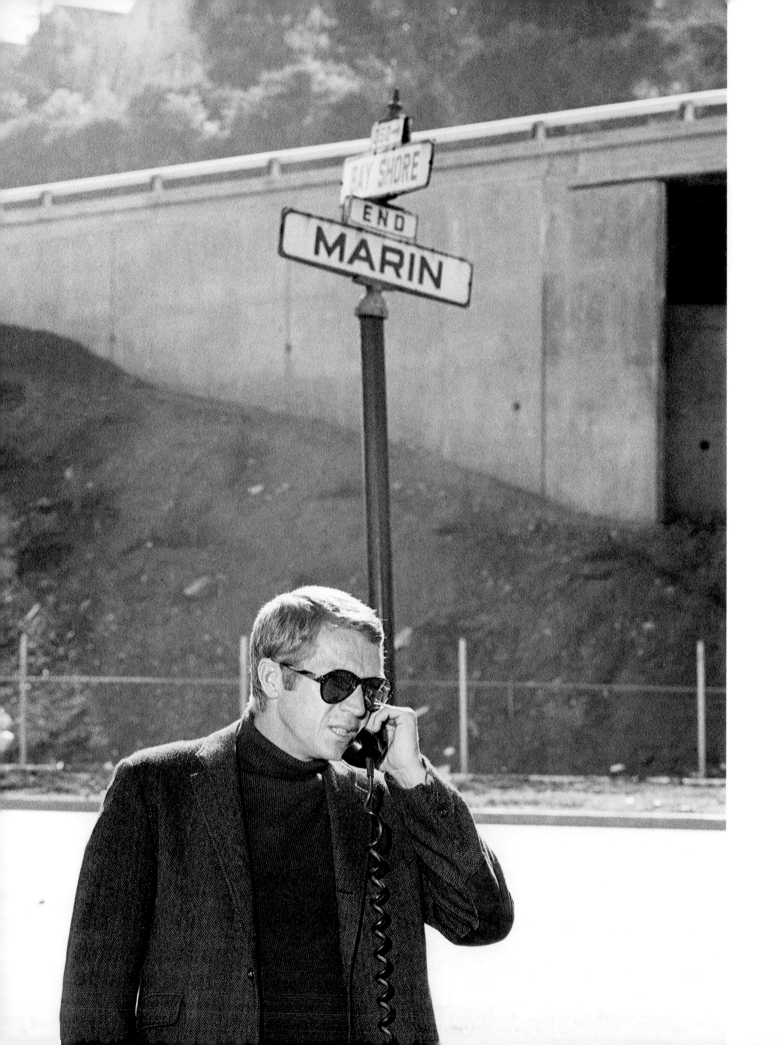

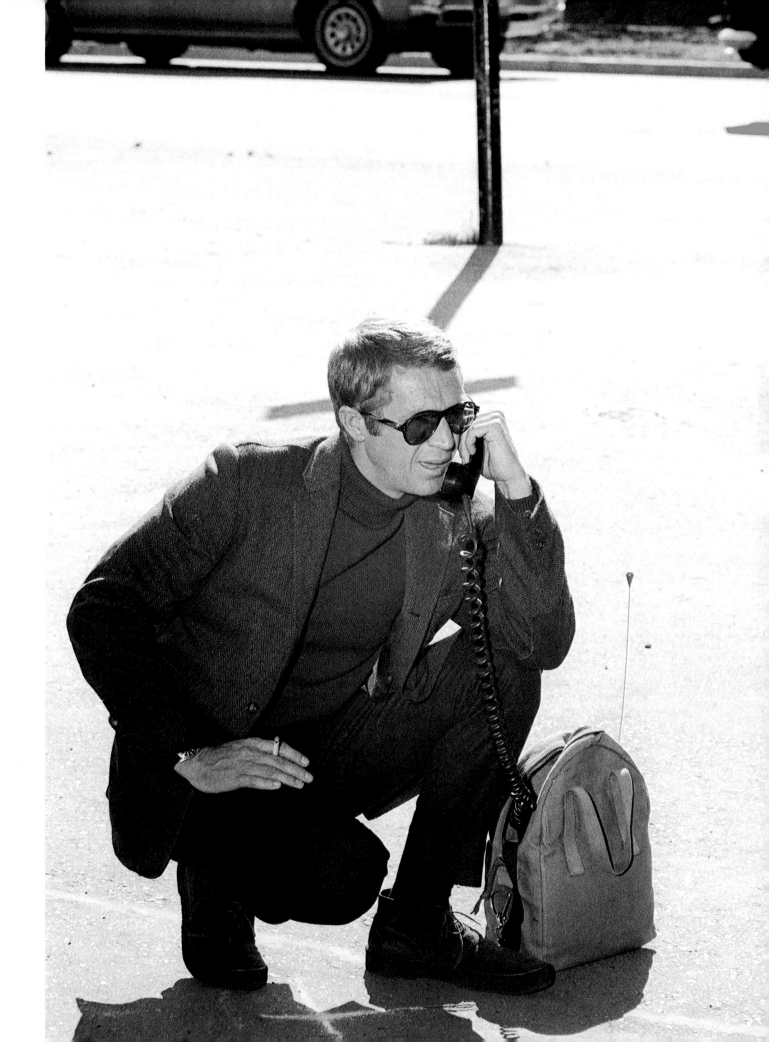

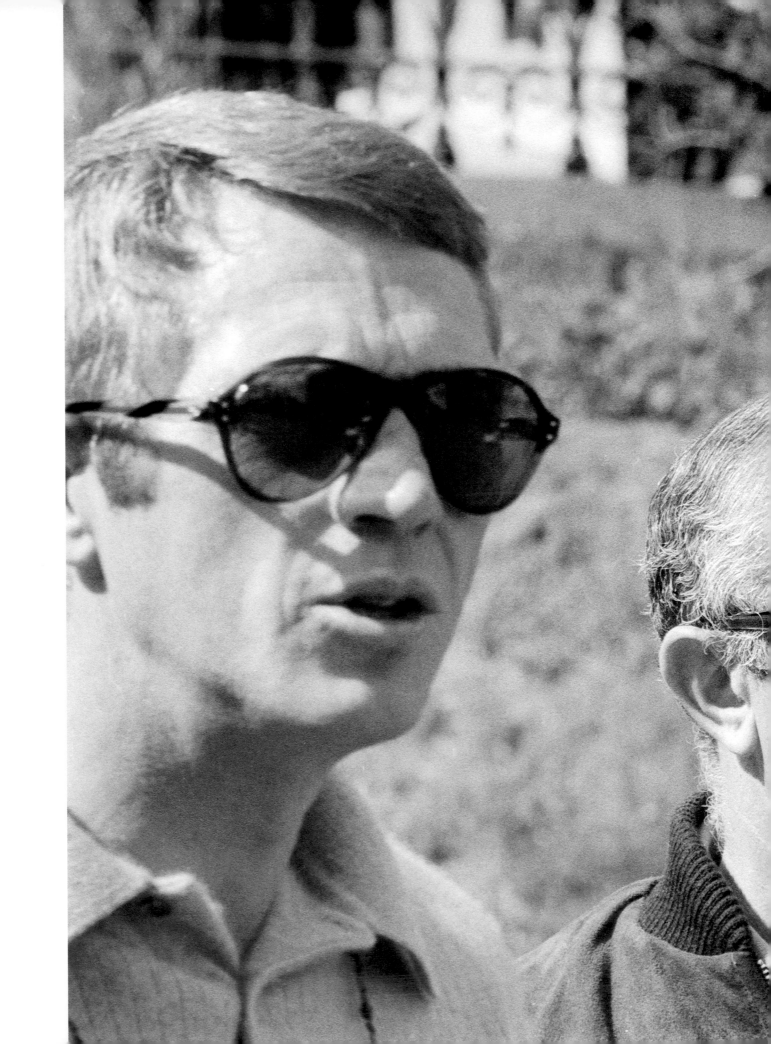

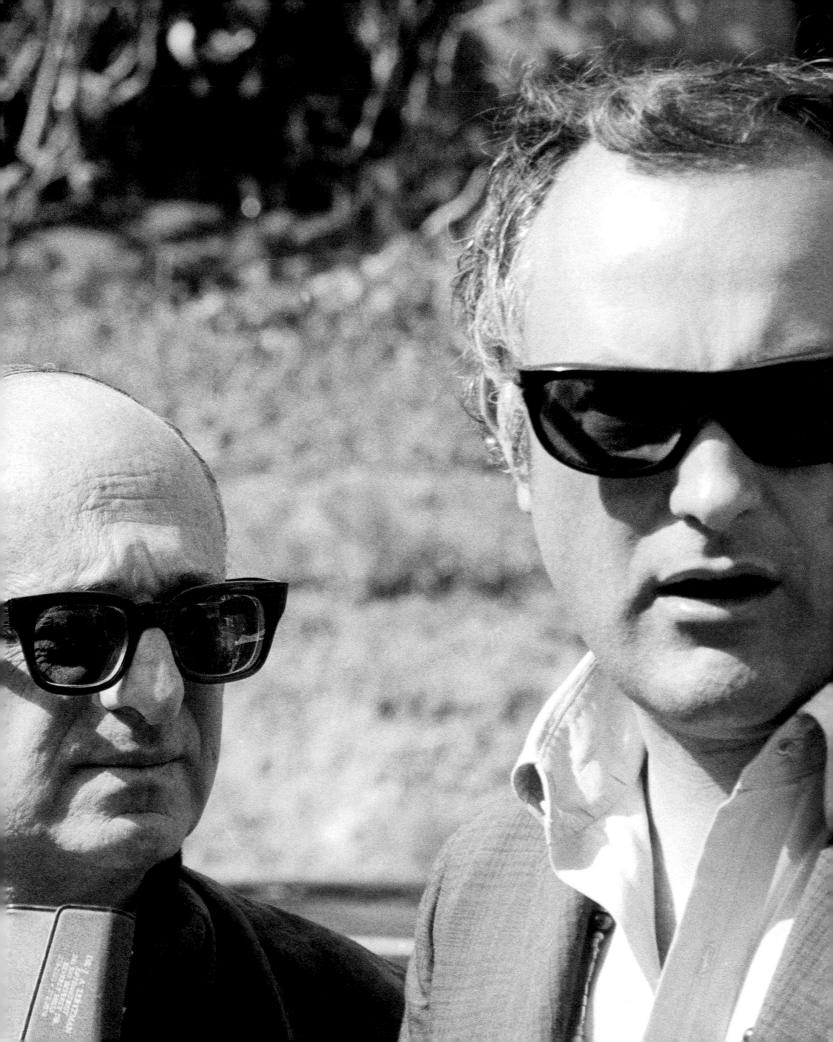

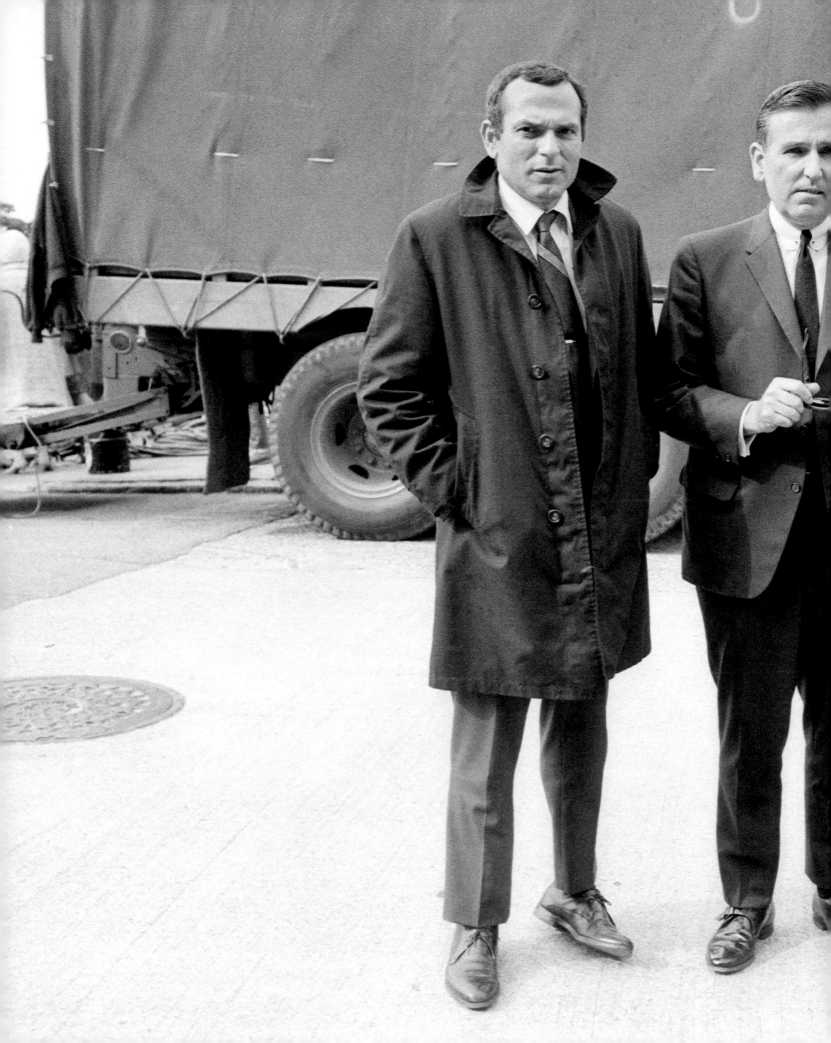

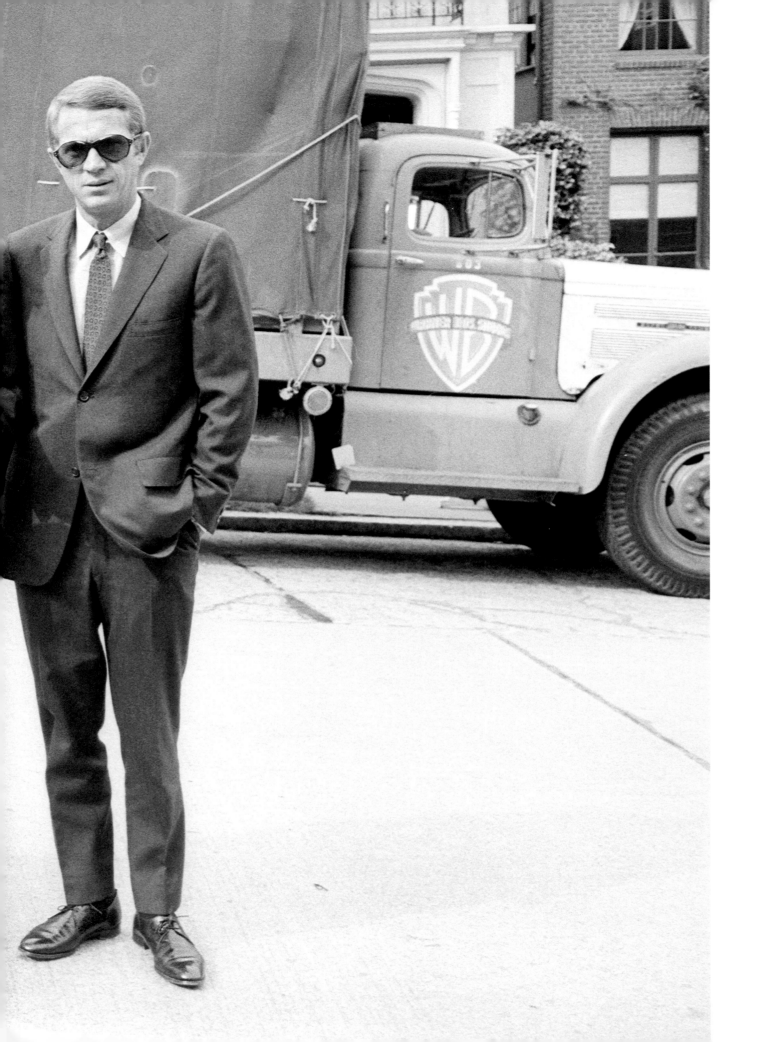

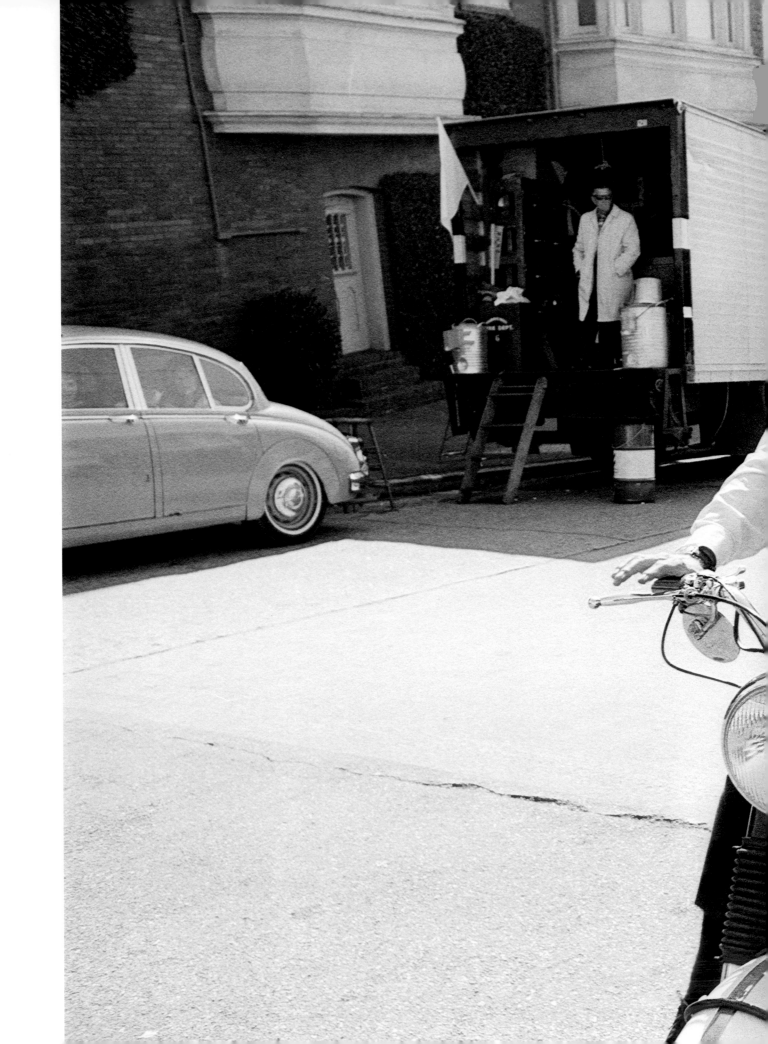

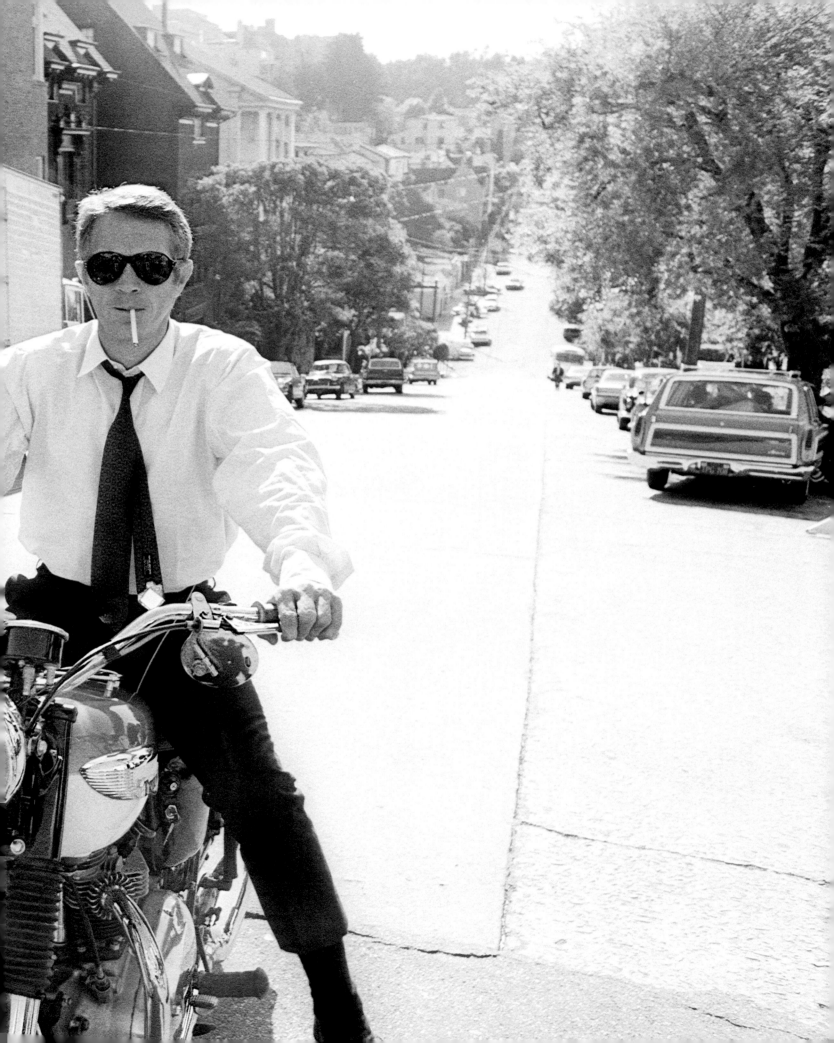

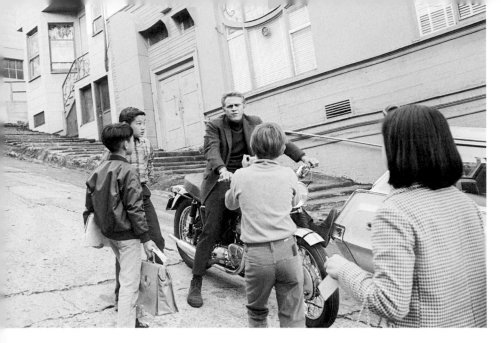
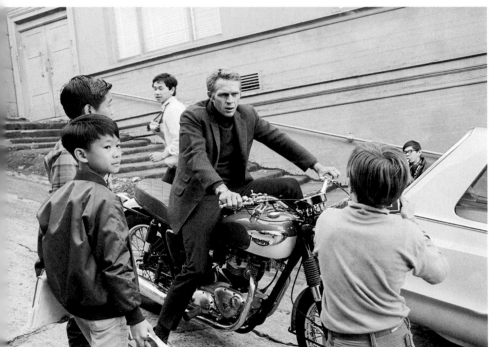
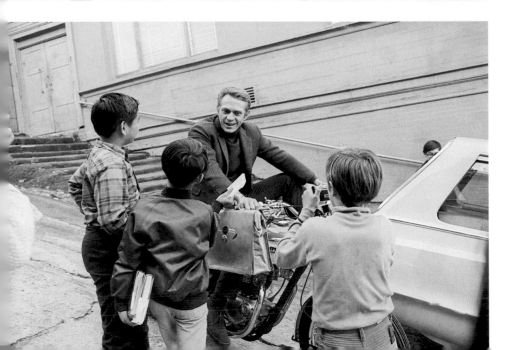

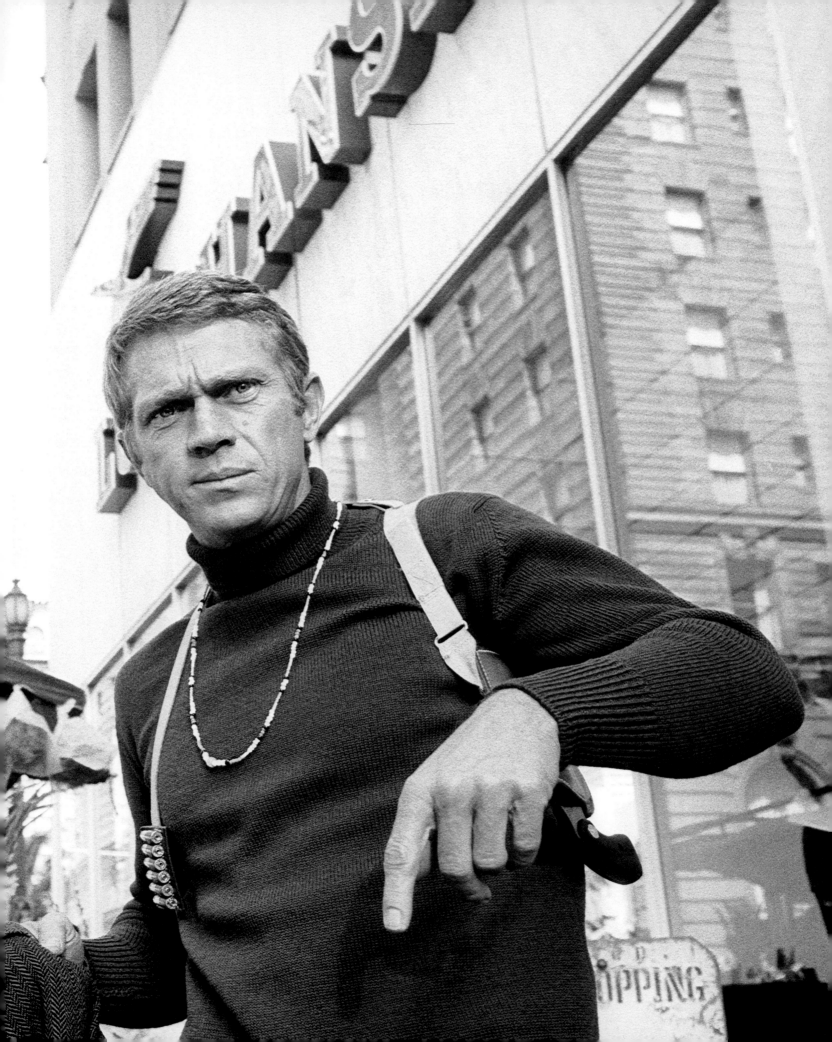

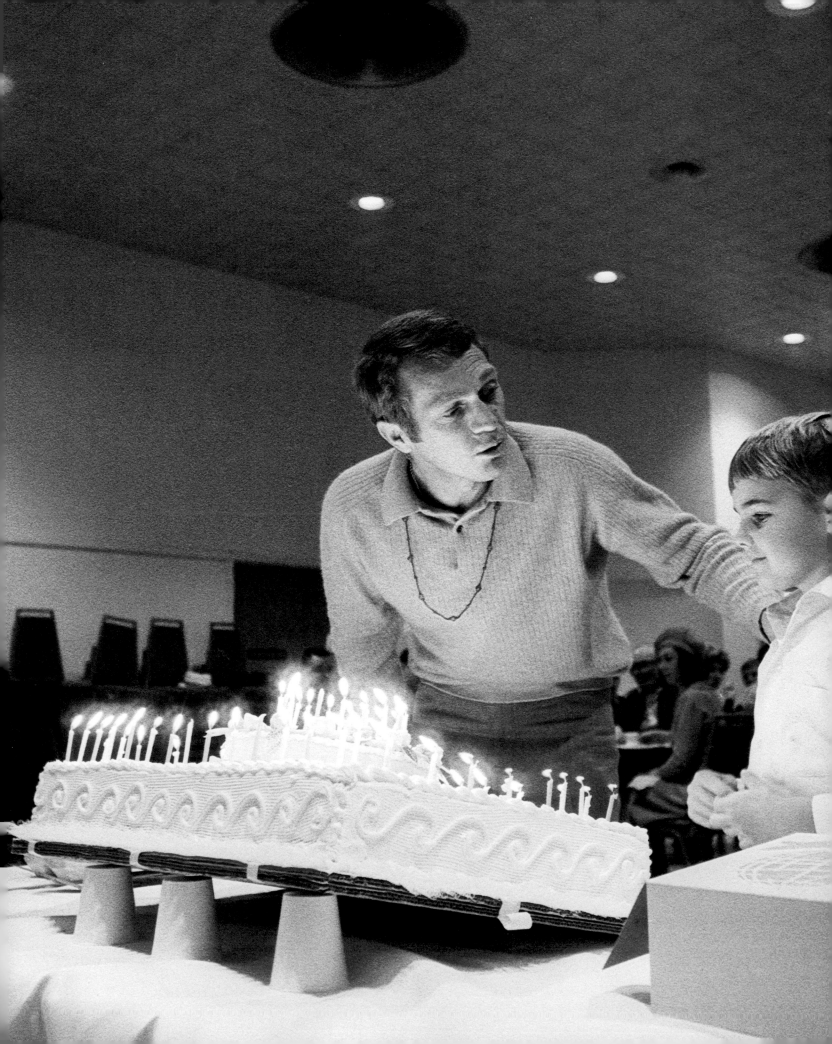

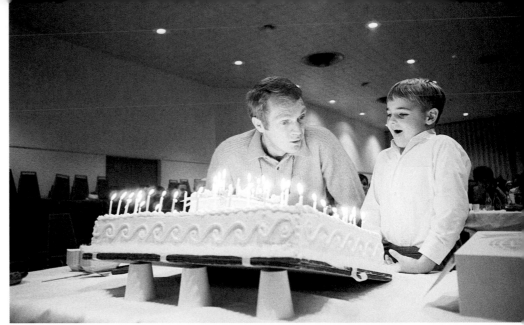
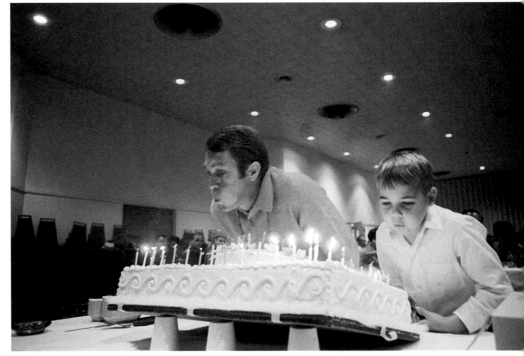
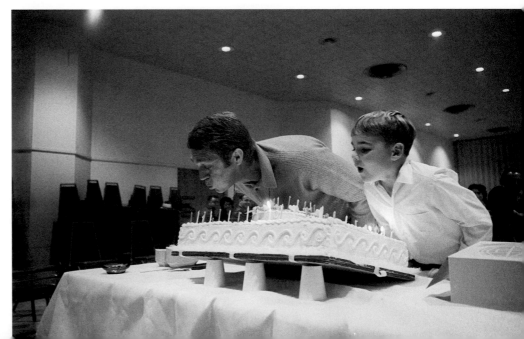

"I'm trying to be a sensible human being who's a credit to his profession."

- Steve McQueen

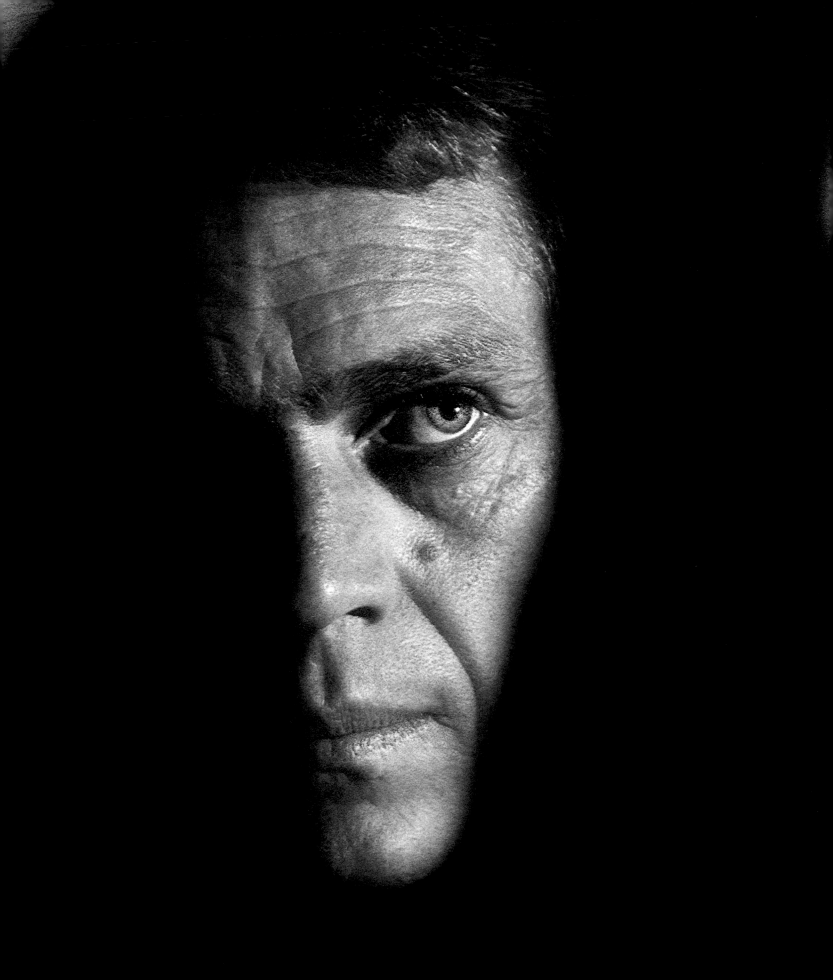

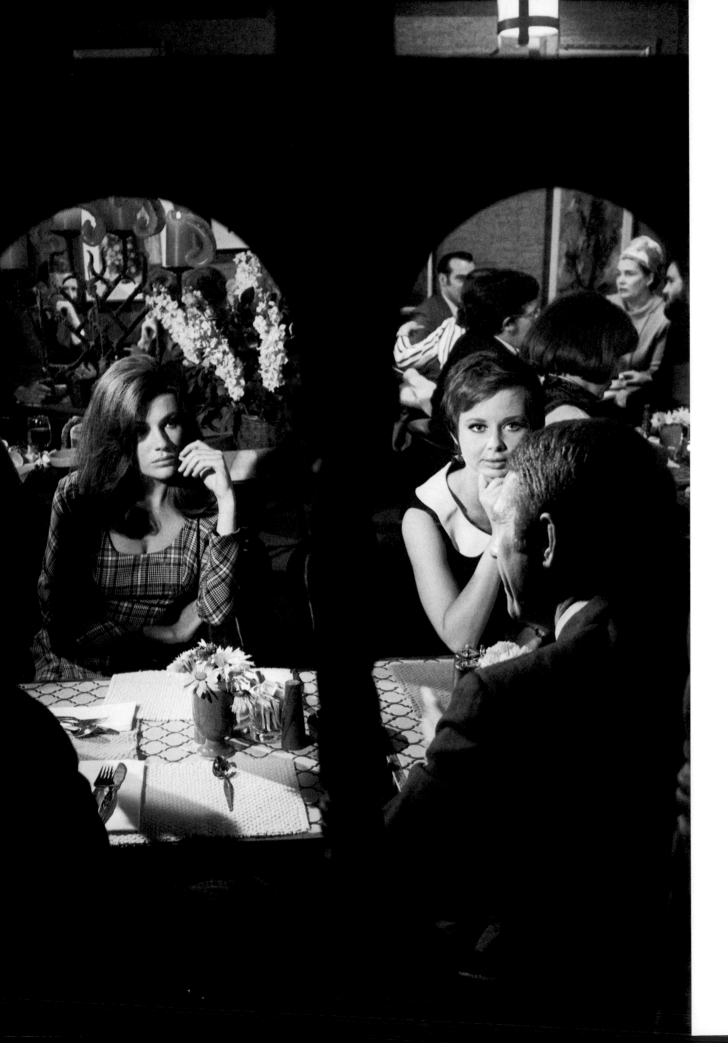

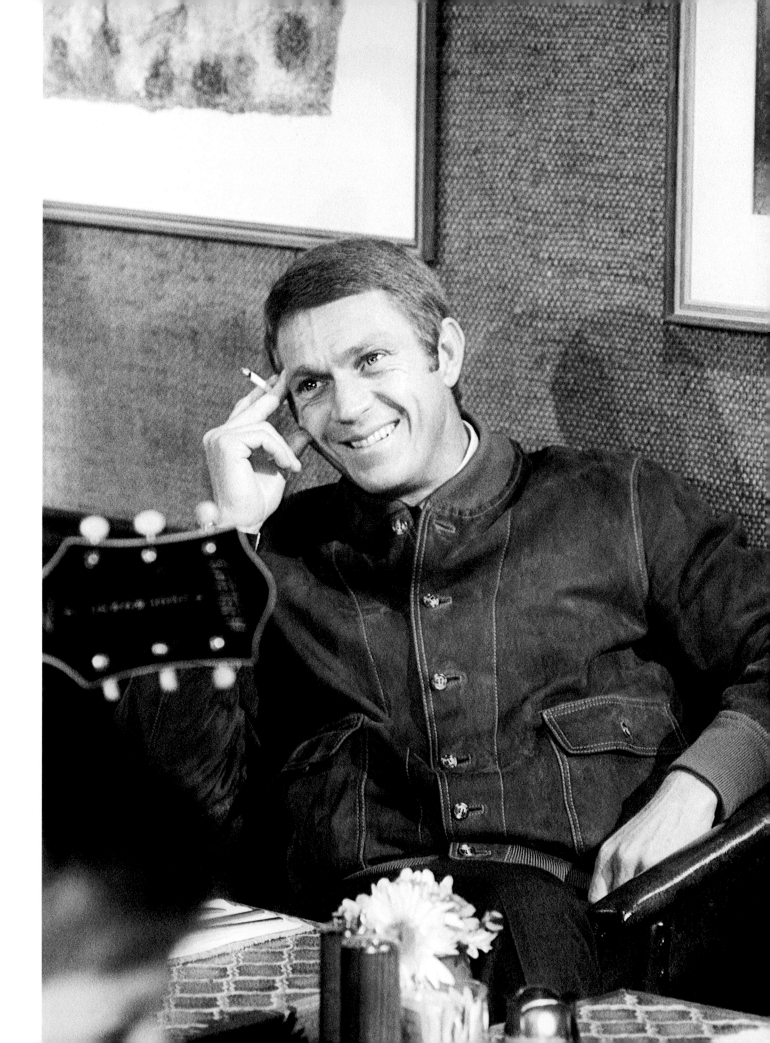

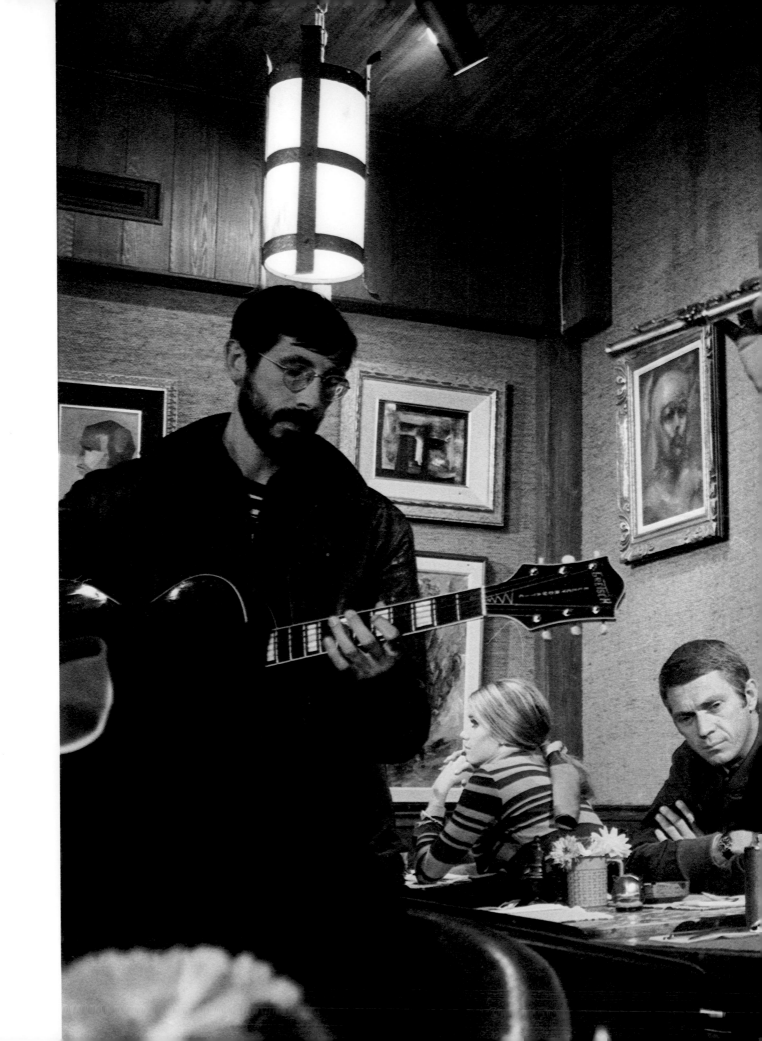

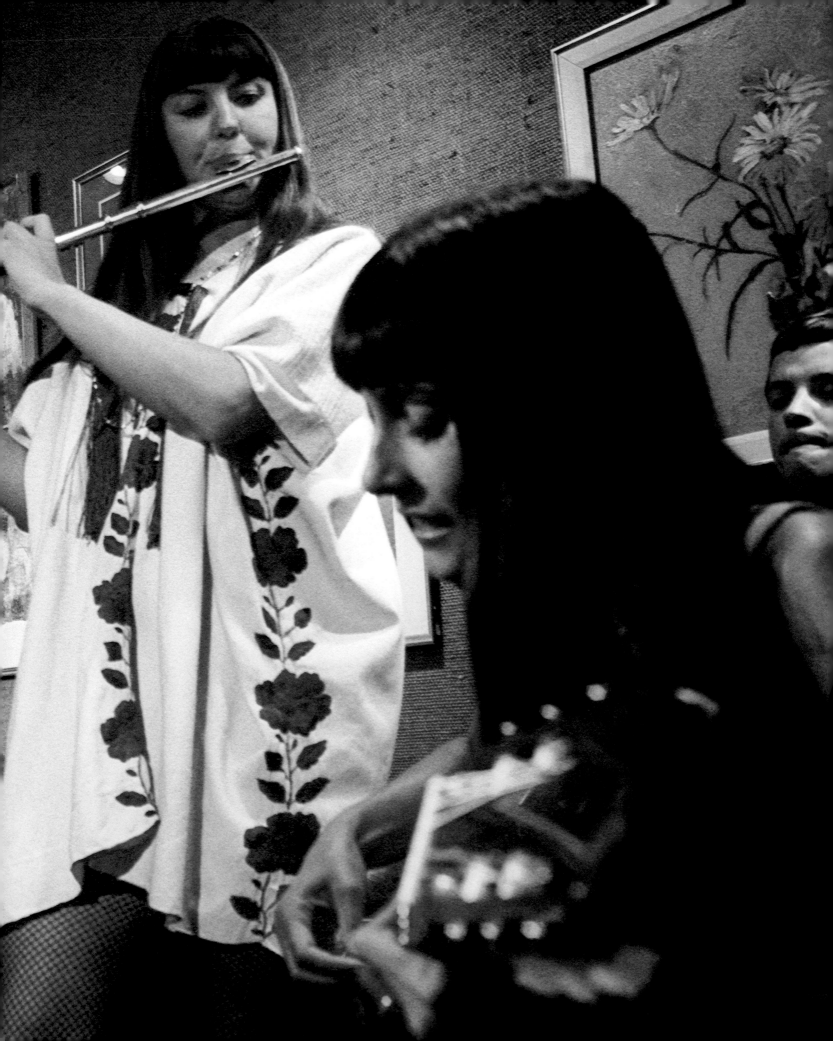

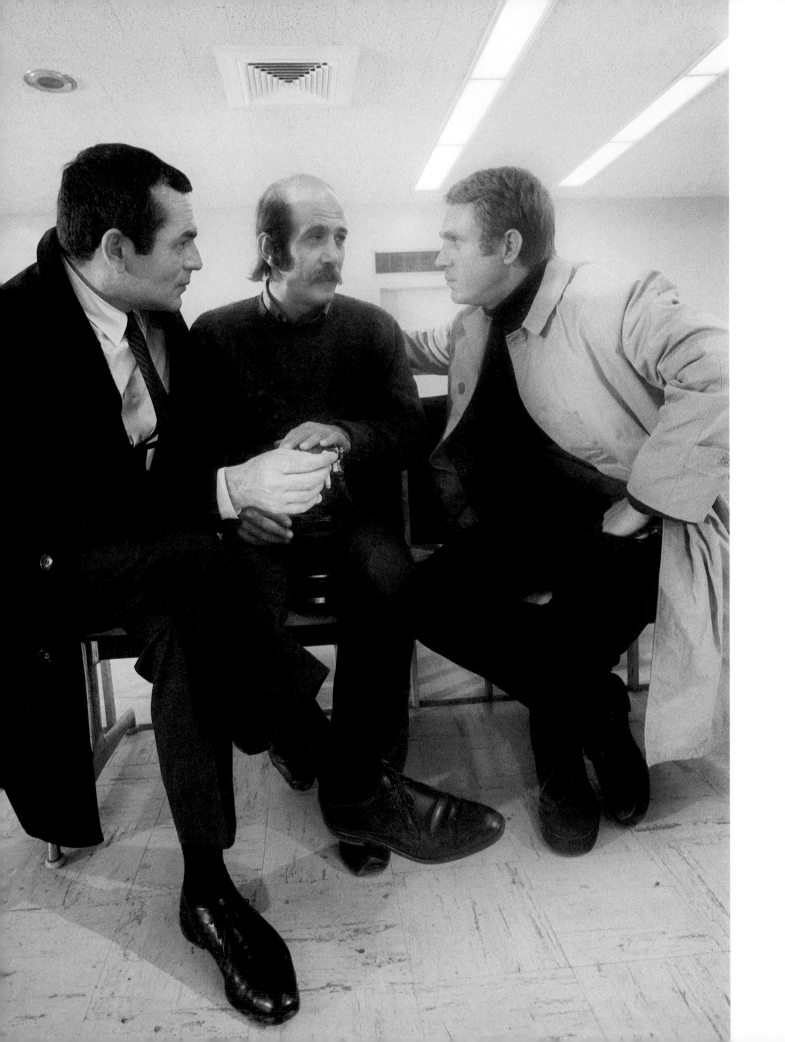

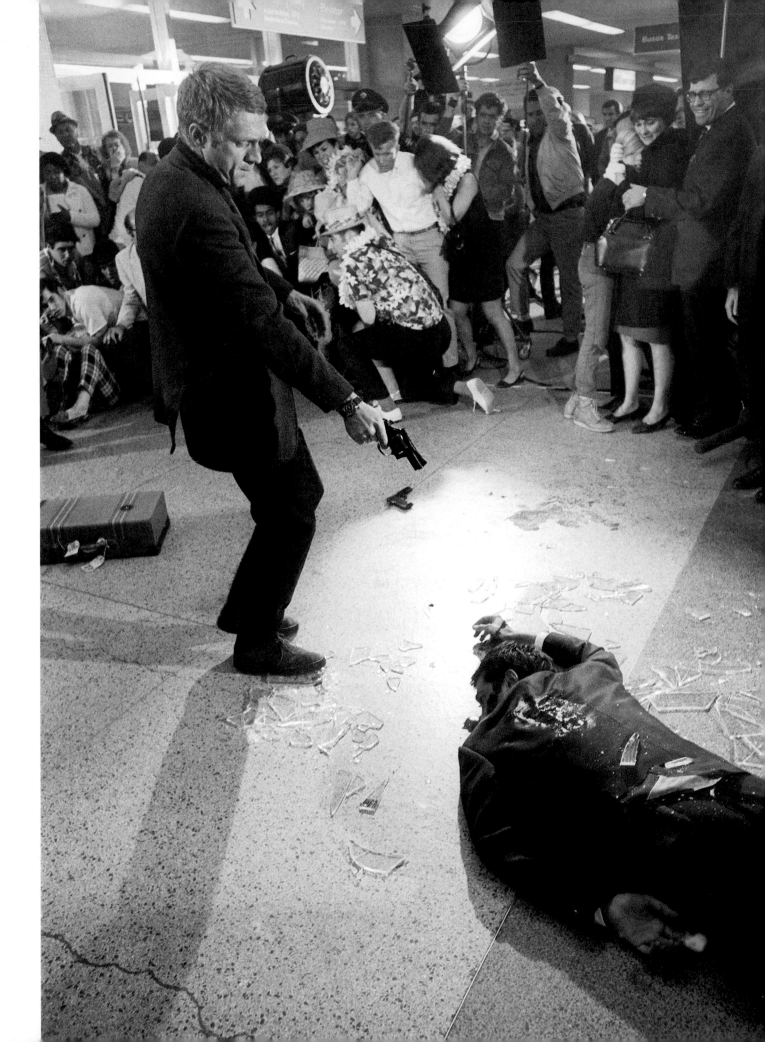

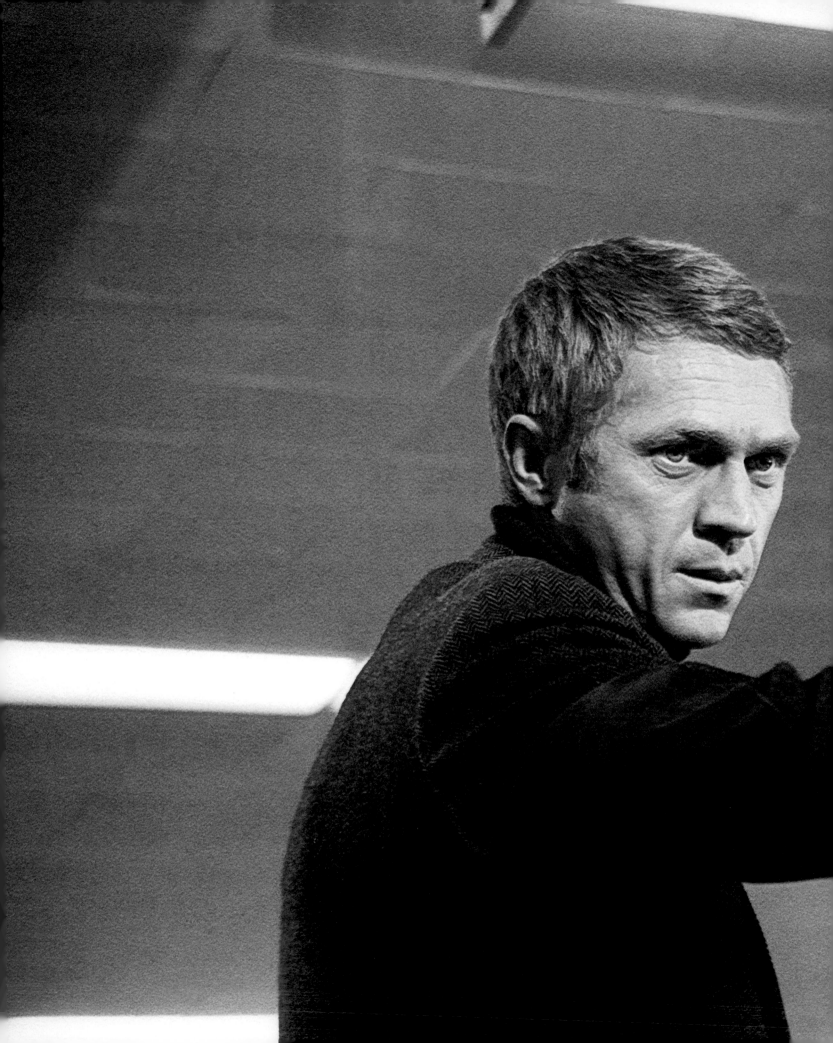

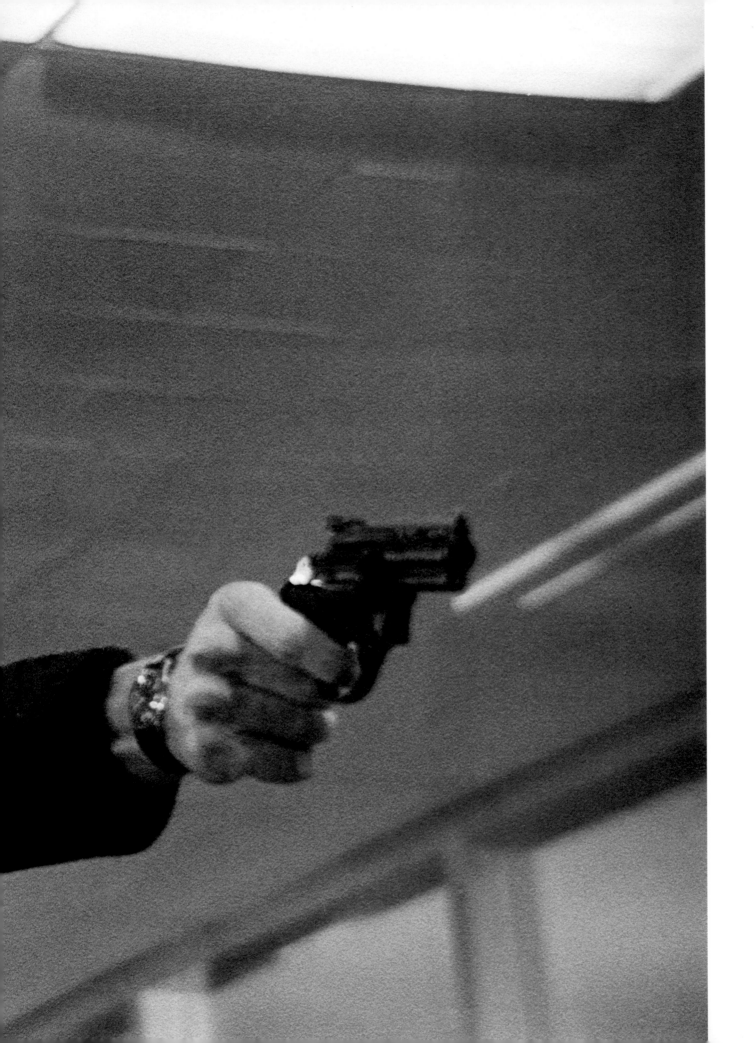

BARRY FEINSTEIN

Barry Feinstein was a photographer, cameraman and art director who created many of the entertainment industry's most compelling and memorable images.

His work has appeared in countless publications including *Life*, *Look*, *Time*, *Esquire*, *Newsweek*, *GQ*, *Rolling Stone*, *Mojo* and *The New York Times*. Most famous for his album cover artwork, Barry is responsible for over 500 cover shoots including the classic *All Things Must Pass* by George Harrison, *Pearl* by Janis Joplin, Eric Clapton's first solo album, *Ringo* by Ringo Starr, *The Times They Are a Changin'* by Bob Dylan, and *Mr. Tambourine Man* by The Byrds, to name but a few.

He was the exclusive photographer on Dylan's legendary 1966 European tour and again for Dylan and The Band's 1974 US tour. As a cameraman, he documented the Monterey Pop Festival in 1967, produced and directed the cult classic *You Are What You Eat* and was a cameraman and official photographer for George Harrison's groundbreaking charity performance at Madison Square Garden, *The Concert For Bangladesh*.

Barry also photographed leading Hollywood and political figures of his day from JFK and Nixon to Marlon Brando and Judy Garland. During his lengthy and varied career, Barry received over thirty US and international art director and photojournalism awards. Several of his awards were often for work he submitted for competition after it had been rejected by clients, just to prove a point!

Barry's work has been exhibited in galleries worldwide including the National Portrait Gallery, London; Museum of Modern Art, NYC; Columbus Museum, Georgia; National Portrait Gallery, Scotland; Gibbes Museum of Art in South Carolina and Hunter Museum in Tennessee.

Barry was born in 1931 in Philadelphia and passed away in 2011 in Woodstock, New York, where he lived for many years with his wife, artist Judith Jamison.

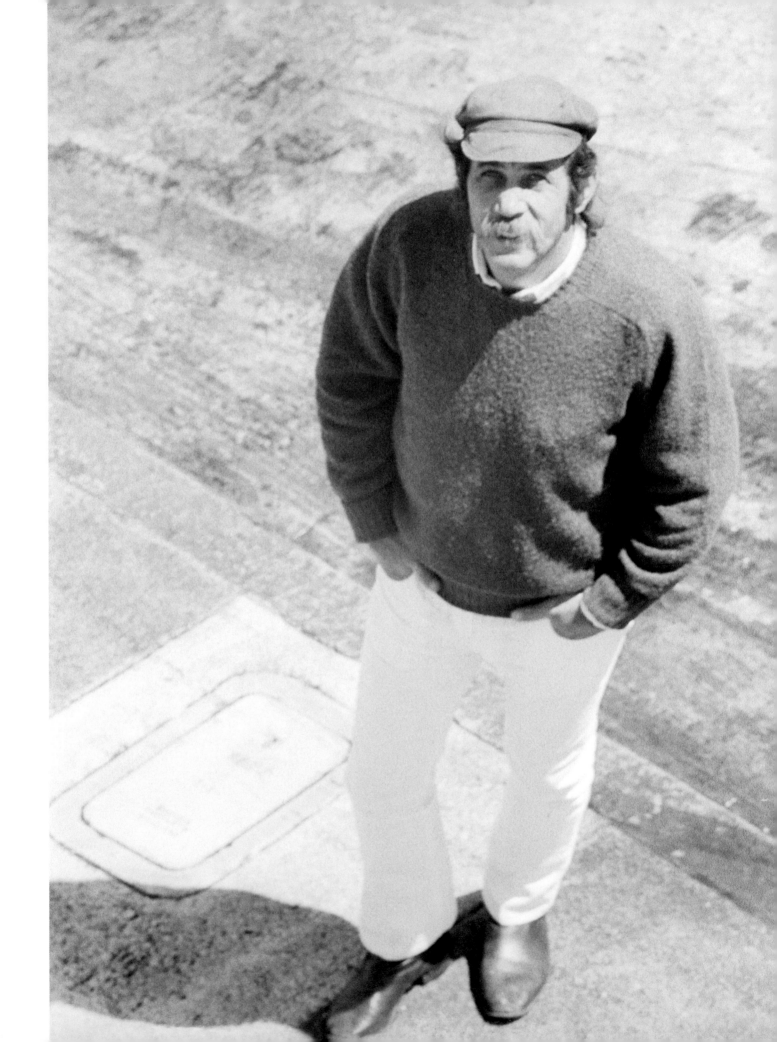

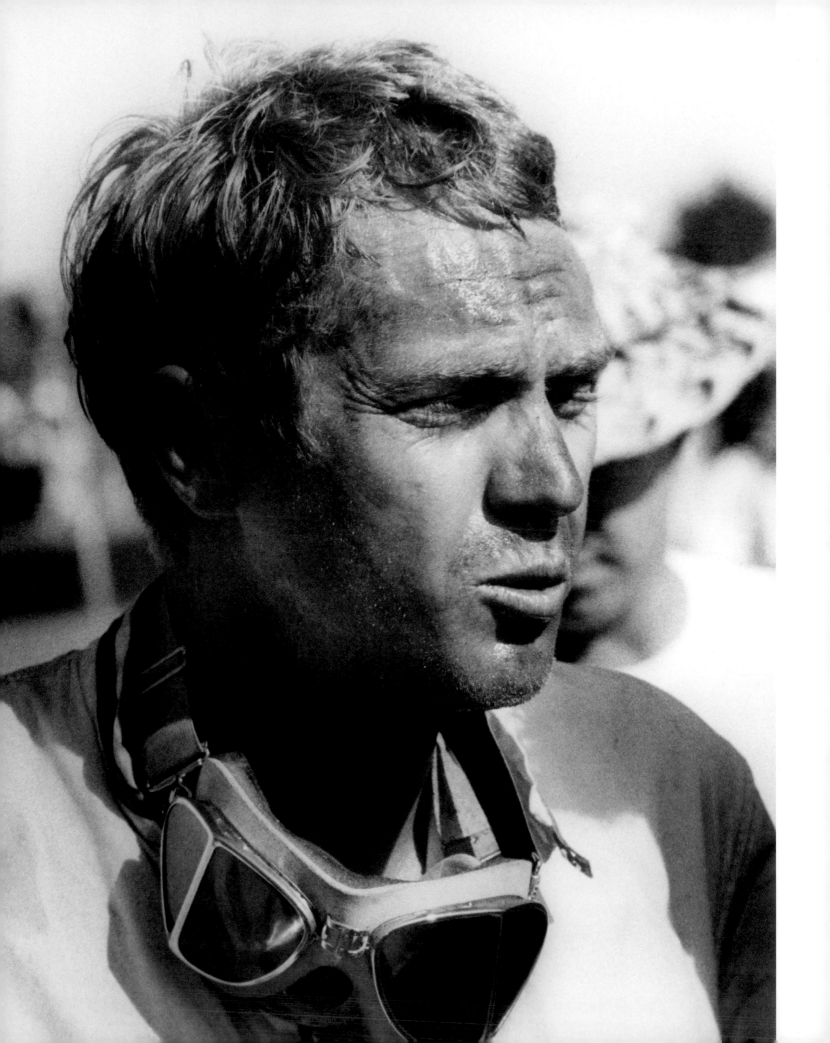

Unseen McQueen by Barry Feinstein

Design by Dagon James
Edited by Dagon James and Tony Nourmand
Introduction by Dave Brolan

For information regarding the Barry Feinstein archive, please visit www.barryfeinsteinphotography.com

Special thanks to Katherine Williams, whose initial introduction and recommendation led to the production of this book.

First published 2013 by Reel Art Press, an imprint of Rare Art Press Ltd, London, UK
www.reelartpress.com

First Edition
10 9 8 7 6 5 4 3 2 1

ISBN: 978-1-909526-04-4

Printed in China

"*I live for myself and I answer to nobody.*"

- Steve McQueen

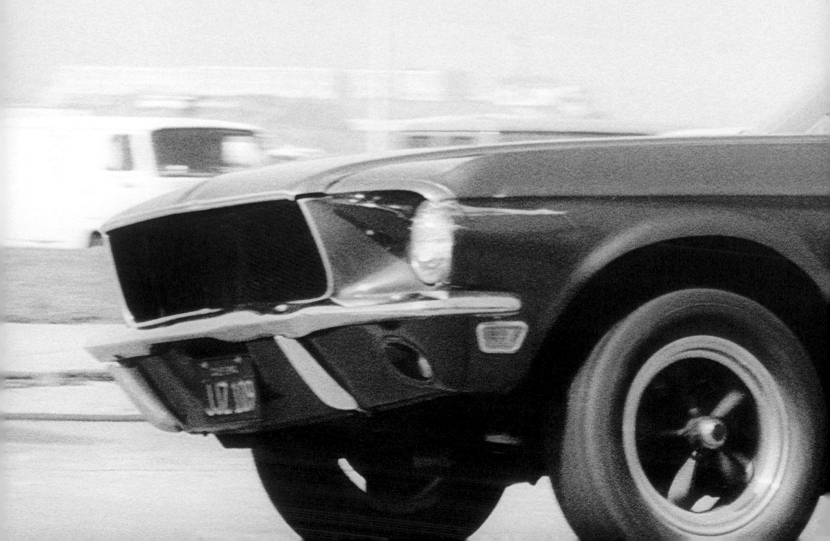

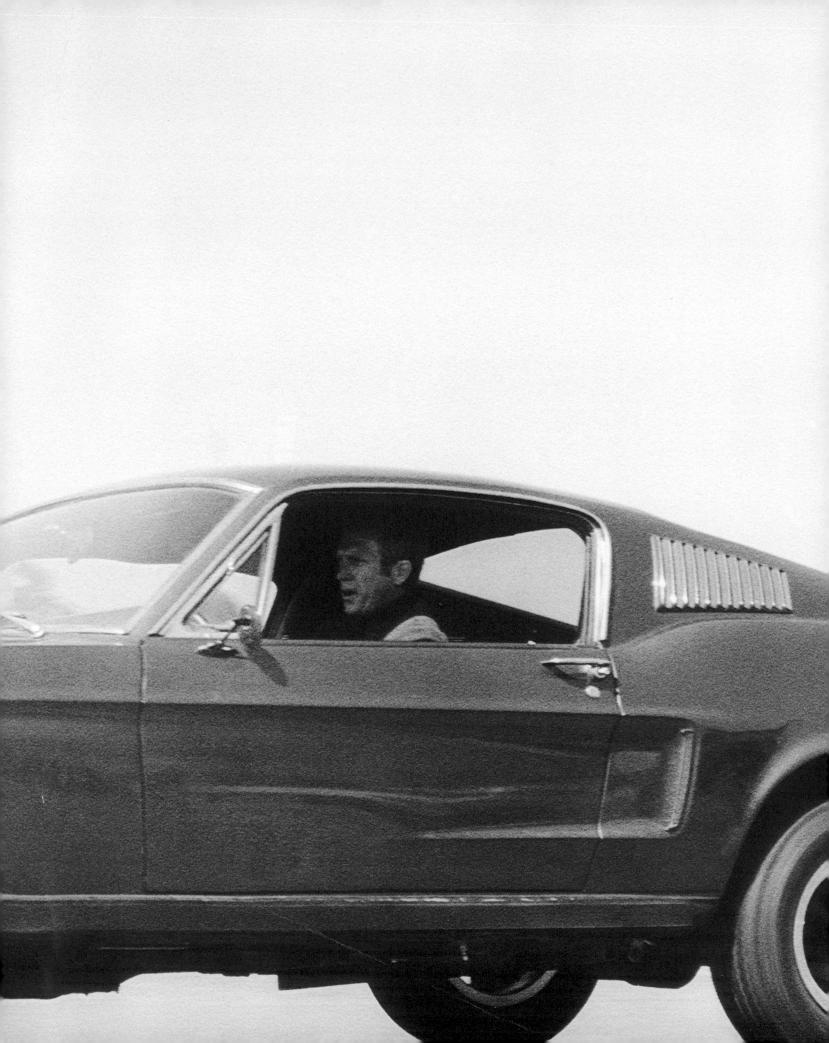

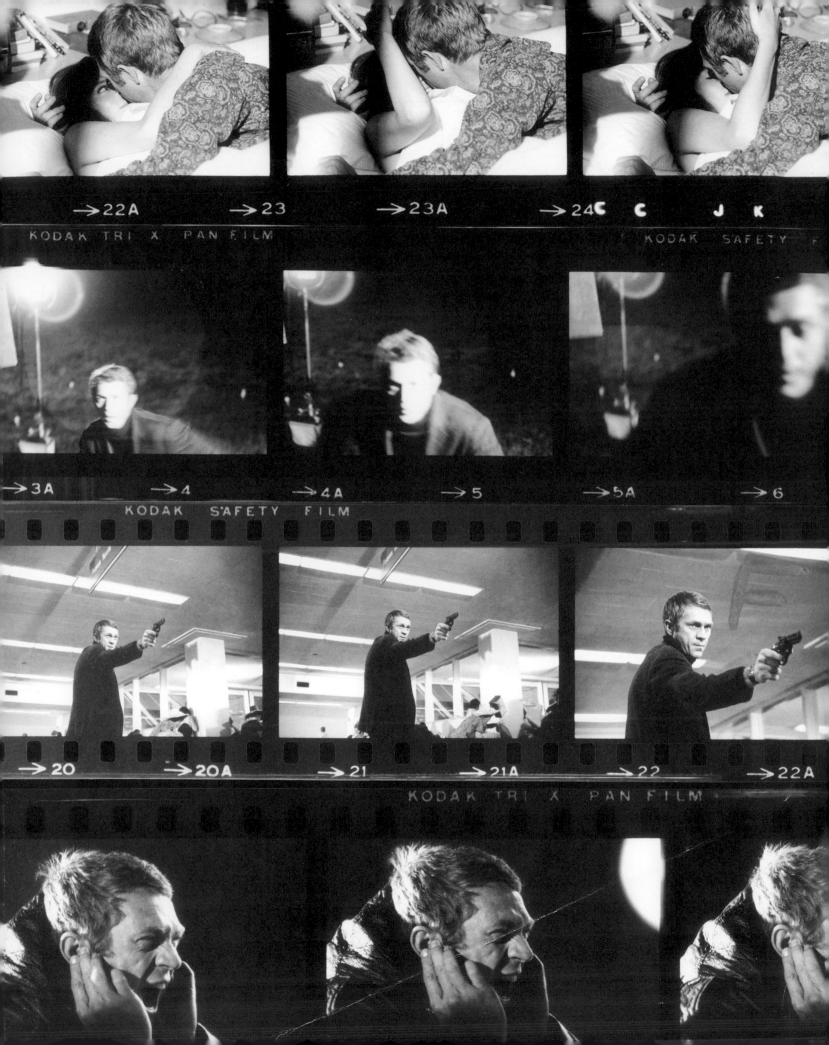